W9-ALX-769

ONCE UPON A TIME IN
QUEENS

An oral history of the 1986 Mets
NICK DAVIS

Foreword by JIMMY KIMMEL

Hyperion Avenue
Los Angeles • New York

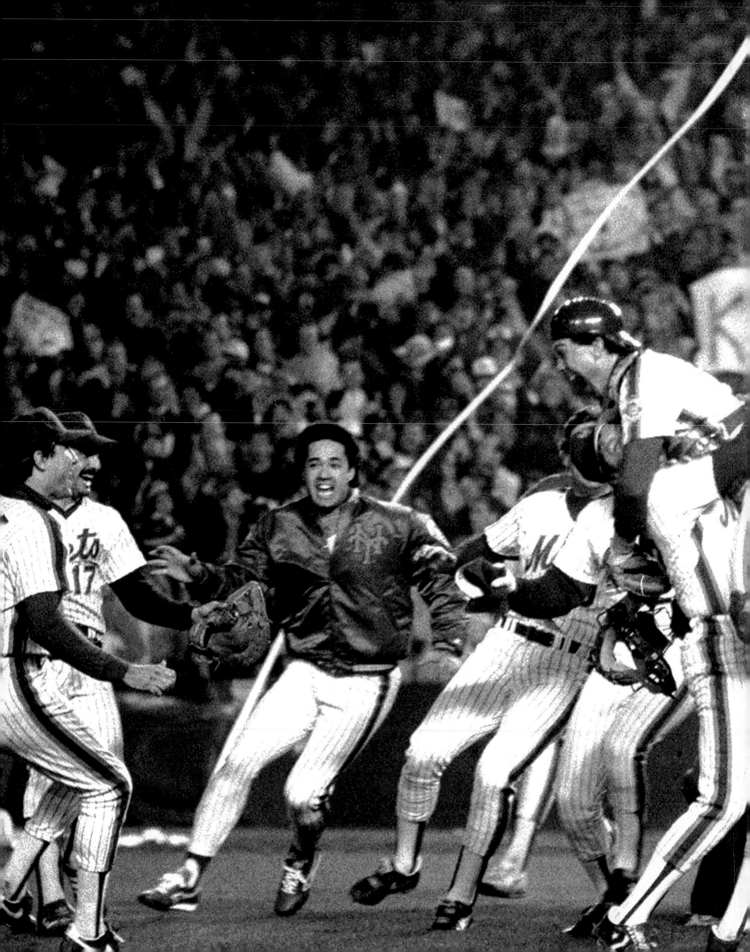

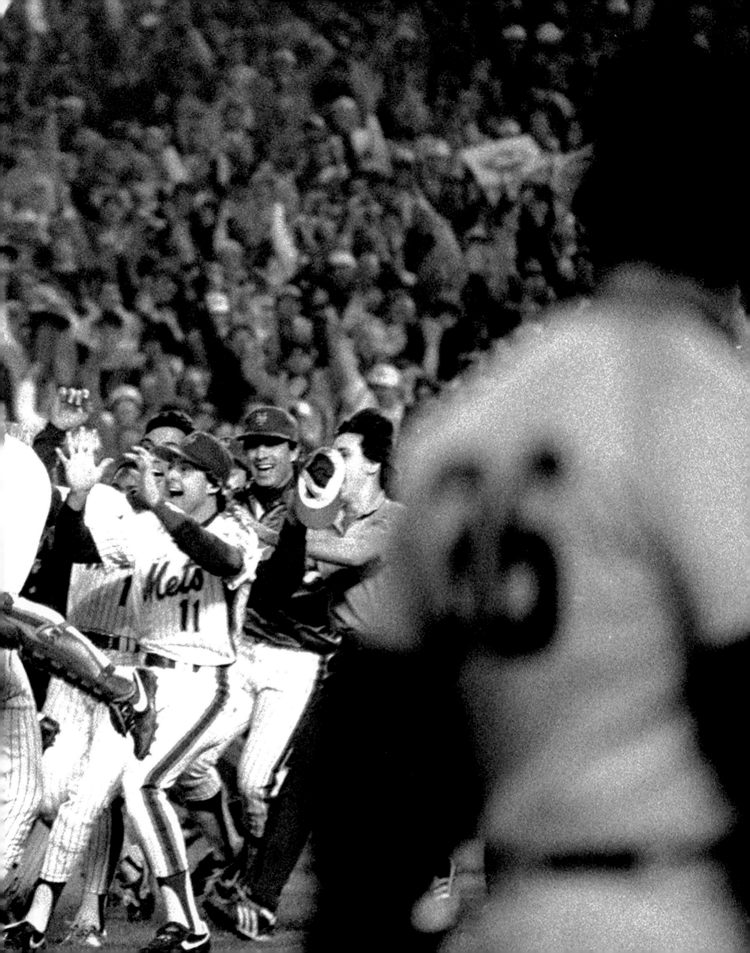

Copyright © 2021 ESPN, Inc.

Photography credits appear on page 246.

"Lost Weekend"
Music and Lyrics by The So So Glos © 2013 Junky Story / Zach Staggers / Market Hotel / Lenore and Yellow (SESAC)
Used With Permission. All Rights Reserved.

All rights reserved. Published by Hyperion Avenue, an imprint of Buena Vista Books, Inc.
No part of this book may be reproduced or transmitted in any form or by any means, electronic or mechanical,
including photocopying, recording, or by any information storage and retrieval system,
without written permission from the publisher.
For information address Hyperion Avenue, 77 West 66th Street, New York, New York 10023.

First Edition, October 2021
10 9 8 7 6 5 4 3 2 1

FAC-034274-21232

Printed in the United States of America

This book is set in Electra LH Regular

Designed by Sammy Yuen

Library of Congress Cataloging-in-Publication Data Control Number: 2021937640

ISBN 978-1-368-07765-1

Reinforced binding

Contents

Foreword

by Jimmy Kimmel

For me, it started with street gambling. Every day after school, flipping baseball cards for keeps on the sidewalk. I lived on E. 64th St. in the Mill Basin section of Brooklyn, a Spaldeen's throw away from Landi's Pork Store. My friend Todd's parents owned the Milk N' Stuff on the corner where, for ten cents, you could buy a pack of Topps baseball cards with a hard rectangle of dusty bubble gum inside. Opening that waxy package was a delight. You never knew what treasures might be sandwiched between unwanted White Sox and unknown Orioles. My team was the Mets. When it came to player cards, a Tom Seaver was at the top of the heap, but I felt like Charlie outside the chocolate factory when I purchased and unwrapped a pack that contained the ultimate prize—a Mets team card. I'll never forget that moment. I was overjoyed. Todd was devastated. And so, like Veruca Salt, his parents allowed him to open every pack of cards in the store, hoping to find another one. He didn't. I wound up trading a tearful Todd my Mets team card in exchange for the hundreds of cards he'd opened, in a transaction I regret to this day.

The Mets were everything the Yankees weren't. Lovable and, yes, losers. At seven years old, I could already identify with that. To this day, I see rooting for the Yankees as a character flaw. It's easy to root for a winner. Being a Mets fan requires humility. My dad was and still is a loyal Dodgers fan. He did not begrudge the Dodgers for moving west and within the next few years, moved us west, too. We relocated to Las Vegas, where the Mets all but ceased to exist—until the mid-80s, when a cast of characters the likes of which reality shows are now built on captured the attention of a nation.

Characters like Keith Hernandez, the perfect first baseman, whose porn-star mustache would make him captain of any team; Darryl Strawberry, the troubled phenom with a swing as sweet as his name; Dwight "Doc" Gooden, as dominant a pitcher as ever there was, whose drug abuse lurked in the pages of the *New York Post*; Gary Carter, the clean-cut All-Star catcher whose Boy Scout demeanor and love of the spotlight made him an unlikely outcast; Kevin Mitchell, the

"cat killer" from San Diego, whose gang-banger reputation scared even his own teammates; Ray Knight, who was as good with his fists as he was with his glove; Mookie Wilson, a sunny favorite of fans and fellow players alike; Lenny Dykstra, the hard-charging and harder-partying overachiever whose future did not include teeth; and Davey Johnson, the easygoing manager who paid little attention to what his players did off the field as long as they won on it.

The '86 Mets was a pirate ship disguised as a baseball team. Dozens of books have been written about their exploits. Somehow, the fact that they won the World Series is one of the least interesting things about them. When Nick Davis, the brilliant director and writer of the great PBS *American Masters* documentary "Ted Williams: 'The Greatest Hitter Who Ever Lived,'" asked me and my cousin Sal Iacono if we'd be interested in helping him produce a documentary about the Mets and New York in 1986, it felt as if I'd found another Mets team card. Helping to build this tribute to this unfathomable team and the city of New York in the 1980s was one of the highlights of my career.

The pages that follow are filled with memories from those who were on this remarkable journey. And as for the rest of us, watching from our couches and the stands, I offer this lyric from the Brooklyn punk band So So Glos: "We grown up 86'd and ended up like this."

Introduction

We all know where we were.

Some national events are so seared into our memories that there is no getting rid of them. The litany is a familiar one: 11/22/63, the *Challenger* explosion, 9/11, of course. For the most part, we would expunge these memories if such a thing were possible.

But unless your sympathies are distinctly Bostonian, the events that took place on five acres of land in New York's Flushing, Queens, a few minutes after midnight on the morning of October 26, 1986, are prized in our memory banks, like precious stones in which can be found traces of the entire history of a lost empire, a saga of monumental talent, swagger, and excess.

Of course, the 1986 Mets were far more than the famous ground ball off the bat of Mookie Wilson that trickled through the legs of Red Sox first baseman Bill Buckner in Game 6 of the World Series. It is in fact because of who that team was that the moment acquired such resonance. The '86 Mets were brash, arrogant, and charismatic, a cocky, hard-partying group that seemed to exemplify everything about New York City at the time.

Indeed, the team was so special—beloved by so many, hated by so many others—that there was a sense as it was happening that we were witnessing a unique historical moment . . . even if, as with the Beatles or the Lost Generation in Paris in the 1920s, there was more than a whiff of self-mythologizing about the whole affair.

My hope in this book, as in the multi-part film I directed for ESPN, is to capture the unique spirit of the 1986 Mets as it developed. I grew up a Mets fan, and so experienced the whole saga first-hand; and all Mets fans understood that the formation of that particular team—the entire history of the franchise, really, starting with the Dodgers and Giants abandoning the city back in the late 1950s for California—was tinged with magic.

The pieces fell ever so slowly into place following the nadir of the awful summer of 1977, when our idol Tom Seaver was ripped from his rightful place atop the Shea Stadium pitching mound and sent packing for Cincinnati. With the city itself struggling to recover from the misery and malaise of the mid-1970s, there seemed to be, at least for a time, nothing but suffering.

But when the franchise was sold to a group headed by Nelson Doubleday Jr. in 1980 and Frank Cashen came aboard as the general manager, stirrings of optimism returned. The drafting of a preternaturally gifted Los Angeles high school ballplayer with the glorious name Darryl Strawberry; the appearance of the original "Mookie," a speedy outfielder with a megawatt smile; the miraculous trade for a onetime National League MVP, the raffish, almost-intellectual idol Keith Hernandez . . . Something was coming, something good.

As the stars aligned, New York City itself seemed to be engineering a comeback. Recovered from the hangover of the blackout and bankruptcy days of the 1970s, the city was strutting, becoming the epicenter of a riotous explosion of culture, music, and art. Rap music was conquering the outer boroughs; nightclubs throbbed with a dynamic new sound—the streets seemed filled with cocaine or its terrifying variant, crack. And, oh yes, money. The yuppies on Wall Street, then in ascendancy, were basking in the Go-Go '80s, as President Ronald Reagan's deregulations, combined with New York mayor Ed Koch's fierce encouragement of real estate development at the expense of anything resembling aesthetic appeal, were turning Gotham into a sprawling, gleaming, but still gritty metropolis.

Over in Queens that summer, the boys with the blue-and-orange racing stripes on their uniforms were playing with remarkable verve and gusto, winning 108 games with a high-flying, rollicking feel that perfectly captured the city. Their dramatic and triumphant season was as miraculous as it was arrogant—full of harbingers of impending doom that were always, somehow, staved off; rumors of sex and drug exploits surrounded the team. Four Mets were arrested after a fight with off-duty cops at a Houston nightclub. Charges of racism in the organization brought one outfielder's Met career to an ignominious halt. It seemed never to end.

But it worked. Above all, New York City and the 1986 Mets felt like a love affair—wild, hot, and short. It began collapsing the very day after the ultimate triumph, when Dwight Gooden, the once-untouchable "Dr. K," missed the championship parade with a case of the "sniffles," gathered

steam when management replaced crucial members of the roster with less-volatile players, and accelerated the following spring training, when Gooden failed a drug test on April Fools' Day.

Ultimately, the Mets' 1987 season (and a chance to repeat as champions) would effectively end with a shocking home run by the St. Louis Cardinals' Terry Pendleton in a game just three weeks before the equally stunning and dramatic stock market crash—Black Monday—that brought New York of the 1980s back to reality.

In the years since, Wall Street recovered, and the city was brought under control in a way it hadn't been in 1986. The much-heralded—or maligned—cleanup of Times Square demonstrated that a thriving city could put its best face forward when it needed to. And while those who lament the loss of the city's grit and grime of the '70s and '80s tend to ignore the shocking crime and squalor of those days, there's no denying that New York has lost something in the translation.

As for the Mets, the glory that seemed destined to last a lifetime when reliever Jesse Orosco hurled his mitt skyward on Monday, October 27, 1986, instead lasted less than twelve hours. Questionable management moves, injuries, and the normal vicissitudes of baseball meant that the breaks that went the team's way one year (hello, Bill Buckner) went a different way in future years (goodbye, Mike Scioscia).

And, of course, the players' well-documented personal problems finally caught up with them. While the public portrait of Darryl Strawberry's and Dwight Gooden's problems has been painted in crude and largely unsympathetic colors, there's no denying that the two men, as well as others on the team, saw their careers debilitated by the demons they'd mostly been able to keep at bay that magical summer.

But for one moment we had it all—a singular baseball team that blazed like a comet across the New York City skyline. A legendary team full of scoundrels, ruffians, and a choirboy or two, characters whose exploits on and off the field continue to thrill and enchant. . . .

—Nick Davis

First Inning

MEET THE METS

LENNY DYKSTRA, *outfielder, New York Mets, 1985–1989*

Once upon a time there was a team that was magical and entertaining and fucking didn't know the word *quit*.

JEFF PEARLMAN, *author*, The Bad Guys Won!

At that time, they were the greatest show on earth.

DARRYL STRAWBERRY, *right fielder, New York Mets, 1983–1990*

From a baseball perspective, how good? We were really good.

ED LYNCH, *pitcher, New York Mets, 1980–1986*

Some of the best, talented, high-energy players that have ever been together in one place. Everything came together and it was an amazing thing to witness.

GREG PRINCE, *author-blogger, Faith and Fear in Flushing*

It was a high-definition cast who had four tent poles: Gooden, Carter, Hernandez, Strawberry. And the supporting cast by itself was Broadway caliber.

BILLY BEANE, *outfielder, New York Mets, 1984–1985*

They had everything: speed, power, defense, pitching.

JEFF PEARLMAN

Their pitching was ridiculously good.

MOOKIE WILSON, *outfielder, New York Mets, 1980–1989*

Every player felt that we were going to win.

BOBBY OJEDA, *pitcher, New York Mets, 1986–1990*

It becomes about—we got to win. The "W" is the monster in the room.

WALLY BACKMAN, *second baseman, New York Mets, 1980–1988*

It was all about winning.

DWIGHT GOODEN, *pitcher, New York Mets, 1984–1994*

One of the things that never got talked about the '86 team—it's the knowledge that we actually had and the passion we had for the game.

LENNY DYKSTRA

We owned New York that year.

BOBBY OJEDA

It's the type of town that embraced that particular team.

KEITH HERNANDEZ, *first baseman, New York Mets, 1983–1989*

It's New York, it's the Mets; it just struck a chord, all the things that happened. The brawls . . .

RAY KNIGHT, *third baseman, New York Mets, 1984-1986*

We were Vikings.

WALLY BACKMAN

There was not one player on that team that you were gonna intimidate. We played hard, and we partied hard.

WE OWNED NEW YORK THAT YEAR.

LENNY DYKSTRA

ED LYNCH

Well, the off-the-field character is well documented.

SID FERNANDEZ, *pitcher, New York Mets, 1984–1993*

Every time anyone asks me about the season, all they want to talk about is the drugs, the drinking. That's all anybody wants to talk about: the plane ride from Houston.

DARRYL STRAWBERRY

We had the talent on the field, but I think the personalities stood out more than anything.

MOOKIE WILSON

We showed something that most people in New York have, which is called arrogance.

KEVIN MITCHELL, *infielder-outfielder, New York Mets, 1984, 1986*

We was cocky.

LENNY DYKSTRA

We had a swagger, you know?

DARRYL STRAWBERRY

They hated us because they thought we were very cocky and a little bit over the top—and maybe we were.

LENNY DYKSTRA

I didn't mind walking around like I had a fifteen-inch cock.

DARRYL STRAWBERRY

We realized, "Hey, we're good. We're really good."

GREG PRINCE

It was something you want to shoot through your veins, to feel that way, every day. You had a team that was succeeding like crazy, and you had a team that was living it like crazy.

JOE PETRUCCIO, *artist, Della Femina Travisano & Partners, 1980s*

The Mets went from being somebody that you wouldn't want to sit next to on a train to somebody that you want to be next to every moment of your life. You want people to know you're a Mets fan. As the team got better, the city got better. I don't know that they had anything to do with it, but they both shined bright.

JEFF PEARLMAN

They *were* New York.

ROGER ANGELL, *writer*

It was like a fairy tale. . . .

Lovable Losers

JOE PETRUCCIO

Once upon a time, there was a city that had a dream.

In 1957, New York City lost two of its three Major League Baseball teams. Lured by a

burgeoning postwar population boom in California, and the increasing ease of plane travel, the Brooklyn Dodgers and the New York Giants fled west. The city was left with a gaping hole.

GREG PRINCE

The Mets were born of loss and hurt. In those days, National League baseball meant something. People differentiated between the leagues, and the almighty Yankees were not to the taste of a lot of people.

JEFF PEARLMAN

You couldn't be a Yankee fan; you couldn't jump from the Giants or the Dodgers to the Yankees. It's too much of a bridge to cross.

GREG PRINCE

So, something had to fill that void. Picking up the fallen flags of the departed—the blue of the Brooklyn Dodgers, the orange of the New York Giants. . . .

GEORGE R. R. MARTIN, *novelist*

All the Brooklyn Dodgers fans who had been without a team and all the New York Giants fans who had been without a team found a team to root against the Yankees in the Mets. Unfortunately, they were terrible.

The Mets lost an astounding 120 games in 1962 (their first year of existence), finishing with a .250 winning percentage. Both marks still stand. Newspaper columnist Jimmy Breslin's

classic volume about the historically sorry team took its title from something Manager Casey Stengel supposedly asked after another loss: Can't Anyone Here Play This Game?

GREG PRINCE

But it didn't matter. Their original owner, Joan Payson, felt that unlike the Yankees, the Mets were the city's team.

ERIK SHERMAN, *writer*

The Mets took whoever the various teams around baseball wouldn't protect, so they were basically left with the Thanksgiving leftovers to make a team out of.

ROGER ANGELL

This team couldn't win at all. They became beloved losers.

GEORGE R. R. MARTIN

They lost all the time in such funny and amusing ways. Casey Stengel was their manager.

By the time Casey Stengel was managing the Mets, he was over seventy years old and prone to sleeping on the bench during games. The ramblings of the wizened "Old Perfesser" became the stuff of legend. . . .

CASEY STENGEL, 1962

As soon as the kid can talk, he's saying Metsy.

Not papa, not mama, Metsy, Metsy, Metsy, Metsy.

ERIK SHERMAN

Casey Stengel was unlike any other manager in the history of baseball.

GREG PRINCE

The Mets were two years at the Polo Grounds and then they moved into Shea Stadium in 1964.

ED LYNCH

It was the time of the 1964–1965 World's Fair. Shea was state of the art, beautiful.

ERIK SHERMAN

So, now you have two teams in New York; and the Yankees were stodgy. They were a very buttoned-up organization, and the Mets were the new kid on the block.

Though the team was terrible on the field, the Mets, after the move to Shea Stadium in 1964, outdrew the mighty New York Yankees in paid attendance every year for the next twelve years.

ERIK SHERMAN

Heartbreaking as it had been for New Yorkers, for Brooklyn to lose the Dodgers, for the Upper West Side to lose the New York Giants, baseball was expanding and it was creating new fans out on the West Coast.

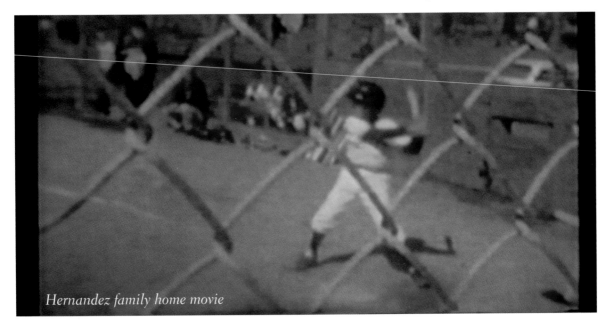

Hernandez family home movie

KEITH HERNANDEZ

My childhood was just like *Huckleberry Finn*. I was born in San Francisco, then we moved down to Pacifica, a beach town surrounded by mountains, all artichoke fields. There was a creek, San Pedro Creek, that ran from the mountains into the Pacific Ocean. We'd go through that creek in the summer; you could go across the creek, and we would have adventures.

It was a very competitive, very athletic neighborhood. There was a nunnery up at the top of the hill, overlooking this area, and the parents went up there and talked the nuns into giving the land so they could make a ball field, and it was like a minor-league complex.

We had a very strong family unit: An older brother, Gary . . . went on to play in the Cardinals' minor-league system. My father was an ex–minor league player, and he got involved in Little League. Dad was . . . Well, our relationship was pretty intricate and complex.

Dad had a great eye for talent and was also a great teacher. We were highly instructed. We knew how to do relays, rundowns; we were very advanced. We won championships, and self-esteem builds with success, especially in a very competitive league.

Dad was wonderful in Little League, the kids loved him. But when I went off into high school, and Dad lost control, that became a problem. Starting in high school, Dad was just paranoid that I would get ruined by a coach.

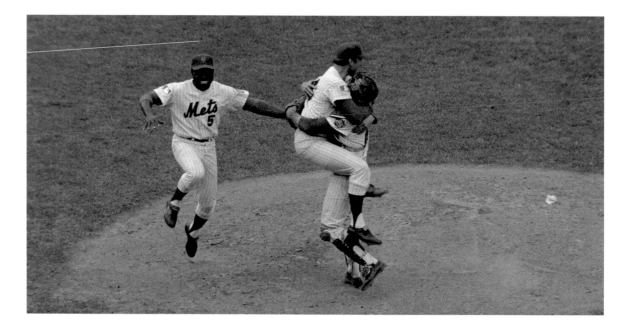

ERIK SHERMAN

In '68, Gil Hodges becomes the Mets' manager. And everything changed when they hired Gil. He was a marine, with purpose. The Mets started bringing in guys like [Jerry] Koosman and Nolan Ryan, and most of all, Tom Seaver.

Upon his arrival at Shea in 1967, George Thomas Seaver quickly became "The Franchise," the man on whose shoulders the entire team rested.

GREG PRINCE

Tom Seaver was the greatest pitcher the Mets ever had, the greatest player the Mets ever had.

MARK HEALEY, *author,* Gotham Baseball

If God created a pitcher with the perfect motion, the perfect mechanics, the perfect face, it's Tom Seaver.

ED LYNCH

He was the guy we all idolized and wanted to be like.

Seaver's excellence had a galvanizing effect on the franchise. The Mets still finished at the bottom or near the bottom of the league in 1967 and 1968. But in 1969, the planet saw two miracles: In July, mankind landed on the moon. The second miracle unfolded in Queens.

ERIK SHERMAN

When the Mets were successful, there was always an element of magic around it.

GREG PRINCE

In the second game of a crucial two-game

series against the Cubs in September of 1969, a black cat shows up as the avatar of "you're not going to get in the way of the New York Mets."

ERIK SHERMAN

The [American League champion] Baltimore Orioles were a juggernaut. They had an All Star at every position. So, after beating the Mets in the first game of the World Series, it was widely assumed that they had a chance of sweeping the Mets. But the Mets turned things around.

The remaining four games, all won by the Mets, were chock-full o' miracles: two dazzling Tommie Agee catches in center field in Game 3; Ron Swoboda's diving catch the following afternoon; the crazy bunt play that ended Game 4; and the Cleon Jones "shoe-polish incident" in Game 5, topped off by the wild celebration after Baltimore's second baseman flew out to Jones for the final out of the series, sending Shea Stadium into a frenzy.

GREG PRINCE

It was all joy. Shea Stadium became a love-in. It was Woodstock South. And I think that sealed forever the concept of Mets magic.

ED LYNCH

Nothing could compare to the Miracle Mets.

GREG PRINCE

Unfortunately, the magic didn't last in the '70s. There was one more great run in 1973, when they won the pennant. But for a long time, as a fan, I was thinking more of what's going to become of us in the future.

)0)0)0

MOOKIE WILSON

When I was growing up, any place was better than South Carolina. We did not have running water. And if you don't have running water, you don't have an indoor toilet either! But we found a way. It made me and everybody else in my family appreciate what little you do have. My father was a sharecropper. Growing up on a farm, there wasn't a lot to do other than go to the fields.

On the weekends, you looked forward to baseball because that was the one thing we had: baseball. There were twelve kids in my family, seven boys and five girls. So we would borrow the neighbors' kids and make two teams. Baseball was a way of life for us, a way to forget about all the hardships that we were facing.

Any place was better than the South. The goal of every young man in South Carolina: "When I grow up, I'm going to New York."

On the morning of July 14, 1977, New York City woke up to a new world. A massive power outage the evening before had brought on a night of riots and mayhem, and now New Yorkers were facing the reality of lawlessness on the streets that seemed to have no precedent.

JOHN STRAUSBAUGH,

writer, New York City historian

New York City hit its lowest point in the '70s the day after the blackout. People woke up to a terrible hangover, I think. You know, a cultural hangover. What little pride they had left in the city was shot that next morning.

GREG PRINCE

It became the embodiment of what New York was like in the late '70s. New York was out of control.

ED LYNCH

You know, crime. It was on the verge of bankruptcy. I remember the famous headline, "Ford to City: Drop Dead."

GREG PRINCE

Our beloved New York Mets had experienced their own blackout, about a month before New York City did.

ERIK SHERMAN

Tom Seaver should have been a Met for his entire career. He was "The Franchise." I think every Mets fan remembers exactly where they were when Tom Seaver was traded.

MARK HEALEY

Losing Seaver was almost indescribable.

JEFF PEARLMAN

That's one of the worst trades in the history of Major League Baseball. The "Midnight Massacre," where they sent Seaver to the Reds for a package of crap.

JOE PETRUCCIO

The Mets traded away Tom Seaver, which I still don't forgive them for.

MARK HEALEY

The greatest player who ever put on the blue and orange. We always had Seaver. You know, that was our default setting. When they traded Seaver, it was depressing. So, summer of '77, it was the worst. Son of Sam . . .

JOE PETRUCCIO

Elvis passed away that year, too, so it's just like, you know what, Seaver's gone, Elvis is gone, shut the lights off, let's just get it over with.

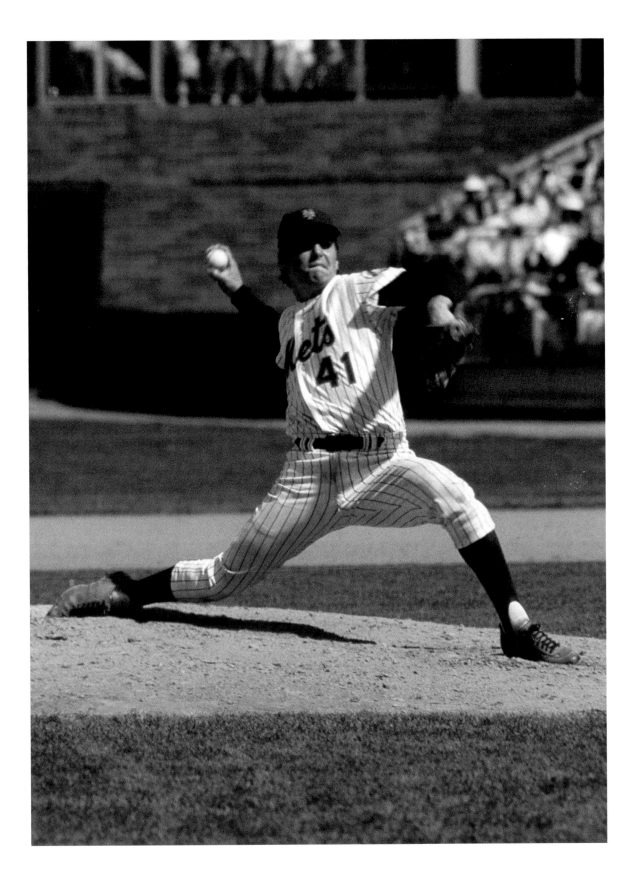

The Bronx Is Burning

JOHN STRAUSBAUGH

By the mid-'70s, you were lucky if they picked up the garbage. They cut the police department, they cut the fire department. At the same time, in the poorer neighborhoods—from the Bronx, to Queens, to Brooklyn, to the Lower East Side—slumlords and the banks were abandoning those neighborhoods. Slumlords didn't just abandon a building, they often had it burned down, so they could collect the insurance on it. So fires, you know, "Ladies and gentlemen, the Bronx is burning. . . ." That went on all the time.

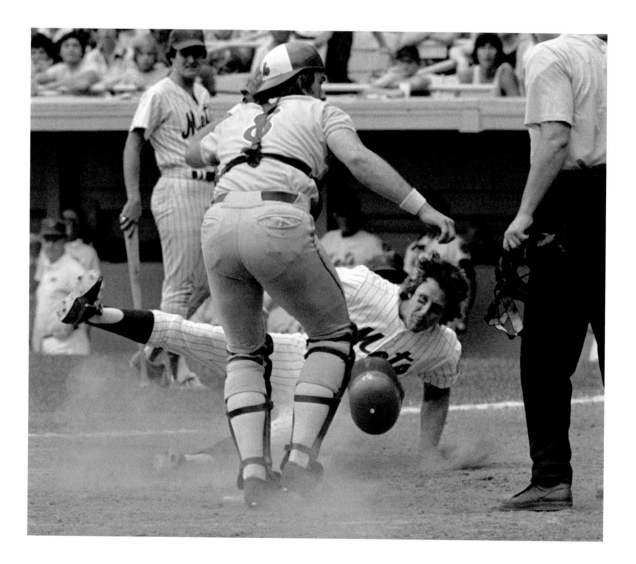

JEFF PEARLMAN

New York City was a Yankee town.

GREG PRINCE

New York turned its back on the Mets.

JEFF PEARLMAN

And it made total sense. The Yankees were the dominant baseball team of the late 1970s.

JOE PETRUCCIO

Having friends that were Yankee fans, it was very hard. They'd go, "Well, we have number seven, Mickey Mantle." And I would be, uh, "We have number seven, Ed Kranepool."

JEFF PEARLMAN

The Mets of the late '70s sucked. They were terrible. They had nothing.

MARK HEALEY

They were terrible. I mean, you had guys like Bruce Boisclair.

GREG PRINCE

Sergio Ferrer.

MARK HEALEY

Doug Flynn.

GREG PRINCE

Ferrer went the entirety of 1979 without a base hit.

ERIK SHERMAN

The Mets had been bad before, but never boring.

JEFF PEARLMAN

I vividly remember going to Shea Stadium for Hat Day. I was like, "Oh my God. I'm going for Hat Day. This is the greatest thing ever," and the hats were the biggest pieces of crap. It was like putting a crumpled yarmulke on your head with a hat bill. It was *so* Mets.

BILLY BEANE

I was coming up to the Mets through the minor leagues. I remember getting a pair of pants in the instructional league, and on the inside they said "Kranepool."

JOE PETRUCCIO

They brought in Lee Mazzilli, and he was our Bucky Dent [Yankees infielder]. He was our poster boy. He was our promise.

MARK HEALEY

He was a Brooklyn guy. He was Italian. It was great!

DWIGHT GOODEN

My thinking of the city of New York at that time was the movie *The Warriors*. How the gangs run through, and you hear about gangs at that time in New York. And I'm not gonna lie, it put some fear in me. That was my vision of New York.

BILLY BEANE

The movie *The Warriors*; that's what I thought New York City was like. Like I was going to run into guys on roller skates in Yankee uniforms.

ED LYNCH

When I first got to the Mets, they said, "Okay, you have a room at that hotel." It was a dump over by LaGuardia Airport. Wally Backman and I are walking up the back of the hotel, up this hill; all of a sudden we look and a window opens, a guy comes falling out with a TV and comes running right by me and Wally. He stole a TV out of the room.

BOBBY OJEDA

I remember my first trip to New York. I was with the Red Sox, and, you know, you get here, and you immediately want to walk around and see this place. I was walking along with a buddy of mine, and this was in the good old days when there's three-card monte, with the cardboard boxes. My buddy's like, "I know where the queen is." So we pool our fifty bucks, we got a hundred bucks, put it on the thing, and you know what happens then. He flips it, the boxes are gone, the guy's gone, there's our hundred bucks gone. I thought, *You know what? I like this town!*

GREG PRINCE

In January of 1980, Nelson Doubleday, descended somehow from Abner Doubleday, the mythical creator of baseball, was buying the New York Mets.

JEFF PEARLMAN

Nelson Doubleday buys the Mets, and he's aware that there's a vacancy of leadership and know-how and he makes the decision to grab Frank Cashen, who had been the Baltimore Orioles' great general manager.

ERIK SHERMAN

He was there when the Mets beat them in the '69 World Series, in that huge upset.

JEFF PEARLMAN

Hiring Frank Cashen changed everything.

BILLY BEANE

Frank looked like one of the oil barons from

a hundred years ago. There was no doubt that he was the guy. The first time I saw Frank, I was eighteen years old, and at that time when you're eighteen, you're playing rookie ball. Your whole reason for living is "get to the Major Leagues." That's all you're talking about. And we're out in the outfield and I see this guy walking. He wasn't a big man, but he had this incredible presence. I said, "I think we got this wrong. We're all trying to get to the big leagues. . . . That's the guy you want to be."

GREG PRINCE

It's as if Frank Cashen was a criminal mastermind, the way he put together this team.

FRANK CASHEN, 2005,

New York Mets general manager, 1980–1991

I took over a huge mess. Talent-wise, in my opinion, there was not much there. My charge was to rebuild the team, and I told them it was gonna take me about four or five years; ownership agreed to it.

JOE McILVAINE, *New York Mets executive, 1981–1990*

We did it the right way.

JOE PETRUCCIO

He had a vision for that team.

This Great Baseball Player

DARRYL STRAWBERRY

Everybody just sees me as this great baseball player who then had all these troubles, but they don't realize that I was already broken before I ever put a uniform on. What we went through in our home, it was a nightmare to live through.

JOHN STRAUSBAUGH,

co-author, Straw: Finding My Way, *by Darryl Strawberry*

Darryl's father, Henry Strawberry, was an abusive, bitter alcoholic who used to whip Darryl and his two brothers with electric cords

and say to him, "You are nothing, and you're never going to be anything."

DARRYL STRAWBERRY

That's a deep pill to swallow.

JOHN STRAUSBAUGH

Baseball was his escape from his life. On the field there are rules, there's a score, everything makes sense—you can go here, you can go there. Life isn't like that.

DARRYL STRAWBERRY

One night, when I was thirteen, my father came home drunk. My older brother Mike told him to get out of here and leave us alone, and then he threatened us. He said, "Well, I'll kill all of you guys," and he pulled out a shotgun. My brother Ronnie went in, ran into the kitchen, and grabbed a butcher knife. I ran behind him and grabbed a frying pan, and it was like, you know, his life was gonna end here tonight: "We're gonna end this." We were so fed up with the abuse, the physical abuse, beating us with extension cords—not belts, but extension cords—and making us take our shirts off and lay across the bed. My mother was like, "No, you guys, get out of here, you get out of the house!"

If it had not been for my mother getting us out of the house, we probably would have killed him. Once the divorce is over and he's out of the household, I said, "Well, I want to take care of my mother," because she's taking care of five kids by herself. I believed in myself that I would make something out of myself because my dad said I wasn't gonna be anything. "I'm gonna prove him wrong."

Fathers and Sons

KEITH HERNANDEZ

I was a Cardinals fan as a kid growing up. My dad was, too. Then I got drafted out of high school, by the Cardinals, and St. Louis was just very exciting.

When I was up-and-coming in St. Louis and I struggled, Dad was my instructor. No one knew me better. We could talk over the phone and I could tell him how I felt. Maybe there's an interdependence there, which I think he nurtured. He kind of lived his life vicariously through me. Back then my confidence was fragile, very fragile.

I was very shy back then. Most of the team was married; there was a little bit of loneliness. And I met my first wife. I remember telling Dad I wanted to get married and Dad said, "Keith, do me a favor; can you just wait one year and see if you feel the same way

in a year?" I'm sure Dad was worried about my career. So, I agreed to wait a year and I wound up marrying her in '78, before I became a star.

I pretty much realized that I'd made a mistake early in the marriage, and that my career was most important. I had a bat in my hand when I was six, I wanted to be a Major League player. My dad had mentioned, you know, do you want to take on this kind of responsibility or do you want to stay focused? So, I think the marriage was always kind of doomed, and then with the success that I had, and I became a star, that just cemented it.

In 1979, I lead the league in hitting and I win the MVP, and I'm on my way. That's it. I finally made it. When I won the most valuable player, I came home; Dad had the projector set up because Mom always took film of us, every game we played in Little League, for instruction. It was like, "Hi, Mom and Dad." "Here, I want to show you something." And he said, "This is when I knew you had it. You were special." I'm eleven years old in Little League, he goes, "Look at that swing." He goes, "That's when I knew you had it, you had something special and I wasn't gonna let you blow it."

DARRYL STRAWBERRY

He was co-MVP that year, wasn't he? I remember him being on the cover of *Sports Illustrated*. Wow, I remember that. I was in that issue, too . . . I was young then, a young buck.

JEFF PEARLMAN

Darryl Strawberry is one of the great sports names of all time, and if his name were Jed Smith it wouldn't be the same. I actually mean that; I'm not being sarcastic.

DARRYL STRAWBERRY

It was pretty weird to have the last name Strawberry 'cause when you do roll call in class, they said "Darryl Strawberry." Everyone turned around and looked. "Who is Strawberry?" I didn't want to be special, I never wanted to be special. I just wanted to fit in. At Crenshaw [High School in Los Angeles], in 1979, our baseball team was incredible, all Black players. They said that was the best high school team ever. Our offense was just incredible; we'd be down six runs, but we knew we were gonna come back and win. But we got all the way to the championship game and then we ended up losing to Granada Hills. John Elway and those guys beat us in that game at Dodger Stadium, and that was heartbreaking. That was the only team that ever beat us. Senior year, now all of a sudden, TV cameras are coming, agents coming, and you know, scouts are packing the place.

On June 3, 1980, baseball's annual amateur draft was held in New York City.

DARRYL STRAWBERRY

My mom dropped me off that morning, she was nervous. She was thinking, "You're gonna be drafted, huh?" I said, "It's a possibility, Mom." Before you know it, the principal comes in and pulls me out of class and says, "The press wants to talk to you, you've been drafted, you're the number one pick in the draft by the New York Mets."

And I was like "Whoa, where the heck is New York at?" [Laughs]

JOE PETRUCCIO

Frank Cashen was a man with a plan for that team, but he knew that he needed to put people in the seats while that plan was being worked on. We developed this advertising campaign called "The Magic Is Back."

GREG PRINCE

They ran these ads, they got off to a terrible start, and nobody showed up.

WALLY BACKMAN

We sucked. It was a bad team.

MOOKIE WILSON

Man, we had a better team in Triple-A. I'm serious, we had a better team in Tidewater.

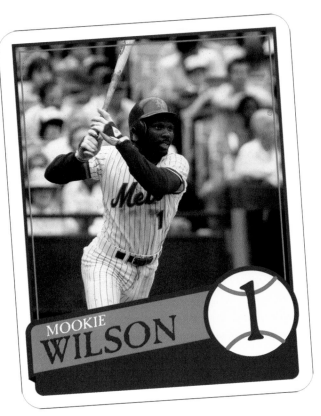

MOOKIE
WILSON
1

GREG PRINCE

They showed signs of life, but the magic didn't last in the standings.

JOE PETRUCCIO

I remember creating a poster that was on all the New York subway cars with [pitchers] Mike Scott, Neil Allen, and Craig Swan. And the headline for that was: "New York Is About to Have a Heatwave." There was no heatwave. My God, I think of those things now like, "What was I thinking?"

KEITH HERNANDEZ

They were basically . . . I don't want to say the laughingstock, but I do remember as a

Cardinal coming to town and they had the motto on the stadium—"catch the rising stars"—and we were going, "Catch the rising stars? What are they talking about? It's a last-place team."

GREG PRINCE

Managers came and went. Players came and went. But a core was being built.

DARRYL STRAWBERRY

They sent me to Kingsport, Tennessee. I was really homesick. I was calling my mother every night; I was like, "I don't really like this." Coming from California to Kingsport, Tennessee . . . there was just nowhere to go. Plus, I had to go through being the number one pick and playing in the rookie leagues. I struggled, and people were talking about, "Oh, he's over-rated, he's overmatched." It was hard.

There was definitely racism. The way people talked, the comments that were being made from people in the stands there when I was playing. My coach was like, "Don't look up there," because he knew I wanted to take a bat and wanted to start hammering people across the head, you know. [Laughs]

I mean, I wasn't well. I was smoking weed every day. You know, I was down in the South, people calling me N-words and "boy," and I just smoked weed every day. I'd go to the ballpark high. I came close to quitting after that year. I said, "If I've gotta listen to people saying these kinds of things to me, I really don't want to play baseball."

MOOKIE WILSON

I always had the ability to run, and that was always one of the traits that I cling to because that was the one asset that I could control.

JAY HORWITZ, *public relations executive, New York Mets, 1980–2018*

Mookie Wilson came up to the Mets in 1980. Energetic, fun-loving guy.

JOE PETRUCCIO

He was just such a sweet, sweet man. I met him at spring training when he was a rookie and I was taking pictures of him and Hubie Brooks together, and I remember Mookie coming up to ask me after, "Hey, could you make sure that my mom gets a copy of this picture when you finish taking them?"

KEITH HERNANDEZ

As a Cardinal, I could see that when you had a lot of guys going through the motions, not wanting to be there, he hustled, played hard, and ran everything out.

MOOKIE WILSON

You might criticize me for swinging at pitches,

you can criticize me for striking out, but you can't criticize me for lack of hustle.

ED LYNCH

He had the worst feet, the worst dogs, in the history of organized baseball. He told me he had to wear his older brothers' shoes all the time and hand-me-downs, and they were too tight. So, if you look at Mookie's feet he had all his toenails removed.

A Baseball Player

KEVIN MITCHELL

The scariest thing to me is having a gun in your face; everything else is a piece of cake.

JEFF PEARLMAN

I don't think there's anyone who would beat up Kevin Mitchell, on the Mets or in baseball, at that time. He was a new level of toughness.

KEVIN MITCHELL

I grew up in inner city, southeast San Diego, a lot of gang violence, you know, shooting and stuff like that, but I was never involved in no gang. Let's get that straight out.

JEFF PEARLMAN

Mitchell got into a fight with Darryl Strawberry, when they were in the minors, on a basketball court.

KEVIN MITCHELL

I didn't know who Strawberry was.

JEFF PEARLMAN

Kevin Mitchell is in the Mets system and has no idea who Darryl Strawberry is.

KEVIN MITCHELL

I thought Darryl Strawberry was a white guy. We get into an argument, and one thing led to another, so I picked him up and slammed him on his back. And they pulled me in the office and talked to me about, "Do you know who you just picked up and did that to?" I said, "No, I don't know." They said, "Well, he's our prospect, he's our number one pick, Darryl Strawberry." I said, "Oh."

JEFF PEARLMAN

It is not a good career-advancement strategy to beat up the most important player in the Mets system.

DARRYL STRAWBERRY

It was '82 that I went to Jackson, Mississippi. I won player of the year, the MVP of that league. And that's when I became a baseball player. I didn't become a man, but I became a baseball player.

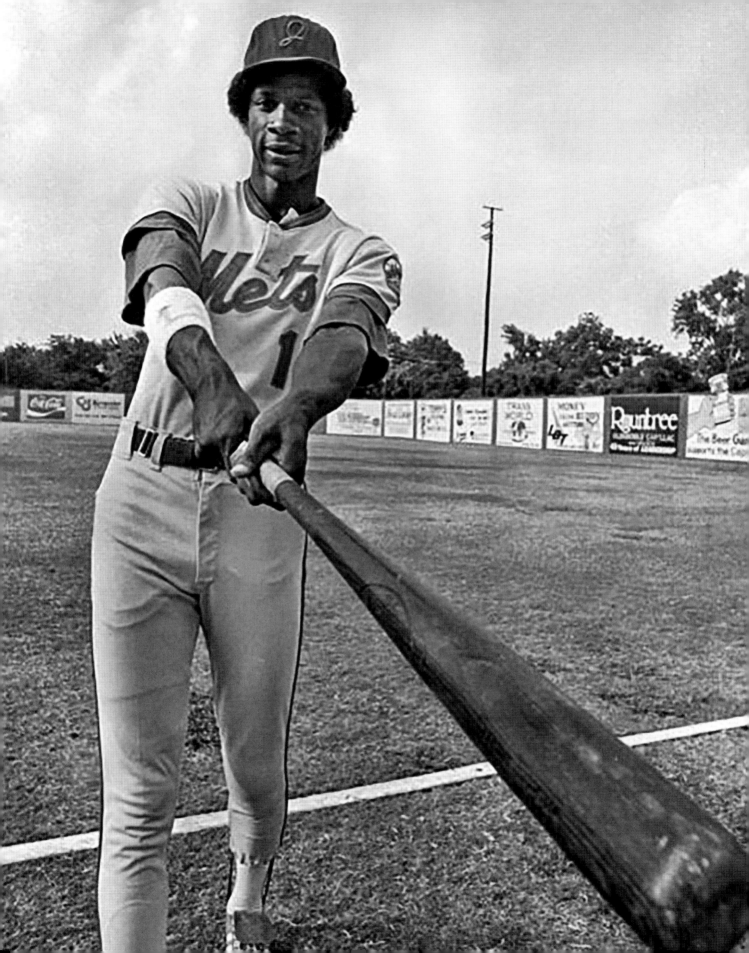

Kids

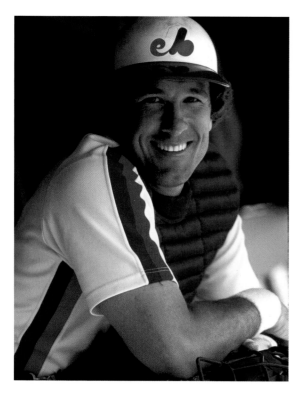

GARY CARTER, 1981, *catcher, New York Mets, 1985-1989*

"Kid" was a nickname kind of given to me in spring training. My first spring training back in 1973.

GREG PRINCE

Gary Carter was the best all-around catcher in baseball, in the early '80s.

JOE PETRUCCIO

Besides being a great catcher, a great baseball player, Gary Carter was probably one of the most beautiful people that you'd ever meet.

JEFF PEARLMAN

He was an earnestly nice man, and he was an earnestly decent man.

KEITH HERNANDEZ

Gary was one of the more disliked players in the league.

ERIK SHERMAN

He had this big all-American smile, and it rubbed a lot of players the wrong way because they perceived him as being a phony.

SANDY CARTER, *Gary Carter's wife, 1975–2012*

He was, I guess you'd say, put down or teased.

JEFF PEARLMAN

Gary Carter was funny, but not intentionally funny. To me, the story that tells everything about Gary Carter: He was appearing on *Good Morning America* for a celebrity bubble gum–blowing contest, and he insisted on having sugar-free gum.

SANDY CARTER

He lived a very straitlaced life, you know, praise God. He was looked at like a little square.

ED LYNCH

A lot of players were envious of him because he got a lot of good publicity, but he worked

at it. He was always available, he lived in Montreal in the off-season. How many guys from Southern California are gonna live in Montreal in the off-season? He learned to speak French.

SANDY CARTER

Every commercial he would do, he would do it in English and French.

ERIK SHERMAN

The Montreal Expos trashed his locker, despite the fact that he was arguably their best player.

KEITH HERNANDEZ

Gary played a lot like Pete Rose, but Pete Rose didn't piss you off. He was very aggressive, very macho. One time I got in a rundown between third and home and he ran me back and he tagged me and put his arms and gave me like a [gestures a shove] . . . It's like, "C'mon what the— Just tag me, I'm out." But that was Kid.

GREG PRINCE

In 1982, Frank Cashen saw the opportunity to make an attention-getting trade and a lineup-changing trade, and he pounced. One of the great run producers of the '70s: George Foster.

JEFF PEARLMAN

Thirteen home runs, 70 RBIs his first year [with the Mets]. He wasn't the same player by a long shot. He didn't have the bat

speed anymore. He just wasn't the same guy.

JOE PETRUCCIO

We also had a poster that had Dave Kingman, Ellis Valentine, and George Foster, and the headline said, "This Is New York's New Power Company" [Laughs]. That power company just fizzled out.

KURT ANDERSEN, *writer, co-founder,* Spy *magazine*

In the early '80s, New York City had come out of its financial catastrophe, was doing okay again, and the word "yuppie" was coined.

JEFF PEARLMAN

Ron Darling was Yale-educated, smarter than smart.

VINNY GRECO, *New York Mets assistant equipment manager, 1981–2006*

We would sit and watch *Jeopardy!* in the lounge. The question was halfway over, Ron knew the answer. He just knew everything.

JEFF PEARLMAN

Perfect hair, dashingly handsome.

KEVIN MITCHELL

"Pretty Boy Floyd." That's what I called him.

DARRYL STRAWBERRY

We used to call him Mr. Perfect, Mr. P.

JEFF PEARLMAN

He was a misfit on the team, 'cause a lot of these guys were like wrinkled sweaters and Ron Darling was Gucci.

JOHN STRAUSBAUGH

The stereotypical yuppie was kind of the grown-up version of preppies. They were out of school now, and they were making far more money than they deserved and spending it all on cocaine and caviar.

KURT ANDERSEN

That sense of "money, money, money is available, money is everything!" was a new part of the New York zeitgeist in the 1980s. Limos and nightclubs and all that stuff was A-OK suddenly.

ED LYNCH

It was a lot of fun. When you're a single guy and you work at night . . . I remember pitching a game, getting back to my apartment, changing my clothes; "Hey, we're going out at midnight, stay out till five in the morning," then you go home and sleep till noon, and then go to the ballpark.

In 1982, Keith Hernandez was playing in his first World Series. On his twenty-ninth birthday, in the seventh and deciding game against the Milwaukee Brewers at Busch Stadium in St. Louis, the Cardinals trailed 3–1 in the sixth inning. Gene Tenace was batting for the Cardinals, with Hernandez on deck.

KEITH HERNANDEZ

Harvey Kuenn, the [Milwaukee] Brewers manager, he brings in Bob McClure, who I grew up with. It's a 3–2 count on Tenace and Bob McClure throws him a curveball to walk him, and I remember saying to myself, "Oh, they want to pitch to *me*." So, I was a bit offended, so the bases are now loaded, and it's on me.

I can't say I went up there beaming with confidence, but the series was on the line, not just the game. I'm just trying to get a base hit, get two runs in, tie this ball game up, and he came in with a fastball up and in. But he didn't get it in enough and I got the base hit. That was a serious, pressure-packed at bat.

Hernandez's hit tied the game, and the Cardinals went on to win the game 6–3, and the World Series, under manager Whitey Herzog.

KEITH HERNANDEZ

I played with a lot of good managers, but Whitey was so good that you couldn't help but

notice. Even my dad mentioned it. He said he just doesn't make any mistakes. But I never felt the warmth from him, and maybe it was partially my fault.

In the off-season I was staying in St. Louis; he called me on the phone and asked me to go fishing with him. I said, "Whitey, I don't fish," and I go, "You're the manager, I can't." He says, "Oh, come on, I want you to go," and I refused, I told him no. I remember later talking to Rusty Staub about it, and Rusty looked at me and said, "You idiot, you should have gone fishing with him."

GREG PRINCE

The Mets make a trade in December of 1982 to bring home Tom Seaver. Tom is thirty-eight years old. He's not far removed from being one of the best players in the National League.

JOE PETRUCCIO

Opening day, 1983, when Seaver came back to the Mets; it was like a son who had come home from the war.

JEFF PEARLMAN

He's pitching against the Phillies. Destroys 'em.

JAY HORWITZ

He pitched six shutout innings.

JEFF PEARLMAN

Mets win!

GREG PRINCE

The excitement died down quickly. The Mets were not ready for prime time. They stumbled after winning the first two games that year, so they needed something.

Finally, in early May, with the Mets' record at a dismal 6–15, they made a call.

DARRYL STRAWBERRY

I go to the park and [Tidewater manager] Davey [Johnson] tells me, "You're not playing tonight." I go, "Why am I not playing? I'm hitting .333, I'm killing the ball in Tidewater." He goes, "You're going up to the big leagues tomorrow."

GREG PRINCE

The hopes of Mets fans hung heavy in the air to have the guy we'd been hearing about for three years.

DARRYL STRAWBERRY

It was exciting, but at the same time I was a little nervous. My mom came, she was standing there and I gave her a big hug, and you know, I was relieved a little bit from being Darryl Strawberry, just being her son.

JEFF PEARLMAN

The guy who came along was just this beautiful baseball player with all this talent.

HOWARD BRYANT, *author and ESPN personality*

He's six foot six, basketball player–style. He was the next generation of what a ballplayer was gonna be.

DARRYL STRAWBERRY

I really didn't start off well at all. I started out struggling, and they just kept playing me. They kept believing in me.

JEFF PEARLMAN

New York loved him from the beginning, and he really brought hope to New York. It was, "Wow, this guy is a generational ballplayer. Darryl Strawberry, he's gonna be a guy who carries us."

BILLY BEANE

I've never seen a young player under so much pressure.

HOWARD BRYANT

You have to succeed, you have to be a champion, and more than likely there's no way that you can fulfill the expectations because they're so high.

BILLY BEANE

The fact that he was as good as he was under the circumstances was absolutely incredible.

ED LYNCH

They dumped a lot of responsibility on Darryl. I remember one of his first weekends there they had "Strawberry Sunday": first fifteen thousand fans get a strawberry sundae. I remember the headlines in the paper, "Save Us, Darryl." I don't know how the hell a right fielder could save an organization that has bad pitching, bad defense, and no bullpen. It was very unfair to him.

ROGER ANGELL

In the field he would run down fly balls, seemingly without effort. You felt that you were watching something extraordinary. If he caught a fly ball and stretched out for it, it was an easy gesture. It was like taking your hat off a shelf and putting it down. If he missed the ball, you would feel like he wasn't really trying, but he was trying. But he was so graceful and he wasn't lunging or falling down. But it seemed cool: nothing hurried, and beautiful to watch.

MOOKIE WILSON

We were in L.A., and George [Bamberger] was the manager. So after batting practice, you know, "Hey, everybody in the clubhouse. Team meeting." Skipper then comes to the clubhouse and says, "All right, boys, I'm going fishing." That was it! He was done. He quit!

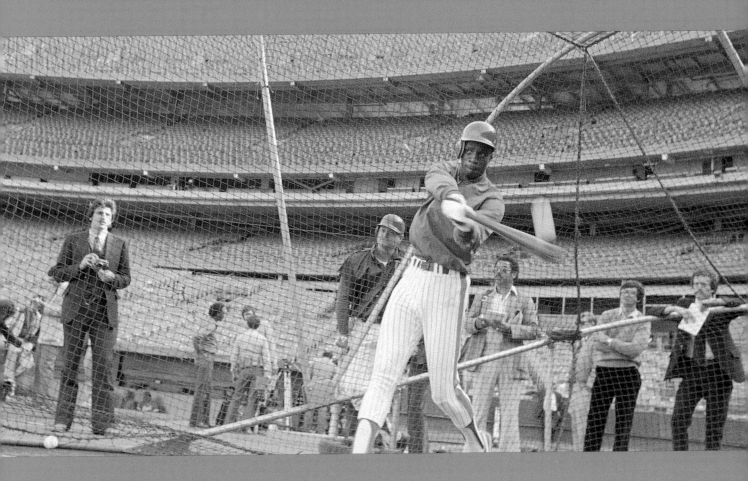

HE WAS JUST SPECIAL. YOU COULD SEE IT THAT YEAR.

JOE PETRUCCIO

DARRYL STRAWBERRY

It was an older team. It was guys on their way out. And I think it was a business for them at the time. It wasn't for me. I was young. I wanted to be a winner, and it was hard because we was *not* a winner, and you just saw guys just go about their business. I realized that something had to be different about us if it was going to be better.

)()()(

KEITH HERNANDEZ

I knew I was going to get traded. I just got the bad vibe from Whitey.

June 15, I'm going to the ballpark; midnight's the deadline. I don't know where I'm going, but I'm pretty sure I'm out. I get dressed, go out to the field, and as I'm ready to leave the field and go to the dugout, I get my bat to take my round of BP and out comes our clubhouse man, Buddy Bates. And I knew. He said, "Whitey wants to see you in the office"; he did it right before I was supposed to hit. So he made me go out there and break a sweat, take ground balls. Fine, I don't give a crap.

I go into his office and he goes, "We traded ya." I think he wanted to send me to Siberia, which is what I thought he did. I'm traded all of a sudden to a team that's eighteen games out of first place, something like that, and they're going nowhere, another last-place finish. I called my agent and I asked him, "Well, can I retire?" And he said, "I don't think so."

ED LYNCH

When Keith first got there, I felt bad for him. I mean, he's coming from the defending world champions to our team, and we were terrible.

The Mets' next scheduled game was against the Expos, in Montreal.

JAY HORWITZ

I knew that Keith was very unhappy about coming to New York, so I called up Frank [Cashen]. I said, "Frank, let me do this, can we break the budget a little bit? I want to go to the airport in Montreal and pick Keith up in the biggest limo I can find." So Frank said, "Jay, do whatever you need to do." So I went to Montreal's airport. I was sitting there, sitting there, and sitting there . . . and no Keith. Make a long story short, I went to the wrong gate.

KEITH HERNANDEZ

Basically, I went right to the field and I remember [first baseman] Dave Kingman coming up to me with a big smile on his face, shaking my hand, and saying, "Keith, I'm so glad you're here. You're my ticket out of here." I'm going, "Where am I here?"

Second Inning
A MONSTER TEAM

LENNY DYKSTRA

My gift was baseball. That was my way out of the middle, you know? I dedicated my life to baseball. In fact, I had one friend in high school, and the only reason I had one friend was to have someone to play catch with, you know? Never had a girlfriend, never went to a dance, never had a beer.

JOE McILVAINE

He was five foot seven, five foot eight, and about 160 pounds; and a lot of times that doesn't spur a lot of interest, but I went out and saw him in a tryout camp in 1981.

LENNY DYKSTRA

The Mets had a tryout, okay?

JOE McILVAINE

We had some of the best kids in Southern California.

LENNY DYKSTRA

And I walk to where you check in, and the guy says—

JOE McILVAINE

—[Mets scout] Harry Minor said to him—

LENNY DYKSTRA

"What are you doing? What are you, the batboy?"

JOE McILVAINE

He said, "No. I'm Lenny Dykstra," and you know what he said?

LENNY DYKSTRA

I said, "No, motherfucker, I'm Lenny fucking Dykstra. I'm the best fucking player here. That's who I am, motherfucker."

JOE McILVAINE

In his mind he was a legend already, but he just was small and he had to convince people how good he could become.

⟩⟨ ⟩⟨ ⟩⟨

JEFF PEARLMAN

I almost get goose bumps thinking about young Darryl Strawberry coming up and how preposterously important he was and how good he was.

ED LYNCH

I was sitting next to Rusty Staub in the dugout, and we're playing the Pirates, and Darryl's in the lineup. He had just come up. His first at bat, he lays down a bunt, flies down to first base. The pitcher just picked the ball up and took a bite out of it. No chance of throwing him out. It wasn't even that good of a bunt. Next at bat, he hits one about forty rows up in right center field. Three innings later he catches a fly ball, throws a laser beam one hop off the turf— throws a guy out at the plate. I remember looking at Rusty and going, "Have you ever seen anything like that before in your life?" And he goes, "Never!"

BILLY BEANE

I remember seeing Darryl and thinking, "Oh my goodness, this is literally the greatest athlete I've ever seen in my life."

GREG PRINCE

By the time September is over, Darryl Strawberry has hit 26 home runs, he's driven in 74 runs, he is the National League's Rookie of the Year, almost by acclamation . . . and this is a guy who didn't come up until May.

DARRYL STRAWBERRY

It was a lot of marijuana smoking on the bus, on the bus rides. I was drinking, I started drinking in '83. I got introduced to cocaine in 1983, you know, on the back of a flight. So, I tried that and I liked it. I just wanted to fit in. I wanted to be part of it. Because you know here, as my dad said, I wasn't gonna be anything, it's all been achieved. Now I'm putting on a Major League uniform and I'm playing at a whole different level.

)0)0)0

In January 1984, for the second time, the Mets lost Tom Seaver.

GREG PRINCE

Frank Cashen made the equivalent of a clerical error, and left Tom Seaver off a list of players to be protected in this free agent compensation draft, and suddenly, "The Franchise" was gone once again. Patience was wearing thin.

ERIK SHERMAN

They had all these great young pitchers coming up. I always thought, maybe they weren't as heartbroken as they let on about having that open spot on the roster, allowing these young guys to come up.

DWIGHT GOODEN

I was a very shy kid, a very quiet kid. I always played in the neighborhood with my friends, but when it came time to sign up for Little League, I wouldn't play. One particular day, a guy on my friend's team quit and they had an open spot, and my friend said, "Come on, sign up. You can be on my team." So, at that point I thought it was okay. I signed up, played, and the thing that sticks out more than anything is, when I saw my parents at the game, for some crazy reason, I wouldn't go up to bat. I would be on deck, I would see them in the stands, then it was my time to hit and the coach would be like, "Dwight, it's your time to bat." I wouldn't go. I would just start crying. I would not play in front of my family and I don't know why.

But I had a great, loving family. My dad had a third-grade education. He self-taught himself everything. He played semipro, he coached, he just loved the game of baseball. We would go to the park when I was nine, ten years old, just working on mechanics. It wasn't fun because as a kid you want to take your ball, you want to take your bat, you want to have the glove. But he said, "You gotta get to the point where you earn that." So, my dad taught me a curveball; I think I was like ten years old. He taught me the mechanics of throwing it, how you get the arm in the right position, that with a fastball, the only thing you change is the grip on the ball.

I truly believe that he was living his dream through me, and then it became my dream.

KEITH HERNANDEZ

Right after the '83 season Frank Cashen called me—

FRANK CASHEN, 2003

My big concern was that he was very, very unhappy about being traded and he vowed that he wouldn't stay in New York. He didn't want to be here.

KEITH HERNANDEZ

—and he basically said, "Look, we really feel like we've got some young talent down in the minor leagues and we're ready to turn the corner. We really want you to be a part of it, but

if you don't want to stay, I totally understand. Just please let me know before the winter meeting so I can try to trade you." So I had some thinking to do. I had a conversation with my dad over the phone. He remembered Darryl Strawberry and he said, "You might want to consider staying." So I thought about it, and I said, "You know, my dad's a wise man and I seem to make wrong decisions in my life, so I'm gonna roll with my father on this one."

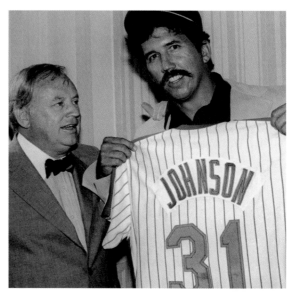

By 1984, the Mets had a new manager.

GREG PRINCE

Davey Johnson was somebody Frank Cashen knew from Baltimore.

JOE MCILVAINE

Davey Johnson was a second baseman for the Baltimore Orioles when Frank was the general manager there.

DAVEY JOHNSON

He made me meet him in an airport. I think it was in Atlanta. I basically said, "I'm the man for the job." Then when I was introduced in New York I remember saying—

DAVEY JOHNSON, 1984

I want to thank Mr. Cashen for having the intelligence to hire me this year.

GREG PRINCE

There is an overused word in sports called "swagger." Davey Johnson had it, and it was infectious.

KEITH HERNANDEZ

Davey was a player's manager. "I don't care what you do as long as you show up at the ballpark in physical condition and mental condition to play and don't embarrass the ball club." He left you alone.

WALLY BACKMAN

There's always the separation between the player and the manager, but we were closer to being player-player.

KEVIN MITCHELL

What I like about Davey Johnson: Davey was honest.

WALLY BACKMAN

You might not want to hear it, but you knew when he talked, he was telling you the truth.

BILLY BEANE

I remember Davey calling me the first year I was on the roster and sitting me down, and he kind of looked at me and said, you know, "I'm not sure how badly you want to play in the big leagues." And I think to some extent he was right.

FRANK CASHEN, 2003

He knew about computers when the rest of us didn't know what computers were.

JEFF PEARLMAN

He made clear from the beginning, "This is my effing team. You're hiring me to run it. I will run it, but you have to stay out of my way."

JOE McILVAINE

But you respected Davey Johnson because he was usually right.

MARK HEALEY

Davey Johnson was the one who wanted Dwight Gooden on the '84 Mets.

JOE McILVAINE

Starting in spring training, 1984, Davey Johnson was in our office, in Frank's and my office, saying, "I gotta have Gooden." And we were more inclined to send him down to Triple-A because he was nineteen years old. Davey said, "No, I gotta have him."

DAVEY JOHNSON

Because I'd seen him pitch. I was in Kingsport as a rover, to take over for the manager's job, and I had him down in the bullpen session. I'll never forget it.

DWIGHT GOODEN

I was doing some side work and he just came and watched me throw—

DAVEY JOHNSON

—and he got in the outside corner, and just kept hitting the mitt, and he moved to the inside corner, hitting the mitt, and I asked him, "Dwight, how do you grip your fastball?"

DWIGHT GOODEN

I was showing him grips on the ball; he was like, "How do you throw your curveball?" I showed him.

DAVEY JOHNSON

This seventeen-year-old said, "Well, I grip it across the seams when I'm gonna put a little giddyup on it, a little ride, and I grip it with the seams when I want a little lateral movement." I said, "That'll do." He knew what he was doing at age seventeen.

LENNY DYKSTRA

Carolina League, '83, Doc Gooden, this motherfucker, struck out three hundred hitters in 150 innings. Dude, the batters didn't want to get in the box—it was pure domination. It was gas with a fucking nose-to-toes hook, okay? I said to him after the season, "Dude, you're going to the show next year."

GREG PRINCE

Frank Cashen, regardless of misgivings, said, "You can have your nineteen-year-old. Let's not screw him up."

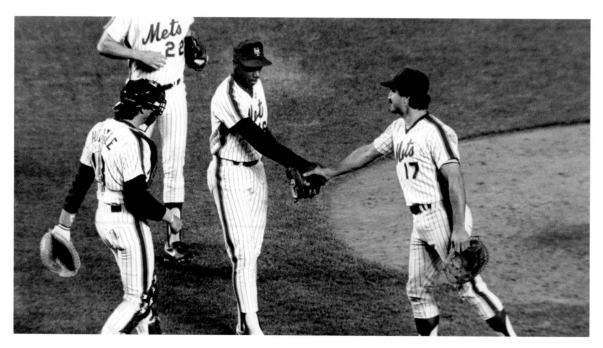

Daddy

JOE PETRUCCIO

I love Keith Hernandez. I mean, he, to me, was like the daddy of all those kids.

KEITH HERNANDEZ

First thing I did, opening day in Cincinnati, before the game, I said, "What are you guys doing after the game?" They all go "I dunno." "Let's all meet in the hotel bar after the game, drink some beers, and talk about the game." It was my main goal, to have them talk to me about their at bats and to get this team together, and lo and behold, from the year before when it was a ghost town at the hotel bar, that road trip we were talking to each other, talking baseball. That's very, very important.

ED LYNCH

The whole atmosphere changed when Keith came over.

DARRYL STRAWBERRY

What I love about Keith is that he loved young players. He was a big brother to all of us.

DWIGHT GOODEN

My first game was Houston. That day was unbelievable. I remember having lunch with my parents and the bus not leaving until five o'clock, but I was so anxious. I went down-stairs about three o'clock, I asked the concierge guy, "Where's the Astrodome?" Walked to the ballpark, and it's like a three-mile walk. Now I get there, I don't know how you get in, there's like an eight-foot fence. I have to climb the fence.

So, then the security guard is right there: "Hey! What are you doing?" "I'm Dwight Gooden. I'm pitching tonight." He's like, "Sure you are." I show him my license and then they call upstairs and the cops come down and take me to the clubhouse, and luckily the trainer's there. Steve Garland, like: "Doc, what are you doing?" And I say, "I didn't know how to get here."

I take the mound and I'm sweating bullets. I struck out Dickie Thon to end the first inning. My dad had never been so happy. It was like his dream had come true. That's when I calmed down and I knew, okay, you belong.

KEITH HERNANDEZ

And I realized within two weeks—I'd made the right decision. So then it was a matter of getting acclimated to New York. When Rusty found out that I was separated, he said, "Well, you cannot live in the suburbs in Long Island. If you're not with your wife anymore—and you're single—you've got to stay in the city." And I realized that New York was a pretty special place.

The City Will Bring You to Your Knees

DWIGHT GOODEN

Myself being from Tampa, coming to New York City and having success, I mean, what more can a guy ask for? [Laughs]

DARRYL STRAWBERRY

They had a lot of beautiful women. The first thing I always knew about ballplayers was the attention that we draw, the ladies. [Laughs]

KEITH HERNANDEZ

We all got the VIP treatment.

DARRYL STRAWBERRY

You wear a uniform, and they're just like flies. *Pssh! Pssh!*

ED LYNCH

I played with a lot of guys who thought they could tame New York, and New York brought them to their knees. Let me tell you something, it's not the city you want to take on one-on-one. No matter what you want in New York, it's gonna be there.

KURT ANDERSEN

There was a club scene that was really flourishing.

BILLY BEANE

For me, the coolest thing about New York City was CBGBs.

KURT ANDERSEN

CBGBs was the center of new wave and punk music.

BILLY BEANE

So I went right to CBGBs to see where my music heroes were from. It was a young team, but we had this dichotomy, you know, a bunch of young players on the Mets, and then you had Rusty.

KEITH HERNANDEZ

Rusty knew all the restaurateurs, knew all the wines, took us to all the great restaurants.

ED LYNCH

So Rusty had this . . . we called it the meat wagon. It was an old beat-up van that he used to pick up meat in the morning for his restaurant. And this thing stunk so bad, like decaying bodies, and had no seats in the back. It was nasty, but hey, it was a way to get to the ballpark. And after the game Rusty would drop me off at the corner of 71st and

1st; Keith would get out there, and we'd have a drink.

KEITH HERNANDEZ

It was fun. I took care of myself, though. I did.

DARRYL STRAWBERRY

When you get to the Major League level, there are no "nos." Nobody ever tells you "no"; everybody is just a "yes" person. You can drink, party, girls, you know. And that's why I got caught up with all the wrong things. Once I got to the Major Leagues, all bets are off, you know, and everything goes, and everything is like a candy store for you.

MIKE "CHOPS" LACONTE,
New York Mets clubhouse attendant, 1978–1980, 1982–2006

These guys were all kids, and everybody's throwing everything in the world at them.

JEFF PEARLMAN

Everyone's telling you how great you are, and everyone's buying you dinner; and everyone's buying you drinks—and everyone wants to sleep with you. And everyone wants to share drugs with you. . . . It's a real test.

In 1984, coming off another dismal season in 1983, the Mets surprised the baseball world by jumping out to first place and staying there until the end of July—though in August, they faltered and lost their lead to the Chicago Cubs. For the first time, a struggling Darryl Strawberry found himself the target of Shea Stadium's boobirds. In addition, his own teammates criticized him for lackadaisical play in the press.

DARRYL STRAWBERRY

Oh, it was hard, I mean, I didn't worry about being booed, but it's hard when your [own] players turn against you.

KEITH HERNANDEZ

You know he'd come to the park and if he didn't feel good he wouldn't play, and usually it was a day game after a night game. Maybe not feeling good from the night before . . . and that's when you've got to make sure you play.

DARRYL STRAWBERRY

I'm struggling, you know. Guys started criticizing, you know, but they were criticizing me to the paper. . . . Why not come to my face and say it?

WALLY BACKMAN

Darryl could be a little bit moody.

VINNY GRECO

Darryl was always the nicest guy— to me. But I saw the other side of Darryl Strawberry where he was crazy; you know, he was insane.

JEFF PEARLMAN

Darryl Strawberry was kind of an asshole back then. He had a real dark side.

DARRYL STRAWBERRY

I would have rage in me when guys came at me in my own clubhouse and said things. I would always find out because the reporters would always tell me who said it, and I was like, "Well, I'll just bust him in the face."

JEFF PEARLMAN

He definitely had gotten full of himself. The kid they drafted, he was kind of this humble kid; but he started believing the headlines. Some athletes realize: "This is amazing. I'm getting paid millions of dollars to basically wear glorified pajamas and swing a stick." He thought he was bigger than the team to a certain degree.

DAVEY JOHNSON

I was tougher on him than I was on anybody. I'd fine him five hundred bucks if he was late. I'd let him donate to an orphanage in Queens, and they loved him there, you know?

JOHN STRAUSBAUGH

Because he was looking up to coaches and managers as father figures, surrogate father figures, when they are cross with him, when they are disappointed with him, when they disciplined him for bad behavior—and there was plenty of bad behavior to be disciplined for—he took it really hard and he would do things to cope with that . . . drinking, and later drugs.

DARRYL STRAWBERRY

I wasn't a good man, you know—I was a heathen. I was a womanizer. I was an alcoholic. I was a ballplayer. I was a drug addict. I was everything except being a man.

JOHN STRAUSBAUGH

Darryl never felt comfortable in the limelight. He would just as soon have played baseball as well as he could and gotten paid for that and gone home, but you can't do that; you're an entertainer. One day he was walking in Manhattan with his mother when they pass a homeless person on the street and he says to her, "Jeez, I wish I were that person." She's shocked, and she says, "What do you mean?" "Well then nobody would pay attention to me or expect anything from me. I'd be at peace."

Unbelievable

GREG PRINCE

The Mets were a good team in '84. They won ninety games.

KEITH HERNANDEZ

New York is genuinely excited about our success and the fact that we turned it around basically in one year.

GREG PRINCE

Keith Hernandez had changed the complexion of the team.

DWIGHT GOODEN

He's the centerpiece of it all.

BILLY BEANE

He was a general on the field. You know,

beyond his physical talent, he just had such a great mind for baseball.

DWIGHT GOODEN

He was the guy that was the manager, the pitching coach, hitting instructor out there on the field.

GREG PRINCE

[Pitchers] Dwight Gooden, Ron Darling, Walt Terrell were throwing to a rookie catcher [Mike Fitzgerald] most of the time. There wasn't a catcher who can nurse these guys, so Keith Hernandez did it.

New York had never seen anything like Dwight Gooden in 1984. His rookie year was spectacular: He won seventeen games with an ERA of 2.60, and set a Major League rookie record with 276 strikeouts. But more than that, when he pitched at Shea, the games became events; average attendance rose by more than ten thousand for his starts. He was a phenomenon.

DWIGHT GOODEN

Man, my rookie season was unbelievable.

JEFF PEARLMAN

He was really poised at a very young age. He was athletically gifted, he threw really hard.

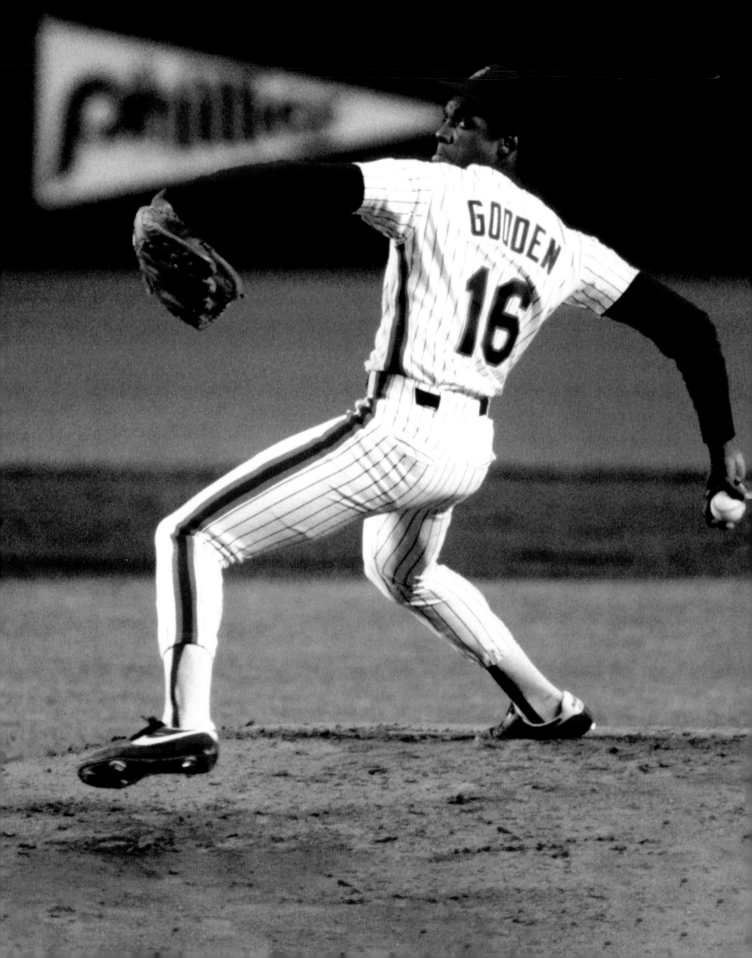

DARRYL STRAWBERRY

You were like, "Wow. How can a guy dominate Major League hitters like that?" Great players. Dawson and Schmidt. Guys up and down the lineup that can't touch him.

JEFF PEARLMAN

He was the most beautiful pitcher I've ever seen. The windup, the high leg kick—perfect form, graceful.

MOOKIE WILSON

He was in total control. He had a presence on the mound that was captivating.

DARRYL STRAWBERRY

You would have never believed that he was nineteen years old when he was pitching like that.

ERIK SHERMAN

Dwight Gooden's so spectacular that in his rookie year he makes the All-Star Game.

DWIGHT GOODEN

That was the ultimate thing for me that year.

GREG PRINCE

And he comes in the middle of the game and he mows down the American League.

DWIGHT GOODEN

I strike out the first three guys I face.

ERIK SHERMAN

And who is his catcher? Gary Carter of the Montreal Expos.

GREG PRINCE

Those guys hit it off, and I think Gary Carter said something like, "Wouldn't it be nice if we could do this more often?

The Final Piece of the Puzzle

SANDY CARTER

Gary got a phone call from [Expos owner] Charles Bronfman. He said, "We're gonna come down and talk to you." And Gary thought, "Oh, I'm probably gonna get a pat on the back and some champagne or something." And they said, "Well, we don't really want you on the team anymore." It was a huge shock. It was after Gary had his very best year.

GARY CARTER, 2003

Charles Bronfman was getting a little upset, and I guess his feelings were, "Well, we didn't win it with Gary Carter, so we certainly can try and win without him."

JOE McILVAINE

Gary Carter was a franchise player. You can count on one hand the number of players in the big leagues who have been both offensive and defensive in one. That was Gary Carter.

SANDY CARTER

At that time, you had to okay the trade, so he could have turned it down. Of course, we prayed about it.

On December 14, 1984, the trade was official. The Mets gave up a lot to get him — third baseman Hubie Brooks, catcher Mike Fitzgerald, and two promising minor leaguers, Floyd Youmans and Herm Winningham. But now they had the best catcher in baseball.

SANDY CARTER

The press conference was like the whole world was there. Montreal had one English paper, I think, and a couple French, so it was always a much smaller group. [Laughs]

GREG PRINCE

"We got Gary Carter." I spent the rest of the off-season just kind of repeating that to myself as a mantra: "We got Gary Carter."

KEITH HERNANDEZ

That was the final piece that we needed to get on our way.

SANDY CARTER

Gary always talked about his mom. When he was twelve, he was on his way to practice on his bike and a kid said, "Gary, you better go home because your mom died." His mom was in the hospital, but back then they didn't talk about it. He didn't even know his mom was critically ill or anything. So, he rode home; his dad and brother weren't there, just a neighbor who hugged him. So, it was always very hard. He was raised going to church, but after his mom passed, his dad wasn't going. They certainly had a faith, but when we got married, instead of just God, it was a personal touch of knowing Jesus, and that became the center of our marriage.

ERIK SHERMAN

When he came to the Mets, there was always a question of if he would meld in well with the team.

All questions would begin to be answered on opening day, April 9, 1985, as the Mets hosted the Cardinals at Shea.

ERIK SHERMAN

Opening day in '85 was a frigid day.

SANDY CARTER

Oh my gosh, it was freezing cold.

ERIK SHERMAN

But, despite the weather, it was so festive. So much anticipation.

His first time up, Carter was beaned on the elbow by St. Louis Cardinals pitcher Joaquín Andújar. Later in the game, he was plunked again. And behind the plate, Carter took several foul balls off his fingertips.

SANDY CARTER

Oh, he was beat up! He came away with several bruises after that game.

The Mets and Cardinals went into extra innings tied 5–5.

SANDY CARTER

It was the tenth inning. And Gary came up and hit a home run, the game winner—and

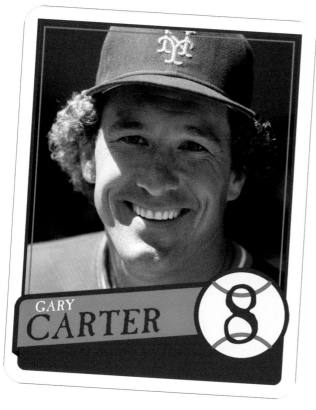

suddenly for the first time in his career there was, I don't know how many were there, forty, fifty thousand in Shea, and it was "Gary, Gary, Gary . . . !"

GARY CARTER, 1985

I just would like to thank the Good Lord for giving me the power, the strength to be able to do that. That's the way I look at it.

ANN LIGUORI, *TV and radio journalist/talk show host*

Gary was a big born-again Christian, and a lot of guys kind of raised their eyebrows at that.

MOOKIE WILSON

I was one of those people that said, "I just don't know how this man is gonna fit in this clubhouse." Because when he was in Montreal, we hated Gary.

KEITH HERNANDEZ

We gave him the nickname "Camera Carter."

VINNY GRECO

If there was a camera, Gary Carter was there. If there was a light on, he's giving an interview. And guys would say, "Gary, shut the fuck up already."

KEITH HERNANDEZ

Gary had a very high, scratchy voice and he'd be in the clubhouse and he just didn't

know how loud he was talking, and so his voice was "Whoa." It's like fingernails on a chalkboard.

But he came to the park every day, he iced up his knees for an hour and they taped his knees and he went back and squatted and called a game . . . and never let his batting, if he was in a slump, affect his defense. He ran on and off that field with bad knees. Deep down inside he wanted to win. That's all I cared about, and we got along fine.

JEFF PEARLMAN
All of a sudden you have this monster of a roster. Hard-nosed, tough, gritty.

GREG PRINCE
Carter, Hernandez, Gooden, Strawberry —all on one team. And it's ours!

JEFF PEARLMAN
Far more exciting than the Yankees.

MOOKIE WILSON
People were starting to talk about the Mets. The "Amazing Mets" are back!

KURT ANDERSEN
Somewhat, in a certain way, it was like what was happening on Wall Street when the sort of old money white-shoe WASP hegemony dissolved.

JEFF PEARLMAN
The Yankees at that time were a really good baseball team, but the Mets were a show and the city was watching now.

KURT ANDERSEN
People from the boroughs and Long Island and beyond, were suddenly much more part of this expanding, ungentlemanly thing that Wall Street had become.

ED LYNCH
Lenny was in spring training in '85, and I was like, "Who is this guy?" And then he gave himself this self-ordained nickname: "Nails."

LENNY DYKSTRA
By the way—not a bad fucking nickname. It's better than "Thumbtacks."

KEITH HERNANDEZ
Lenny's invited to camp in '85. We're the veterans taking BP and he's supposed to be out shagging, and he's hanging around the cage with the big boys. So, I take my BP and after my third round I come around and he goes, "Dude, I've been watching you. You got

a sweet swing." So that just won me over right away with Lenny.

MIKE "CHOPS" LACONTE

His personality was baseball . . . and that's it.

BILLY BEANE

Coming up through the minor leagues, I always had a book, and Lenny would look at me, he would always say, "Come on, man. You read too much. It's bad for your eyes."

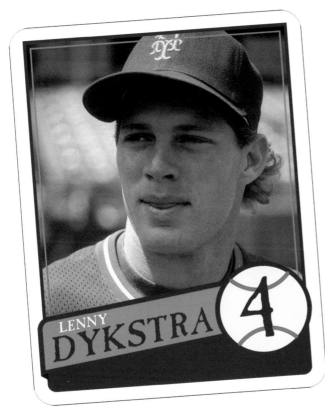

LENNY DYKSTRA

My manager— I was in Triple-A and we won the game, and we were shaking hands. And as we were shaking hands, he's like, "I need to see you in my office after the game." I'm like, "Oh, fuck!"

I walk in, and he's there with the pitching coach. You know, everyone in the minor leagues, they're all professional alcoholics. They all got their drinks in front of them and I sit down and he says, "You see that sport coat over there?" I said, "Yeah." He said, "Go try it on." So, I put it on and he says, "You're gonna need it, man, you're gonna be leading off tomorrow against Cincinnati in the big leagues."

It was one of them feelings that you can't buy, you know what I mean? I mean, you get to the fucking park at like 11:00, I walked around the outfield and I was like, "Wow, man." My first at bat, when I lead off against [Cincinnati pitcher] Mario Soto, I come in there and he throws, I go, "That's it?" I'm thinking I'm in the big leagues and it's gonna be something fuckin' special, so I literally mindfuck myself, and I punched out my first at bat.

So, I went and got on the bench and said, "What are you doing, man? It's baseball, you've been doing it your whole life. Play the fuckin' game." So my next at bat, my first hit, fuckin' home run. My first big league hit was a home run.

ROGER ANGELL

Lenny was a pistol.

DARRYL STRAWBERRY

He was just a fireball, man. The fans loved him.

KEITH HERNANDEZ

Cocky, but not fake; it was real cockiness. He made great plays. He got dirty. He was like Pigpen.

GREG PRINCE

Lenny Dykstra was the personification of a wad of chewing tobacco.

JEFF PEARLMAN

He was also a disgusting pig of a human being. I mean, there's a story I was told: There's a bunch of priests at the clubhouse this day, and Dykstra says to his friend, "Watch this," and he lifts his leg and lets out the loudest and stinkiest fart ever, at the priests.

On May 11, 1985, with the Mets off to a strong start and in first place in the division, Darryl Strawberry dove and made an awkward catch on a slicing line drive off the bat of the Phillies' Juan Samuel.

DARRYL STRAWBERRY

I knew, once I made the play on the ball: Something was wrong.

LENNY WAS JUST A FIREBALL, MAN. THE FANS LOVED HIM.

DARRYL STRAWBERRY

GREG PRINCE

Darryl Strawberry injured a thumb, was out most of May, most of June, and the Mets offense suffered as a result.

DARRYL STRAWBERRY

Missing a lot of that season of the six weeks that I went through in that period was very hard, very challenging.

JEFF PEARLMAN

He started drinking more, he started getting kind of ornery and kind of gross.

ANN LIGUORI

Anytime I was anywhere near his locker it was, "Come on, Ann, let's go out, let's do this, let's do that," and it was getting annoying. Darryl had injured his thumb and it was wrapped, so I said, "Listen Darryl, if you don't back off, I'm gonna get my boyfriend to break your other thumb." And he never gave me a problem after that.

JEFF PEARLMAN

The Mets are bringing up one successful pitcher after the next. Darling, and then Gooden, and Sid Fernandez. Sid Fernandez was awesome. He had this crazy, weird delivery. He was hugely important.

ERIK SHERMAN

And now you've got this top rookie, Calvin Schiraldi.

JEFF PEARLMAN

He was a top prospect, came out of Texas.

BILLY BEANE

His nickname was Tex. Yeah, we were pretty creative with nicknames.

JEFF PEARLMAN

And he was supposed to be Roger Clemens–ish. They thought they were getting this tobacco chewing, hard-nosed, badass star pitcher.

KEITH HERNANDEZ

He was quiet. You could hardly get two peeps out of him.

CALVIN SCHIRALDI, *pitcher, New York Mets, 1984–1985*

I'm an introvert. I kinda stay to myself.

JEFF PEARLMAN

Met players thought he was soft.

CALVIN SCHIRALDI

I could give a rat's ass what they think about me.

KEITH HERNANDEZ

We were a little rough on younger players.

JEFF PEARLMAN

In 1985, there was this blowout game against the Phillies.

On June 11, at Veterans Stadium in Philadelphia, Calvin Schiraldi came in the game in the first inning in relief with the Phillies already leading 3–0.

CALVIN SCHIRALDI

I got lit up like a Christmas tree. Is that the one you're talking about?

ERIK SHERMAN

He gave up something like ten runs.

CALVIN SCHIRALDI

One of those games where just everything you throw gets hammered. And there's really not a whole lot you can do about it.

ERIK SHERMAN

At one point, Schiraldi, he's looking in the dugout like, "Why am I still out here? Save me, get me out of here."

By the time he left the game in the second inning, the score was 16–0. The Mets lost the game 26–7.

ERIK SHERMAN

I think that rubbed some of the players the wrong way; like, hey kid, take one for the team.

CALVIN SCHIRALDI

Yeah, that was not a good game.

"He Ain't God, Man"

GREG PRINCE

In 1984, Dwight Gooden was a kid who could throw, who could pitch, who was finding his way. In 1985, he was Metropolitan Museum of Art caliber from the beginning of the season.

JEFF PEARLMAN

Dwight Gooden in 1985 was the best pitcher I've ever seen.

DAVEY JOHNSON

He was un-hittable.

DWIGHT GOODEN

I felt with Gary Carter catching me, I was un-hittable.

GARY CARTER, 1985

Dwight is a rarity. My part is just to call the pitches and let him do his thing.

GREG PRINCE

He was 24–4, 1.53 earned run average; 268 strikeouts. There was about a three-month period where he didn't lose a single game.

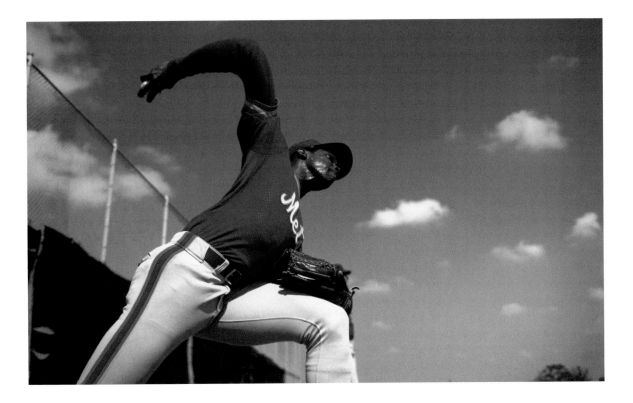

KEITH HERNANDEZ

It was almost like every time he went out there, he'd strike out double digits.

In 1984, in reference to the K symbol for strikeouts that gave Gooden his "Doctor K" nickname, Mets fans had started hanging cardboard K's off the upper deck façade at Shea Stadium whenever he struck out a batter. By 1985, the K Korner had become an institution.

DWIGHT GOODEN

Every time I took the mound, I felt like I had to get ten strikeouts. Every time I struck out a guy, they would pass the ball around the infield. Every time I got the ball I would look up in the K Korner to see how many strikeouts I had because I wanted to get to ten. Had to get the ten strikeouts. Had to pitch a complete game. Carter wouldn't take anything less. He brought that out in me.

GREG PRINCE

We had a front-row seat for the greatest season you'll ever see a pitcher have.

KEITH HERNANDEZ

He was something special. It comes around once in a generation.

GREG PRINCE

Chili Davis of the San Francisco Giants managed to get a hit now and then.

DWIGHT GOODEN

I could not get this guy out.

GREG PRINCE

And he was asked the secret to hitting on the great Doctor K: "He ain't God, man."

GREG PRINCE

The Mets and Cardinals spent 1985 just going at it hammer and tong.

JEFF PEARLMAN

The Cardinals were really good. That was at a time when you built around your stadium and the Cardinals were built for Busch Stadium, which was speed, speed, speed.

DARRYL STRAWBERRY

They didn't have a home run hitter most of the time.

MOOKIE WILSON

The one thing that goes into a slump on occasion is power. Speed never goes into a slump. The Cardinals let you know that every single game.

DAVEY JOHNSON

And we had to get through them to get to the World Series.

GREG PRINCE

The Mets are on a very intense West Coast road trip when Keith Hernandez has to be called away.

Rumors had swirled around Keith Hernandez when he'd first been traded to the Mets—why had manager Whitey Herzog been so willing to trade away his star first baseman? Now, with baseball facing a drug scandal, many people thought the answers were forthcoming.

KEITH HERNANDEZ

Spring training of '85 I got a call from the FBI office in Pittsburgh, an FBI agent, and I hung up on him. And he called back and he said, "Don't hang up on me, I'm gonna give you my number and this is for real."

In September, Hernandez flew to Pittsburgh to testify in what became known as baseball's drug trial.

KEITH HERNANDEZ

I sweated through my suit. They turned the air off on purpose. It was not a good experience. My friend, the U.S. Attorney: "We'll get you in the side door, avoid the press," and the minute I was done testifying, it's like, they made me perp walk out the front. They got what they wanted. That's fine. I deserved it.

"I think that was the love affair . . . the romance year of cocaine in baseball," Hernandez testified. *"It was a demon, an insatiable urge; in my opinion, it [cocaine] is the demon of this earth. It's hard to get away from it."*

KEITH HERNANDEZ

It was a big mistake in my life, and I feel like it's kind of hurt my reputation.

ED LYNCH

The writers were pretty hard on him.

KEITH HERNANDEZ

Dick Young was burying me in the paper. Jimmy Breslin was calling to hang me from the highest oak tree.

On September 10, with the Mets tied with the Cardinals in the standings, St. Louis came to New York for a crucial three-game set. It was Hernandez's first game back in New York after the drug trial testimony in Pittsburgh. Before his first at bat, Hernandez received a rousing thirty-second standing ovation from the home crowd. Hernandez had to step out of the batter's box to compose himself while the fans roared.

ED LYNCH

That's why you gotta love New York fans.

KEITH HERNANDEZ

It kind of took all the pressure off.

TAMA JANOWITZ, writer

It was just a very much sweeter time, and if you got on the subway, you saw the people carrying their signs, this swell of people all getting on to take the subway out to the ball game. So diverse, from all the boroughs and from fancier places. . . . It was great, and it united you with everybody living there. It hadn't been like that before.

ED LYNCH

We didn't have a rivalry with the Cardinals; it was flat-out hatred. We hated each other.

MOOKIE WILSON

With the Cardinals, it was going to be a dogfight . . . and maybe having Keith helped it along a little bit more because you always want to beat the team you leave, you know.

The Mets beat the Cardinals two of three at Shea to move into first place, but over the next few weeks, the Cardinals surged past the Mets.

KEITH HERNANDEZ

The Cardinals went on that tear . . . and it was like three weeks. They didn't lose. So then we go into that series in St. Louis.

The stage was set for a crucial three-game series that would determine the winner of the National League East. The Mets were three games behind with six games to play.

KEITH HERNANDEZ

We have to win all three. And I think this is one of the greatest things Davey ever did. Our rotation set up Darling against [John] Tudor, and everyone's howling in the press, "Move Doc up," 'cause it was an off day. Davey came out with, "Ron Darling's my starter." And that's just Davey.

Darling pitched brilliantly. The game went into extra innings with no score.

KEITH HERNANDEZ

So Ron goes out there and they match goose eggs for nine.

With two outs in the eleventh inning in a game the Mets had to win, Darryl Strawberry came up to bat.

KEITH HERNANDEZ

Ken Dayley hung a curveball and Darryl just—*pew!*

DARRYL STRAWBERRY

I crushed the ball off the clock. Busch Stadium was a big ballpark, and Ken Dayley was a pretty good left-hand pitcher.

KEITH HERNANDEZ

I never saw that in all of my years in St. Louis.

DARRYL STRAWBERRY

Everybody was just in shock.

Strawberry's mammoth home run gave the Mets a 1–0 victory, and the Cardinal lead was down to two games.

KEITH HERNANDEZ

Second game, Doc beats 'em. Complete command.

Gooden pitched a complete game, scattering nine hits to win 5–2, and now the Cardinal lead was a single game.

KEITH HERNANDEZ

So the third game, we are one game out; if we win, we are tied with three to play.

The game began promisingly for the Mets: Mookie Wilson singled, moved to second on a Backman ground out, and scored on a long Hernandez single. Gary Carter singled, then Darryl Strawberry lined a single to right field, scorched too hard for Hernandez to score from second base. But the Mets had the bases loaded, Cardinals pitcher Danny Cox on the ropes . . . and the chance to break the game open.

WALLY BACKMAN

There'll be one player who hates me for this, but I don't really care. George Foster. George really cut our throat.

Foster bounced into a force play with the out made at home plate, and Howard Johnson

followed with another ground out. The Mets led, 1–0, but a golden opportunity had slipped away.

KEITH HERNANDEZ

Instead of having a big inning, we only scored one run. That changed the whole complexion of the game.

By the ninth, it was 4–3 Cardinals. With the Mets down to their last out, Keith Hernandez came to bat, greeted by a wild chorus of boos in the same stadium that had cheered his World Series heroics just three years earlier.

KEITH HERNANDEZ

I think I went five for five that game. I had two doubles. I just had a great game.

Hernandez blooped a single to keep the Mets' hopes alive. Gary Carter, who would finish the year with 32 home runs, more than any Mets catcher had ever hit, stepped to the plate.

SANDY CARTER

Gary did not like to make the last out. Gary was the last batter in that series.

Carter swung and flared a routine fly ball to shallow right field. The Mets' pennant run was effectively over.

SANDY CARTER

He was very tough on himself. When he didn't come through, he was devastated. Gary hated to make the last out.

Despite the Mets coming up short, 1985 had brought the city—and the team—to the brink. Although the Mets had been eliminated from the pennant race, over thirty-one thousand fans

gathered to celebrate Fan Appreciation Day on the last day of the season.

JEFF PEARLMAN

At that point the Mets owned New York. There was no doubt about it.

MOOKIE WILSON

We took the town over. New York was a Mets town.

GREG PRINCE

All at once Shea Stadium had Fan Appreciation Day, a well-timed celebration. They just get up and they start applauding. It's a standing ovation for a season well done, for a race well run.

DARRYL STRAWBERRY

Losing in '84 and coming in '85 so close again was hard. But our fans were there, you know, and they were cheering us on.

ERIK SHERMAN

After the final game of the season at Shea Stadium, Davey goes into his office. He can still hear the cheering, and he has a flashback—

With two outs in the ninth inning of the final game of the 1969 World Series, Davey Johnson had come to the plate for the Orioles with a man on base. A home run would tie the game.

DAVEY JOHNSON

I hit the ball, I thought I hit it really good.

Instead, the ball landed softly in the glove of Mets left fielder Cleon Jones, kneeling just in front of the warning track, setting up the wild celebration as Mets fans swarmed the field.

DAVEY JOHNSON

By the time I got to second base, he caught it, and I looked at home and fifty thousand people were coming for my dugout. I said, "How am I gonna get home? They're gonna take me as a souvenir." In '69 we had the best team in baseball. No question. Mindset on the whole club was, "Well, we'll get 'em next year."

In '85 in the clubhouse, same thing. I think everybody's looking at each other in the eye, we knew we weren't gonna let this happen again. We were gonna come back and give the city what it deserves.

Third Inning

"DOMINATE"

In New York, the months between the end of the 1985 baseball season and the start of spring training were filled with several shocking events: the Godfather-style slaying of mob boss Paul Castellano at Sparks Steak House on East 46th on December 16, a hit that everyone in the city seemed to know had been ordered by the "Dapper Don," John Gotti; the bizarre and tragic fate of Queens borough president Donald Manes, who, embroiled in a real estate scandal that threatened to implicate virtually half the city's government, was found in his car, wrists slashed, in early January, and after first claiming he'd been the victim of a robbery, later admitted it had been a failed suicide attempt, which would be followed by a successful attempt not long after, when he thrust a knife into his own heart; and most horrifyingly, the Challenger disaster on January 28, a blow to the national self-confidence that President Ronald Reagan had striven so hard to revive.

As the Mets gathered in St. Petersburg, Florida, in late February, the sense of instability—of shock and possible doom lurking around every corner—was unmistakable. Equally clear: The Mets were determined to let nothing stand in the way of success.

ERIK SHERMAN

As great as the Mets were in '85, Davey Johnson knew they were still missing a couple of components.

JOE McILVAINE

Davey Johnson, you gotta remember, was an offensively oriented manager. He wanted hitters.

DAVEY JOHNSON

When we played the Cardinals, Whitey Herzog, he'd bring in left-handers to face HoJo and Backman.

JEFF PEARLMAN

He was a really good infielder, but Wally Backman was a switch-hitter who couldn't switch hit.

WALLY BACKMAN

I sucked from the right side.

BILLY BEANE

Well, the first question is, why are you talking to me? I guess my contribution to the '86 Mets was, uh, they got Tim Teufel for me. [Laughs]

FRANK CASHEN, 1986

We need a right-handed-hitting infielder who'd match Wally Backman. We also needed a right-handed hitter who could hit off the bench. I made the rounds and came up with Tim Teufel.

BILLY BEANE

Frank told me I was traded, and he said it was a hard trade, and you know, I was thinking, "Well, I would've traded me for Teufel, too," so . . . quite frankly I was thinking, "Man, they're gonna be good next year!"

JEFF PEARLMAN

Their rotation was Dwight Gooden, Ron Darling, Sid Fernandez, Rick Aguilera; all four of those guys are aces on a lot of teams in baseball. Their fifth starter was Calvin Schiraldi.

CALVIN SCHIRALDI

I got married that winter and found out on my honeymoon actually that I'd been traded to Boston. So that's kind of how that went.

ERIK SHERMAN

Bobby Ojeda [who the Mets got for Schiraldi] was your average left-handed pitcher with the Boston Red Sox. His record was .500; he pitched to an ERA of around four runs a game. But Frank could see the potential.

ED LYNCH

Bobby Ojeda is the biggest difference between the '85 and '86 team.

BOBBY OJEDA

I was in Boston for five years, and at that point, I was ready for a change. But I didn't know the first thing about the New York Mets. So I first get to spring training, and it was like, whoa. These guys are nuts.

All these characters. Everybody wanted to be a star . . . Ronnie. Keith. Straw. Kid. Lenny. The batboy. Everybody. Put a mic in front of them, line them up, there they go.

GARY CARTER, 1986

Putting on a Met uniform means a great deal to me because we've got an opportunity to win here, and it's the twenty-fifth year of the organization; and nothing would be more thrilling than to top off a twenty-fifth year with a championship season.

BOBBY OJEDA

It was a team that was, uh, how do I put it? It was long on confidence.

DARRYL STRAWBERRY, 1986

The dream will come true in 1986 for the New York Mets.

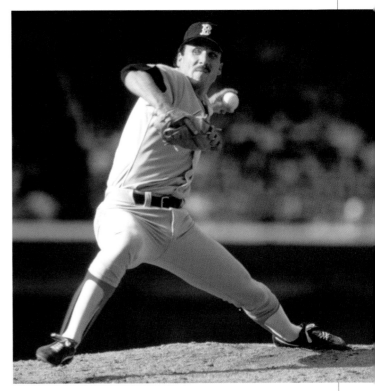

BOBBY OJEDA

These guys can't shut up, and I came from Boston, where nobody wanted to talk.

LENNY DYKSTRA

I don't need to sit on the couch, you know, like therapy and all that bullshit. Fucking paying $1,000 to tell my stories.

BOBBY OJEDA

I had no idea what I was getting into.

DAVEY JOHNSON, 1986

You know, I expect us to win. There's great chemistry, and everybody wants it real bad. So we're hungry.

KEITH HERNANDEZ

Some player came up to me and said, "Did you see what Davey just said?" And I remember going, "Holy cow."

GREG PRINCE

The reporters want to know, "Hey Davey, what kind of year is it gonna be?" Davey said, "I don't expect us to win. I expect us to dominate."

JAY HORWITZ

I said to myself, "Boy, he's got balls."

KEITH HERNANDEZ

That was a bold thing for him to say.

JAY HORWITZ

Frank didn't respond great to that. He called Davey into his office and said, "Davey, what'd you say that for?" You know, Frank was more old school: Just be calm, win the game, keep your mouth shut. That wasn't Davey.

DAVEY JOHNSON

As a manager, you're asked questions all the time: What do you believe? You know, when I first got there, I said, we can compete, in '84. And then in '85, we're better. Now in '86, now we're gonna dominate. I mean, what's the difference in saying, "We're okay," "We're better," "We're gonna dominate"? I mean . . . am I the only one ignorant here that doesn't understand that that's normal?

MOOKIE WILSON

"Dominate"? Managers don't usually say things like that. They don't want to step out a little too far. Davey stepped out there. Davey's out there in a boat, but good thing he had about twenty-five paddles. [Laughs]

BOBBY OJEDA

I'd never heard that confidence from a manager to his team.

ED LYNCH

We all had a chip on our shoulder because of the way that the '85 season ended with the Cardinals; and watching them dance around Busch Stadium, that was hard to swallow. So he voiced what all of us were thinking: "We're gonna dominate."

JEFF PEARLMAN

It's like setting up the worst expectations you could ever. Like, the odds aren't with you. There are always destructive elements that come in and screw things up.

Shards of Glass

On March 5, during a routine base-running drill at the Mets' Payson Field complex in the midst of spring training, disaster struck.

JEFF PEARLMAN

Gary Carter's working out at first a little.

Mookie was a base runner. He had sunglasses on.

MOOKIE WILSON

Outfielders always do the base running. I don't know why they always do that, but they said, "Last play." So being the competitor I am, I'm telling the guys, I'm gonna get out of this rundown. Watch me get out of this rundown! Well, when I did that, the ball hit me, and I turned right into it.

I feel absolutely nothing. No pain, nothing. All I could hear is Gary Carter's voice in my ear. And I'm a little concerned now. Not so much as to whether I'm going to be able to play, but whether I was going to be able to *see*. That was scary. That was scary!

ERIK SHERMAN

Mookie was the spark plug of that team. So they had to find a replacement.

KEVIN MITCHELL

Personally, I like Lenny.

DARRYL STRAWBERRY

Oh, Lenny was a character. You know, he had a personality on the wild side.

DAVEY JOHNSON

I loved his competitive drive.

Mets' Wilson Hurt; Right Eye Injured

By JOSEPH DURSO
Special to The New York Times

ST. PETERSBURG, Fla., March 5 — Mookie Wilson, already limited after two operations on his right shoulder, was lost to the Mets for perhaps two months today when he was struck in the face by a thrown ball and suffered a severe eye injury.

The 30-year-old center fielder was hit alongside the right eye during a base-running drill in the Mets' training camp and shattered his eyeglasses. He was carried off the field on an electric equipment cart, took 21 stitches to close the wound, and his vision was blurred from blood that filled a chamber of the eye.

Dr. John Olichney, associate team physician for the Mets, said that Wilson would require five days of strict bed rest to prevent new bleeding. It will be three or more weeks before he is allowed to resume training, and after that perhaps six weeks to regain the strength in his throwing arm, which he has been nursing along this spring, anyway.

A Repeat Performance

Manager Dave Johnson remembered that Wilson lost two months after his first shoulder operation last July 3 during a season when injuries undermined the Mets, and said:

"I heard the sound of the ball hitting somebody during our infield drill, and I thought: 'Here we go again.'

"If Mookie is unable to go for three weeks and then can't even throw, you can add six weeks to that for rehabilitation of his arm. He needs all of spring training, as it is. I won't even know for a week how long he'll be gone."

Wilson, a switch-hitter and the leading base-stealer in Mets' history, was replaced last summer by the rookie Lenny Dykstra, a hustling and headlong type of player who bats left-handed. Because of Wilson's shoulder trouble, Dykstra had already been considered the "other" center fielder this spring. He now will take over the job. For added help, the Mets have Danny Heep, the reserve outfielder, and Darryl Strawberry, the right-

May Be Out For 2 Months

fielder, both of whom also bat left-handed.

Wilson was injured at the Payson Field complex while running the bases during a drill that stresses pick-off throws and base-running. He was trapped between first and second base, headed back toward first and then stopped again, facing home plate, as Rafael Santana came across from shortstop and fired the ball to first. From about 40 feet away, the throw struck Wilson alongside and above the right eye, and he went down.

He was taken into the trainer's

Continued on Page B18, Column 1

The New York Times / Barton Silverman
Mookie Wilson

RAY KNIGHT

We loved him. But he was just immature. There were times when we'd have to have talks with Lenny.

JEFF PEARLMAN

He would gamble any amounts of money.

DAVEY JOHNSON

He always thought he was going to turn a penny into a billion dollars.

DARRYL STRAWBERRY

He bets on everything—playing golf, cards, or whatever it was.

KEITH HERNANDEZ

Well, he didn't have any money to do it. So he was always looking for action.

GREG PRINCE

Among the fans, there was a feeling that "I could do what Lenny Dykstra does." He's not that big, he's not that strong, and he doesn't think before he speaks.

LENNY DYKSTRA

I don't fuck with wives. I don't fuck with friends' friends. Except sisters, maybe.

GREG PRINCE

But he could play the game.

DARRYL STRAWBERRY

He didn't come with a lot of expectations, but when he got there, man, he was just a fireball.

VINNY GRECO

When he went out on that field, it was, "no prisoners."

LENNY DYKSTRA

I was put on Earth to play baseball. That was my fucking gift.

On April 8, 1986, the Mets started their season in Pittsburgh.

GREG PRINCE

Going into 1986, expectations were as high as they could have possibly been. The Mets were supposed to go 162–0.

The Mets beat the Pirates in the first game, 4–2, as Hernandez drove in two runs and Gooden pitched a complete game.

JEFF PEARLMAN

The Mets win one game and the players decided, "We need a hip-hop song." The year before, the Bears had done "The Super Bowl Shuffle." They got a lot of attention for it. So George Foster thought they were gonna get rich. With George Foster, it was always, "How can I make money?" at all costs. So Foster's like, "Let's get rich quick." And the other guys were like twenty-three years old, and here's this thirty-whatever-year-old veteran, who won an MVP, saying, "Let's do a record," and they're like, "Oh, yeah, let's do a record."

DWIGHT GOODEN

I think it was Aguilera, Teufel, Howard Johnson, me, Lenny, [shortstop] Rafael Santana, Mitchell, Straw, and [relief pitcher] Roger McDowell. It was fun doing that.

DARRYL STRAWBERRY

We thought we were like rock stars because everybody was good-looking and young. "These are the new boys on the block and they hot."

JEFF PEARLMAN

The whole thing was so bad. Foster's whole plan was to sell it at Met games, and the Mets were like, we're not selling this dog crap. In the end, I think they sold maybe a hundred copies.

GREG PRINCE

After getting off to a 2–0 start, they lose two games in Philadelphia, kind of sloppy; they come home to Shea Stadium, pregnant with expectations, facing their archrivals, the Cardinals.

Instead, in the home opener, on April 14, 1986, in the top of the thirteenth inning of a tie game, Howard Johnson mishandled a ground ball, two runs came in, and boos echoed around Shea Stadium.

GREG PRINCE

They lose in extra innings, 6–2. The Mets are 2–3. For all of Davey Johnson's pronouncements about domination, there is a rumbling that maybe the Mets aren't that good.

ED LYNCH

We came off our initial road trip, I think we're 2 and 3, and we had this welcome home dinner at the Sheraton in Manhattan. I remember all the players were up there apologizing. The feeling was, hey, this is not acceptable.

KEITH HERNANDEZ

Got off to a terrible start. The press is going, "The sky is falling," which didn't bother me.

The Mets promptly thumped the Phillies in three straight games.

DARRYL STRAWBERRY

. . . because we played at such a high level in those first two years and we were this close, two times. We knew we were capable of playing good baseball. Not part-time, but all the time. Our thing was, we're gamers now.

The Mets came home and spanked the Pirates two straight.

GREG PRINCE

Then it's off to St. Louis, and it's the last time it would feel like 1985.

KEITH HERNANDEZ

We went into St. Louis with a big four-game

series, and they're coming off losing the World Series. They had such hatred of us. But we're a team that wasn't gonna get stepped on anymore. We wasn't gonna get pushed around; you want to push me, I'll push back. Bring it on.

DARRYL STRAWBERRY

In St. Louis, we realized we didn't just need our stars. We needed every piece.

In the first game of the series, with the Cardinals ahead 4–2 in the ninth inning, Howard Johnson hit a game-tying home run. The Mets scored again in the tenth to win, 5–4. The next night, behind two home runs from Ray Knight, Gooden and the Mets shut out the Cardinals, 9–0.

KEITH HERNANDEZ

We were a tough bunch. The tone was set in the top of the order with Dykstra and Backman. Two hustlers with speed and grit. Wally was very brazen.

WALLY BACKMAN

Lenny and I knew what our job was. Lenny could get on base, he could steal the base, and I got more fastballs to hit. I liked it.

LENNY DYKSTRA

Backman was a veteran player; he could drink some scotch, too, man. Dewar's. Dewar's on the rocks.

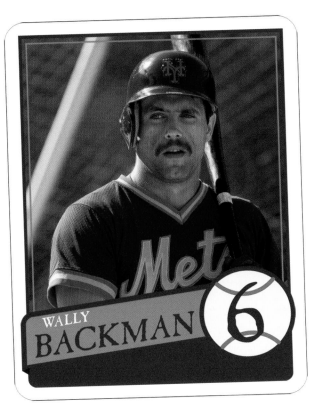

JEFF PEARLMAN

If you showed me Wally Backman and said, "This guy, he delivers the beer to 7-Eleven every Thursday," I'm like, "Yeah."

SID FERNANDEZ

Speaking of Wally, someone hit a bullet off me to Wally, it was knuckling, it was cold. Wally caught that ball right in the heel part. He was "*motherfuck*ing" me the whole way to the dugout. "You cocksucker, that fuckin' hurt." That's Wally.

JEFF PEARLMAN

They would drive pitchers crazy because they would battle and battle and foul pitches

off and take pitches; they were happy with walks.

ANN LIGUORI

A lot of times I'd go in the locker room and they were covered with dirt from head to toe from sliding, just blood-and-guts players.

LENNY DYKSTRA

Wild boys!

In the third game of the April series in St. Louis, the Mets took a 4–1 lead into the ninth, but the Cardinals scored two runs off Roger McDowell to make it 4–3, with a man on first and only one out. Jesse Orosco came into the game.

KEITH HERNANDEZ

The final play of the game, Tommy Herr is up against Jesse. *[Note: The '86 Mets can be unreliable narrators; the batter was Terry Pendleton.]* Runners on first and second, and we've got a one-run lead. It's amazing I can remember all of this. And Tommy Herr hit a bullet up the middle.

Wally Backman made a diving stab at the ball and turned it into a game-ending double play.

WALLY BACKMAN

Yeah, that was routine. [Laughs] No, it was a good play, and it was a game-changer for us. We knew we were good, and we were on a mission after winning as many games as we did in '85. The mentality of the players, the coaching staff: We were not gonna lose.

BOBBY OJEDA

What gets overused is, "We sent a message." We didn't go in there to send a message. We went in to kick their butt, and we did it.

DARRYL STRAWBERRY

We might have fell short in '84, '85, but we wasn't gonna quit this year. We wasn't gonna beat ourselves. In St. Louis, we turn it on, we show people who we really are; we show them that we know how to win.

That Sunday the Mets completed the sweep as Bobby Ojeda pitched a complete game to beat the Cardinals, 5–3.

KEITH HERNANDEZ

Okay, four straight in St. Louis. Four, not three. That's a statement.

ERIK SHERMAN

One month into the season, and Whitey Herzog told some reporters, "You know what, no one's catching the Mets this year."

DAVEY JOHNSON

You know, the white rat, he jumped ship quick.

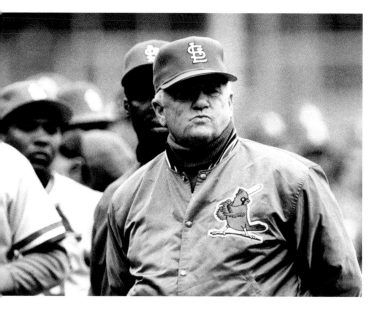

BOBBY OJEDA

It was this awakening for me, as a player. I guess it's okay to be confident.

ERIK SHERMAN

So after the slow start, the Mets go out and they win twenty-three of their next twenty-five. They became brash.

DARRYL STRAWBERRY

We just knew that once we got hot it would be fun.

GREG PRINCE

The Mets were a first-place team: This was the new normal.

WALLY BACKMAN

In the clubhouse, our number one goal was about winning, until the game was over. Baseball was number one, women might have

came second, liquor was third, or vice versa on two and three.

VINNY GRECO

After a game, you know, we would have beers in a lounge. Guys would sit there, have six or seven beers like they were nothing, and then maybe go out. Keith would always like to have a drink after the game.

JAY HORWITZ

The team wasn't all milk drinkers.

DWIGHT GOODEN

We were playing in New York; we're having lots of success. We had a lot of guys who had a lot of confidence, big personalities. At the time in the '80s, during that era, partying was the thing to do.

WALLY BACKMAN

I can remember going to a place in the city and we drank like ten bottles of Dom Pérignon. We had a doubleheader the next day, and you got to go out and get a couple of hits that day when you get home at four or five in the morning. It's not easy, but it happens.

VINNY GRECO

One day, I remember, Darryl was out all night. BP was already started, he was late. He called me up; he said, "Hey, meet me in the

parking lot with my uniform." I take his uniform, put it under my arm, run it out to the bullpen—he'd get changed in his car. Take his glove, walk out through the gate, and start shagging fly balls. Davey knew.

DAVEY JOHNSON

I didn't have many rules. Occasionally if a guy came in a little blurry-eyed, like occasionally Strawberry did, I would say, "You know, you can't stay up all night, number one, and number two, you can't drink all night, and three, carouse around all night. Just pick one!" [Laughs]

JEFF PEARLMAN

At the time you would see a lot of ballplayers drinking coffee in the Mets clubhouse, forty-five minutes before a game starts. Which is a weird choice of beverage, you would think. Are you drinking Gatorade? No. You drinking water? No. Coffee, hot coffee. What hot coffee did was it kicked in the speed and it made it really take off.

LENNY DYKSTRA

Let's put it this way, we put the S in speed. Amphetamines. Fuckin' A, man.

JEFF PEARLMAN

Speed was a drug throughout baseball at that time. It was unmonitored, anyone could use it, it was easy to use, it was easy to get, it was cheap. It just made you go, go, go, go, go . . .

and made you feel like you could lift a thousand pounds.

LENNY DYKSTRA

Mex [Keith Hernandez], the fucker, he would always tease me: "These are gold—and you can't have them."

VINNY GRECO

We called them crosses. At the time, they were white crosses. We usually would have a stash of greenies, crosses, in vitamin bottles, stow it in our equipment things. Guys knew where they were; they would go take them. There would be guys that would take more, and there would be guys that would take less. But I would say 90 percent of that team took crosses. That was a big part of baseball, not only with the New York Mets; it was everywhere.

JOHN STRAUSBAUGH

Speed was a performance-enhancing drug, and if one guy's doing speed and they think that's going to give him an edge, then they're going to do speed, too. And pretty soon everybody, all baseball players, were on speed. They were all speed freaks in the '80s.

WALLY BACKMAN

Baseball's all about longevity. Players would do whatever it took to stay on the field.

LENNY DYKSTRA

People don't understand how rigorous Major League Baseball is. It's the toughest schedule in all of professional sports. I mean they talk about football. Football's seventeen fuckin' games, man. I mean, come on. We're playing 162 fuckin' games. The Kid didn't take 'em. I used to try to put a couple in his locker. I said, "Kid, take a couple, man. . . ."

VINNY GRECO

Gary Carter was a real family guy, but he was tough. I used to always joke around with him and I used to say, "Gary, you couldn't shine Johnny Bench's shoes," and it started a thing with him for a couple years, where if I wasn't looking at him and he was sneaking up behind me, he would physically come underneath me and grab my balls, where they almost fell off my fuckin' body, until I said he was better than Johnny Bench.

LENNY DYKSTRA

We're in Atlanta, dude, and I go out with Mex . . . and I was buzzed. I come back and I remember it's like three in the morning, Gary Carter's next to me, in the hotel. I start mule-kicking his fuckin' door, the Kid, mule-kicking it as hard as I could, and he wouldn't come, so I kept doing it louder and louder. And then: "Kid, get up, man!" And he got up all right. Dude, he comes out, he fuckin' puts me up—pins me up against the wall—he says, "You ever fucking do that

again, I'll fucking kill you." I said, "Whoa, okay." He threw me like a fuckin' toy over there. Kid was a gamer, man. Cockstrong, dude.

KURT ANDERSEN

Nineteen eighty-six, the swingin', swaggering Mets developed a bullying, attention-grabbing reputation. But it was an embodiment of a certain type of New York–iness of the 1980s.

JEFF PEARLMAN

Ed Koch, he was the mayor, and he was very into reminding everyone how great New York is and New York is the best and New Yorkers we do this, and New Yorkers we do that.

JOHN STRAUSBAUGH

Mayor Ed Koch had a vision that he was going to bring New York back to its days of glory. He wanted to see new buildings go up, so there were a lot of sweetheart deals for new developers to develop high-rises, tall apartment buildings, skyscrapers. Plenty of folks benefited. And it's all because New York City was cheap and nobody was paying attention. The authorities weren't there to pay attention, so you could get away with almost anything.

JEFF PEARLMAN

New York chutzpah. New York really is a showbiz kind of town.

"Look how rich I am, look how famous I am. Look at my face on this billboard. You need more of me." But you can't have too many egos. Man, if you think about it, Doubleday was a perfect owner for that team because he kind of kept out of the way and let Frank Cashen do his thing.

MARK HEALEY

It's completely overlooked how important Nelson Doubleday and his stewardship of the New York Mets from 1980 to 1986 was. It really should be known as the Doubleday era.

ED LYNCH

He believed in the people that he hired and he let them do their job.

JOE McILVAINE

He was so supportive, you know. He was the type that would come to you: "What do you need?"

ED LYNCH

I remember the first time we all met Nelson. He was a big, blustery guy, and he'd slap people on the back and he talked loud

DARRYL STRAWBERRY

He'd go golfing with guys, he did a lot of things, different things, with players and stuff like that. He loved the players.

KEITH HERNANDEZ

He would come to day games and watch us take BP, and he'd always have a vodka. I told him, "Nelson, please, could you hide the vodka? Can you hide the drink, please? You're making me thirsty."

LENNY DYKSTRA

He'd have drinks for us, cocktails for us. Nelson. Cool motherfucker.

MARK HEALEY

Nelson Doubleday did not like publicity. He hated it. He would never, in a million years, question or second-guess his baseball people. He wanted to be the opposite of George Steinbrenner. He wanted to be a fan and sign

the checks and let competent people do their jobs and get out of the way. That's how the Mets were run—until 1986.

DARRYL STRAWBERRY

I just know that something happened.

MARK HEALEY

In 1980, Doubleday Publishing buys the team. Nelson Doubleday, through Doubleday Publishing, bought the majority stake, for $21.1 million, which at that time was a record for any franchise. Nelson Doubleday had "fuck you" money, okay? Fred Wilpon, at the time when they bought the Mets, had cookie money. He was in for, I think, 1 percent. And because Nelson Doubleday was not one who wanted publicity, he decided that Fred Wilpon should be the front guy. It turned out to be a huge mistake, in retrospect. Nelson Doubleday was $21 million, but at the end of the day Fred Wilpon was still a partner.

)0)0)0

JEFF PEARLMAN

Ray Knight is at a banquet with his now ex-wife, the pro golfer Nancy Lopez.

RAY KNIGHT

It was this big deal. Everybody who was anybody in sports was there, including Peter Ueberroth, who was then commissioner of baseball. I'm sitting there with Nancy at the table. Peter Ueberroth comes and taps me on my shoulder, and he says, "Ray, can I talk to you for a minute?"

JEFF PEARLMAN

Ueberroth says, "I can't give you too many details, but we know for a fact that one of your young Black stars has a drug addiction, is a drug addict."

RAY KNIGHT

"We've had detectives follow him around, and this thing is gonna blow if something isn't done about it." And I ask him, "Who is it?" And he says, "You are going to need to figure that out."

JEFF PEARLMAN

Ray Knight knew immediately who it was. He knew it was Darryl Strawberry.

RAY KNIGHT

The next day I walk up to Darryl in the clubhouse, and I said, "Darryl, I need to talk to you."

JEFF PEARLMAN

He goes up to Darryl Strawberry and says, "Is it you?"

RAY KNIGHT

I said that I heard from a high-ranking league official last night that we had a young Black superstar that had a drug problem.

JEFF PEARLMAN

Ray Knight says that Darryl Strawberry, who's wearing sunglasses, pulls down his glasses and goes, "It's Doc."

RAY KNIGHT

Immediately, before I got "problem" out of my mouth, he says "It's Doc." Darryl denies that.

DARRYL STRAWBERRY

No, I just said it's not me. How many Black players on the team that's young?

DWIGHT GOODEN

Ray did come to me and say that. I said no, at the time it had to be either me or Darryl. Darryl said no it ain't him, it was Doc; but I just said no, it's not me. I would never point at anybody, that's not me. I would never do that. It was not for me to do.

DARRYL STRAWBERRY

There was only two Black young stars on the team. If I told him it wasn't me, guess who they're talking about?

RAY KNIGHT

You gotta realize we're together two hundred days out of the year. I saw that every day Doc got there at the same time, he was consistent, he wasn't moody, so I went to Darryl because Darryl was the most inconsistent. I said why don't you and I go into Davey's office and explain to him what transpired last night. So I go in there and Davey gets the coaches out, and I said, "Skip"—I told him everything—"I'm coming to you after talking to Darryl. My thought was it was Darryl. Darryl says that it was Doc." Darryl's standing right here with me. I said, "I'm just going to leave it with you, that's all I know." So then I left.

A little bit later in batting practice I looked out in center field and there was Davey, Doc, and Darryl talking. And to this day I don't know what was said, and I never heard anything back from any of them.

JEFF PEARLMAN

Ray Knight told Davey Johnson, and they didn't do anything about it.

VINNY GRECO

Dwight Gooden, he was the best. He loved my mother's cooking. We'd go back to my parents' house and he would sit down and my mom would cook him whatever he wanted. He came up more than a couple of times. Back then Wiffle ball was a big sport in the Bronx. We grew up on concrete, you know, on cement. We would set up Wiffle ball games in front of our houses. When Gooden came to the neighborhood, he would say, where's your grass? You guys play on fields? We're like, "Doc, there's one field in the whole neighborhood and we're not getting on it." He was

mystified, he couldn't believe how we played any sport. One day he said, let's get a Wiffle ball game going on and it was only maybe five or six kids, friends of ours, but by the time word got around, there was probably a hundred kids in the street that were watching Dwight Gooden play Wiffle ball in the middle of the Bronx. People were like, how is this even possible? And he would sit there and sign autographs for hours, talk to kids. Tell kids how to pitch. That's the way he was.

DWIGHT GOODEN

When I started having a lot of success in 1985, I can only imagine, if this is the way I felt, what it must have been like for Michael Jordan his whole life, or Michael Jackson, or someone like that, because you couldn't go anywhere. Even outside of my house there would be people lined up in their cars, waiting to get autographs. That part I understand from the fans, and I appreciate that, but for me as an individual it wasn't fun because I couldn't live like a twenty-year-old lives. I couldn't get pizza, I couldn't go on a date. You couldn't go to the movies, you couldn't walk around the mall. You couldn't do nothing; you couldn't go anywhere. I was just stuck in the house. It was tough.

ANN LIGUORI

He became a star in New York so quickly, and he was so young. Darryl the same thing. All

of a sudden they're under the big lights. And they didn't have a lot of time to mature.

JOE McILVAINE

Gooden got off to a really good start in 1986, won his first five games. You know, we were thinking that here's the man that just won the Cy Young Award and the Rookie of the Year the year before that. He's gonna just continue on and become the greatest pitcher in history.

Going into his start against the Reds on Mother's Day, May 11, 1986, Dwight Gooden's record was 5–0 with a 1.04 ERA. But that day, he pitched only five innings, gave up three runs on eight hits, and the Reds beat him, 3–2. The Mets record was now 20–5.

DWIGHT GOODEN

Growing up in Florida, I was a very shy, quiet kid. It was a loving family, but a lot of things happened in my childhood that I thought was normal, but as you get older, I realized that there was a lot of trauma there.

As a kid, my sister used to live in the projects and I used to go there all the time, because there were always a lot of kids there, lots of things you can do. But unfortunately being in that atmosphere you're used to a lot of stabbings, a lot of shots, a lot of fistfights; you saw a lot of different violence.

When my sister got shot, I was five years old. Her husband at the time was very violent. I remember I saw her get shot, and she fell down, in a puddle of blood, and the guy was just *pow, pow, pow, pow*. My sister's getting shot, and I grab my nephew, at the time he was a newborn, and for some reason I went in the bathroom, got in the tub, and I pull the curtain. I just knew it was a matter of time before he comes in there. My sister's laying there, he was screaming, then you don't hear anything, you hear the door slam, so now obviously I'm thinking she's dead.

Finding out my sister had been shot eight times . . . She lived, but I think that's where my problems started.

And then, it was probably a year later, I was six or seven years old, I remember my dad taking me to this lady's house, and he goes inside. Maybe a couple of weeks later, I was around my mom, and I said, "That's the house where Dad goes." She goes, "Really?" One day she followed him to the house—he was coming out of the house late. She shot him. Fortunately, he lived. When I got older, I asked my mom about that, she said, "Yeah, it's unfortunate. I shot him." She said he was having an affair. I said, "Did he stop?" She said, "Well, he slowed down." So we laughed about it, but then sometimes I look back at it, I'm like, man. You know, inside, I'm thinking, "She shot my dad."

But when you're twenty-one years old, that inner pain, it builds up and builds up. I didn't know how to deal with that. But things that you don't deal with, eventually it comes out one way or another. And unfortunately it came out the wrong way for me.

Fourth Inning
WHAT'S UP WITH DOC?

GREG PRINCE

Gary Carter and Keith Hernandez were the yin and yang of the '86 Mets. They were the two guys who were the foundation of the team. And it's impossible to think about those Mets without the both of them.

JEFF PEARLMAN

They were the two best players of their positions at that time period, and the two savviest and the two smartest. Hernandez was the leader of the Mets. Carter thought he was the leader of the Mets, but was kind of ignored. Sometimes, Carter would go out to the mound, and maybe he'd say to Ron Darling or Dwight Gooden, "Look, *blah, blah, blah, blah, blah*." He'd go back, Hernandez would come out and say, "What did Gary tell you?" "*Blah, blah, blah, blah, blah,*"

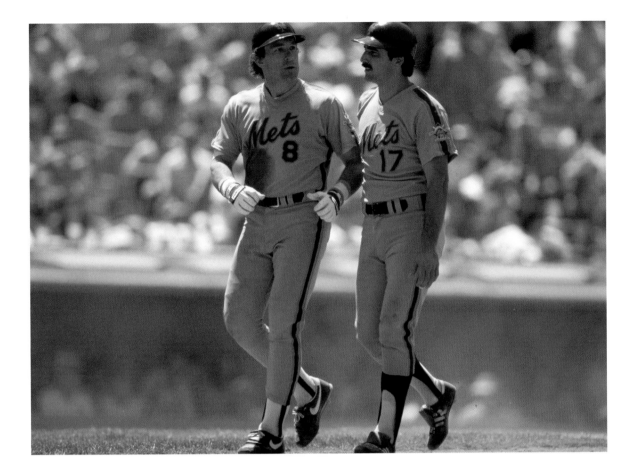

and Hernandez would say, "Well, fuck that, just throw them the fastball."

SID FERNANDEZ

Look, I'm not discounting Gary, but for me it was Keith.

MOOKIE WILSON

Gary was a leader in his own right. But Keith was the big kahuna on that team, all right? Let nobody fool you.

KEVIN MITCHELL

Super Mex. I might be hitting second that day, and he's hitting third. Keith would come to me and he'd say, "Mitch. We gonna compete today against each other. How many hits both of us get." So he'd push me.

JOE McILVAINE

Keith could be difficult sometimes to deal with. He was gonna do it his way, all the time. He didn't feel that anybody else knew the game better than he did.

BOBBY OJEDA

Keith wanted to tell you he invented the game. And he never got challenged on it.

Gary wouldn't do that. Gary just liked to talk.

LENNY DYKSTRA

I'll tell you who taught me how to play: Keith Hernandez. He helped me. He set up pitchers, and there's a lot of little things involved, and I really looked up to him.

ROGER ANGELL

Amazing baseball mind. I loved to watch him during games, the different people he talked to, he was so involved in the goings-on of the game.

LENNY DYKSTRA

Misery loves company, so before the games he'd always want to smoke. I never had a fuckin' cigarette in my life, man. But when Hernandez says, you know, "Hey, you want to have a smoke with me?" I'm like, "Okay!"

ANN LIGUORI

I remember going into the clubhouse after every game to interview these guys, and you'd have Keith Hernandez with a cigarette in one hand and a beer in the other, holding court, and then you'd have Gary Carter. I used to tease Gary that I could put a microphone in front of him and leave for about an hour and he'd still be talking.

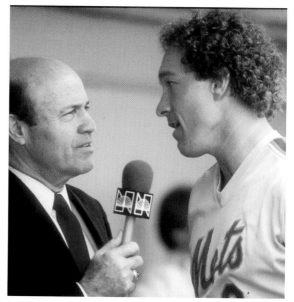

KEITH HERNANDEZ

It's not like hockey. You don't have to name a captain. It's you come, you play hard, you play to win, you set an example. Gary, with his knees, running on and off the field every inning, if Gary Carter runs on and off the field, then don't I got to run on and off the field? You know, that's where the examples are set.

GARY CARTER, 1986

You look at him, and it's like on the eighth day Darryl Strawberry was carved. [Laughs] He's just got an outstanding athletic ability. He's got a great body for it, he's six foot six, he can run, he can throw, he can hit, he can hit with power. He can really do all of the things that it takes to be a top superstar. He's still only twenty-four years old. And it's just a matter of how he applies himself.

JEFF PEARLMAN

Darryl Strawberry was kind of a jerk, to be polite, and he was really mean to Gary Carter in particular. Strawberry just saw him as a guy *I* could needle and needle and needle and needle.

DARRYL STRAWBERRY

At that time in my life I just didn't care about a lot of things. It wasn't that I didn't like people. It was that I didn't like myself.

RAY KNIGHT

Straw and Gary almost got in a fight in St. Louis. It was hot, we were sitting at Busch Stadium, everybody's on the bus but Gary; he's signing autographs. Darryl started yelling out the window, "Hey, Camera Carter, get your ass in here, let's go!" And when Gary did come in, oh my gosh, he was like a raging bull. Straw was at the back of the bus, here comes Gary. . . . They're coming this way. I'm in the middle, I stand up. I stop them both. I said, "You get your butt back there, Gary, you just find a place and sit down. You know, we're not going to fight each other."

BOBBY OJEDA

There's an internal captain, and then there's an external captain. Ray Knight, he was the real deal. He was the captain of the internal team.

RAY KNIGHT

Sometimes there are leaders on clubs that you don't even know that are leaders, that the leaders go to and talk to.

BOBBY OJEDA

I'm telling you right now, the leader of that bunch was Ray Knight. And I got that early, in spring training. Ray don't say a lot. But as it unfolded, I said, "That's the hammer. That's the hammer right there."

JEFF PEARLMAN

Ray Knight was a sage veteran. He'd come to the Mets after an off year in Houston.

JOE McILVAINE

Davey was the one who pushed for Ray Knight.

ED LYNCH

Ray did not have a great year in '85. His batting stance—[hitting coach] Bill Robinson was working with him, he was crouched over at the plate. Then in '86 he came in, he'd lost a bunch of weight, and he was standing straight up, and he was hot from day one.

DAVEY JOHNSON

Ray always would look to me a little bit jittery because he was so wound up.

On May 27, with the Mets leading the Dodgers 3–1 and the bases loaded in the sixth inning, George Foster clobbered a grand slam off the

Dodgers' Tom Niedenfuer. The next batter was Ray Knight.

JEFF PEARLMAN

The Mets got in four fights that season. Four on-field fights, and they won them all. Number one is Ray Knight against the Dodgers.

RAY KNIGHT

I knew he was gonna hit me. Niedenfuer is looking at me, and he watched me all the way to home plate like he's telling me, okay big boy, I'm gonna drill your butt. [Mike] Scioscia's catching, and I'm like, "If he throws at me, I'm gonna go get him." He drilled me. I don't remember anything after that except just running to the mound.

WALLY BACKMAN

Everybody knew it was intentional. Ray was a Golden Gloves boxer; well, that was a mistake. But there was nobody going out there by theirselves. If it was right, wrong, or indifferent, we had your backs. You had twenty-five players that were all in.

BOBBY OJEDA

We're all on the same page. We had Davey tell us how good we were, and if anybody crossed that in a way that we didn't feel was acceptable, we're gonna fight.

JEFF PEARLMAN

A lot of people learned you just didn't want to mess with the Mets.

The Fighting Mets

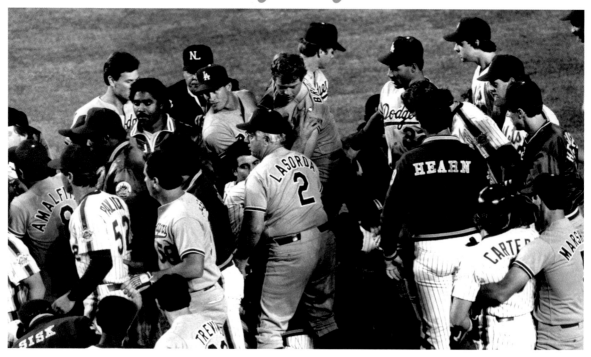

KEITH HERNANDEZ

We were brash. We used to woof from the dugout. Boy, we were hard. We were a tough bunch.

WALLY BACKMAN

There were some mean players back in the day. It wasn't about what your OPS was and all that stuff. It was about winning baseball games. And you would do everything that you could do to try to win a game.

DAVEY JOHNSON

It's the makeup. It's the heart. And that's a driving force that overrides shortcomings. I mean, I took Wally Backman over this guy named Giles that had all kinds of talent. I wanted Backman because he was a little dirtbag that just loved to get dirty.

WALLY BACKMAN

You know, when I was married to my wife back then, she'd get so upset because the game would be over, and I wouldn't be home for three or four hours. And it wasn't because we were going out; we'd be sitting in the clubhouse talking about baseball.

DWIGHT GOODEN

After the Sunday day game at Shea, there's so much traffic you can't go anywhere; we'll sit in the lounge, drinking beer and just talking baseball. I mean, we did that for hours and hours, nonstop. We loved the game of baseball. I think we had more knowledge than anybody.

BOBBY OJEDA

It was more of a climate. That '86 team was miserable if we lost. You went five-for-five and you were hooting and hollering, one of our own's gonna punch you in the face.

WALLY BACKMAN

The game was really all about winning at all cost. If you were on first trying to break up a double play, you didn't care if you hurt him, how hard you hit him: That was the game.

DWIGHT GOODEN

Kevin Mitchell, Strawberry, Ray Knight—these guys were ready to go at you anytime. I mean, it's funny, because we had some guys used to tell me, "Doc, hit somebody, let's fight today." I'm like, "Man, let me get five innings in first."

GREG PRINCE

The Mets were taking no prisoners as 1986 moved on.

DARRYL STRAWBERRY

You know, every night we were coming back, we were winning ball games. We would fall behind in a ball game and we just knew that we could come back because we had so much offensive threat sitting in the dugout.

KEVIN MITCHELL

The bench guys, me, HoJo, Teufel, Mookie: We knew we had to be ready. Ain't no telling with Davey Johnson, you might be in the game in the second inning. Ain't no telling.

JOE McILVAINE

You see the players on your team more than you see your family members during the season. So it has to be a brotherhood.

LENNY DYKSTRA

Seven months you're with the same dudes, so there was so much chemistry with that team.

KEITH HERNANDEZ

The road is where we stayed out together as a group. You couldn't help but notice. There was some camaraderie here.

WALLY BACKMAN

I can remember just flying into St. Louis, the plane had hit the ground and we say, "Okay, let's kick their ass and take all their women." It was another word, but—

DARRYL STRAWBERRY

That's what it was like on our bus drive to the hotel after we landed, and we were all crazy, all hammered: "What we gonna do?"

DWIGHT GOODEN

"Gonna drink their beer, F their women, and kick their ass." I mean, it's sad to say, but that was the thing, that's real.

SID FERNANDEZ

We land in a city, say, "We're gonna drink their beer, fuck all their women, and kick their ass and leave town."

LENNY DYKSTRA

We're going to their house, we're taking their money, and we're fucking their women, okay? Period. We never fucked their women, but—

BOBBY OJEDA

There's always cliques, there's always guys who like to do certain activities together. Good or bad. But that particular team, that year, that '86 year, it was all welcoming. When we would go out, on the road, as a group, it would usually be eight or ten of us, and we would go out and take over a bar. And you've got big, giant guys, so they stand out anywhere. So now here we all come in, and we're ordering beers by the dozens.

WALLY BACKMAN

We drank hard. We partied hard. We chased. We were a family. I mean, that's the best way to put it. We were as close as you could get as a team.

KEVIN MITCHELL

There's too many serious people in this game now that don't have fun. You gotta have fun in this game, man. We had fun. We did it all.

JEFF PEARLMAN

I've never written about another team where fifteen guys would go out to a bar after a game together. Never. It's sort of a priceless and hard-to-find thing. You know, managers talk about chemistry as if you can create it, but you really can't create it. You hope you have it, and you hope it works.

DAVEY JOHNSON

If you've been around sports long enough, it's not something you can just turn off and turn on. You get the water just right, the right temperature, and you just keep it that way; you don't start tweaking everything. We're just doing what we're normally supposed to do, and that's beat people.

DARRYL STRAWBERRY

I think a lot of teams really hated coming into Shea Stadium because of the way the crowds were, and the crowds were loud, and they knew we were bad boys, and we had a lot of guys who talked a lot of smack.

KEITH HERNANDEZ

When I'd come out and warm up, Shea would be packed, and there would be a buzz. You just felt the electricity already before the game started.

DWIGHT GOODEN

Nobody's gonna beat us at home.

DARRYL STRAWBERRY

When the Wave was out, you know, and the crowds were crazy, the ballpark was just on fire.

BOBBY OJEDA

Being in the visiting clubhouse, you would see teams coming in, and they knew they were done. Players would walk in the clubhouse shaking their heads. If they lost the first two, they were gonna lose the third.

DWIGHT GOODEN

We didn't care if teams liked us. We didn't like no teams. It was just us, that was it. It was us and our fans, that was all we cared about.

LENNY DYKSTRA

Fuck yeah, man, that was fucking awesome. New York's the best. New York's the greatest.

ED LYNCH

You've got generations of generations of baseball fans sitting there, and they know the game inside out. I mean, you might go to L.A., and people are just looking for movie stars in the stands. But New Yorkers are very serious. Probably a little bit too much.

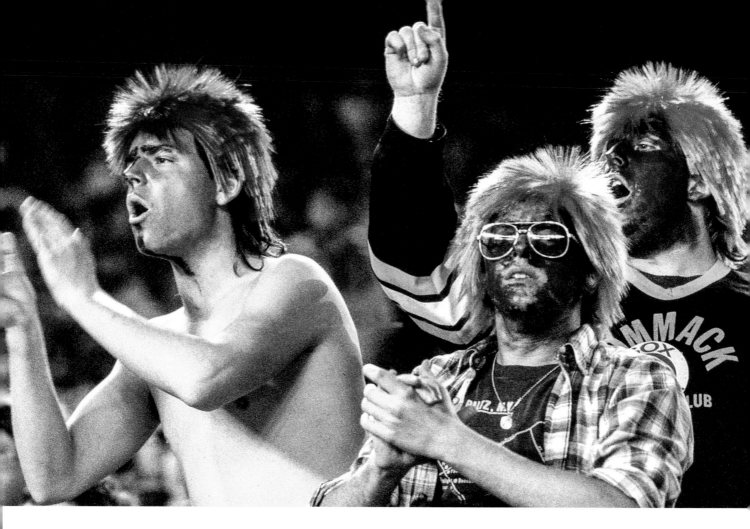

LENNY DYKSTRA

See, in New York they throw coins at you. But I like that shit.

JEFF PEARLMAN

If you win in New York City, you're sort of permanently part of the city, right? People remember you, and people will tell their kids about you. Especially with this team.

JOE PETRUCCIO

The '86 Mets—it really was a brotherhood, and

you could sense that; and I think it spilled over to the fans. We really started to become one.

TAMA JANOWITZ

That's why I was tuning into the TV every night, you know. Mookie Wilson, Dwight Gooden, you know, they were all like names of, like, not your friends, but your characters.

ROGER ANGELL

There must have been twenty-five thousand cats in New York that year named Mookie.

TAMA JANOWITZ

They were so vivid and wacky, it was like reading a novel, like, "Oh, what are they gonna do tonight?" Everybody was tuned in, and if you walked down the streets you would hear people cheering out the windows. It was hysterical.

GREG PRINCE

There was something larger-than-life about the '86 Mets that kinda swallowed New York.

JEFF PEARLMAN

They weren't hiding who they were. I didn't think they viewed themselves as brands. Like Gary Carter, Darryl Strawberry, Keith Hernandez, Dwight Gooden, they may have been brands, but they didn't view it that way. It wasn't like, "I'm Dwight Gooden, and I have to protect my intellectual property. And I'm gonna hire someone to tweet for me." Like, that didn't exist. They were just ballplayers.

HOWARD BRYANT

Don't tell me that all you care about is winning. Because you don't. It really is all of the other things. We want stardom. We want star power. We want "it," right? What did Miles Davis say? "That thing." We want that thing. And you know it when you see it. And you definitely know it when you see it in New York.

JOE PETRUCCIO

I think sports is entertainment today. And I think that that '86 team was just starting to put that together.

Family Dynamic

ROGER ANGELL

The moment Keith came aboard the Mets, Davey Johnson began to notice something strange.

KEITH HERNANDEZ

He walked in on me one time. He goes, "The phone would have pine tar on it; it'd stick to my hand . . . so I knew you were up calling your dad."

ROGER ANGELL

After every at bat, Keith went back and called his father, and they'd discuss the last at bat, whether it was a hit or not a hit. No other player did this.

KEITH HERNANDEZ

I'd only call when I was euphoric, when I was just really red-hot, and I wanted to share it with him. I was showcasing for my father. "Here I am, Dad, I think I have arrived now." The issues came when I got him a satellite dish. Big mistake. And he watched every game. And he videotaped every game. Those old VCRs. And that became a big problem.

When I did slump, it always was, "Well, if you'd listened to me, you hit .312, you would've hit .325." It's like, ugh, come on, Dad. If I want your help, I'll call you. But Dad wouldn't see it my way. One time, it was in '86, I was in a bad slump, and Dad said, "Keith, you're not gonna come out of your slump. I know what you're doing wrong." And I screamed at my dad and dropped every bomb on him, and told him where to get off and go shit in your hat and *blah, blah, blah* . . . and I hung up on him. Oh my God [Laughs]. That was probably our worst argument. So we didn't talk all summer.

RAY KNIGHT

His daddy was so hard on him. But it was always something that his father would tell him that would get him in the groove.

KEITH HERNANDEZ

Gary, my poor brother, would defend Dad,

and I'd go, "Gary, you don't understand. I am a grown man. I gotta come out of this on my own." One time I hit a home run, and I knew he was watching, and I went around first base and I was just saying bad words as I was running the bases. That's how much he'd gotten under my craw. You know, I was a five-time All Star, won an MVP and a batting title. . . . "Can you be happy with that? Your son won an MVP and a batting title, was a five-time All Star, eleven Gold Gloves! Can you just be happy with that?"

It is what it is. The family dynamic, the Hernandez family dynamic.

By June 16, the Mets had an 11½-game lead on the second place Montreal Expos. The Cardinals were 19½ games behind, in last place.

GREG PRINCE

By the middle of June, they were 44–16. The Cardinals were dead, the Phillies, Cubs were nowhere; the Pirates were nowhere. It was the Mets show. They were twenty-eight games over .500 with 102 games left to go. And by then, there was no doubt we were seeing something that we had never seen before, and we could never ask to see again.

JEFF PEARLMAN

Bill Robinson was the first-base coach. He

was very feisty. He would give these weird pep talks to Dykstra and Backman: "You guys are a bunch of motherfuckers. You go out there, you grimy fuckin' . . . You go out there and you fuckin' create havoc, and you're fucking gonna go out there and you're gonna . . ." And it would, like, charge them up, you know, they'd be probably half soaring on speed already, and they would be, "Yeah, we're gonna fuckin', yeah!" It was like a *Rocky* pep talk. I mean, they loved that guy.

KEVIN MITCHELL

Ain't no words I can say about Uncle Bill, man. He taught me a lot about the game, stayed on my bumper like I was his own son. Stayed on my bumper.

JEFF PEARLMAN

He used to play on the Pittsburgh Pirates when he was a player, and one of his teammates was [pitcher] Rick Rhoden. And Bill Robinson knew that Rhoden scuffed the baseball.

KEVIN MITCHELL

Uncle Bill told him to quit cheatin'. Walked by him and told him to quit cheatin'. They got into it right there.

JEFF PEARLMAN

All of a sudden the first-base coach is getting in a fight with a pitcher for the other team.

WALLY BACKMAN

We'd fight anybody. It didn't matter what happened.

DARRYL STRAWBERRY

Our bench would clear—you know, it's time to go. Guys would be in there. Kevin Mitchell would be in there fighting. Hernandez was tough, you know. Ray Knight would be in there fighting, you know. Carter was a peacemaker, but he was always in there, too.

LENNY DYKSTRA

See, I was smart: I stayed away from them fights, I stayed in the back, see, 'cause, remember, what am I gonna do, man? Like, you get hurt in them fights, you know. Let some other fucker get hurt.

KEVIN MITCHELL

It's a team fight now, I see [Pirates infielder] Sammy Khalifa running, fixing to clothes-hang Uncle Bill. But he didn't see me come from the blindside. I end up grabbing him and putting him in an illegal choke hold.

JEFF PEARLMAN

And that's when Kevin Mitchell grabs Sammy Khalifa's face, drags it across the turf, and says, "White meat."

KEVIN MITCHELL

Everybody is hollering at me: "Mitch, let him go, let him go, let him go." I can't hear nobody, I got him locked down. He passed out, started choking and all kinds of stuff, man. That got me in trouble.

BOBBY OJEDA

The fact that he had somebody in a headlock, not surprising.

JOE McILVAINE

Nobody messed with Kevin Mitchell.

JEFF PEARLMAN

He was terrifying.

SID FERNANDEZ

In the clubhouse, you heard stories.

MIKE "CHOPS" LACONTE

I heard he was a street kid from San Diego.

JEFF PEARLMAN

Hard-core upbringing, bullet lodged in his back.

JAY HORWITZ

I heard he killed a guy in a gang fight.

ERIK SHERMAN

There was the tale of him decapitating a cat.

VINNY GRECO

You were like, "All right, this guy's crazy, I'm afraid of him."

ERIK SHERMAN

So when he came up to the Mets, there was a lot of mysteries surrounding Kevin Mitchell.

JOE McILVAINE

When I became the scouting director for the New York Mets at the end of 1980, I got a call about Kevin Mitchell.

KEVIN MITCHELL

One of the scouts for the Mets—he ended up seeing me in a pickup game. He was out there scouting somebody else. And the first guy that I faced, I took him deep, twice; so I had a scout come to me and tell me, "Kevin, do you know who you just faced?" I said, "No." I thought it was one of the players for San Diego State. They say, "That was Buddy Black." They say he's one of the ace pitchers for the Kansas City Royals. I said, "Well, he don't have nothing." They told me they wanted to give me a contract: "How do you feel about playing baseball?" I said, "Well, the game is boring. I might go play football."

JOE McILVAINE

So we spent $2,500 on Kevin Mitchell and gave him a chance.

HOWARD BRYANT

That's the beauty of baseball, more than any other sport, because it's such a hand-eye game. It's really hard to hit a baseball, and he could do it any way you needed. He could hit it for power, he could hit it for average; he just had it.

DAVEY JOHNSON

I had to find ways to get Kevin in the line-up. I'd just play him anywhere I could find a spot.

KEVIN MITCHELL

You know, in Little Leagues you probably play that many positions. But the only way I can make it to this team is I've got to be able to play anywhere on the field. Because I played so many positions on the field, they nicknamed me "World."

LENNY DYKSTRA

Kevin Mitchell's a fuckin' stud. He could play anywhere, man. Shortstop, left field, clutch hitter. And could fight like a mother-fucker.

SID FERNANDEZ

When he'd go to the batting cage, the sound coming off his bat is like nobody else's. Like you hear guys *pah*, *pah*, *pah*; then Kevin: *PAH!* I mean, he just made a different sound. You knew that was Kevin hitting.

KEVIN MITCHELL

I was like, man, this is easy.

KEITH HERNANDEZ

He had a phenomenal swing. My dad loved Kevin as a hitter.

JEFF PEARLMAN

He was big and strong and didn't take any crap.

DWIGHT GOODEN

One thing he told me was, "When we're in a fight, do not grab me, I don't see colors; I'm just swinging."

KEVIN MITCHELL

"Mitch, you hit me! I'm your friend!" "Well, it's nothing personal, man. Take one for the team."

BOBBY OJEDA

You talk about the enforcers—there *was* two real tough guys, the real deal: Ray Knight and Kevin Mitchell. The rest, we were all paper tigers. Kevin Mitchell was scarier, though, because he had that gold tooth.

KEVIN MITCHELL

I think intimidation is so important, in every game that you play. So that's that tough guy, you

know, so if you want to put that label on me, go right ahead. Everybody need their gimmick.

ERIK SHERMAN

Everybody assumed when he came to the Mets organization that he might be trouble, that he might be a bad influence on some of the other players. In all my years covering baseball, I've never met anyone that was misperceived more than Kevin Mitchell.

KEVIN MITCHELL

We can set the record straight. My childhood, I grew up in inner-city, southeast San Diego and you know, lot of gang violence, shooting, and stuff like that. But I was never involved in no gang. Some places I was in the wrong place at the wrong time, got hit a couple of times, that was it. But people made a lot of stories out of something. Just like I killed this cat with a sixteen-inch blade. Somebody made that up. I don't know who made that up.

DWIGHT GOODEN

I'm not touching that. No, that, that was crazy. Kevin actually got upset about that. We talked about it, so I'm not allowed to talk about it anymore.

KEVIN MITCHELL

Like I'd do something like that! I'm an animal lover, bro. There's no way. I'm a big bear myself; I love animals.

BOBBY OJEDA

Nicest guy in the world, but don't cross him.

KEVIN MITCHELL

Might as well put that sixteen-inch blade that I cut the cat's head off with, take that off my résumé now 'cause it's all done, you know?

DARRYL STRAWBERRY

I think people exaggerate a lot of stories. Kevin was probably one of the best teammates that we had.

KEITH HERNANDEZ

Kevin Mitchell was very much misunderstood. He was fantastic, a great teammate.

KEVIN MITCHELL

All these guys made me feel like I was part of this team. As a rookie they tore me up, man. In Chicago, they wake you up about one o'clock in the morning. You have to take your color spray can, you gotta climb that statue, that horse that stands up in the middle of the city; you gotta climb that thing and paint the wobbles. Go paint the horse's nuts. Every team does it. I'm pretty sure right now they still do it. If you go over there to Chicago and go look at the horse, the horse probably got fifteen thousand, fifteen hundred million colors on it now. [Laughs] On the nutsacks.

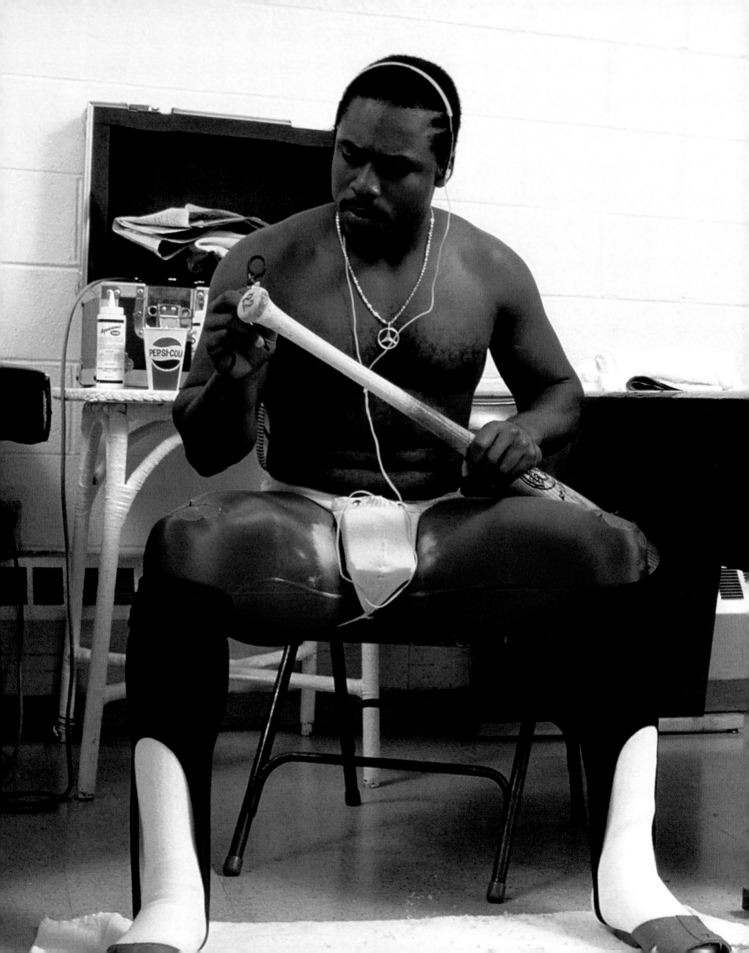

KURT ANDERSEN

For forty or fifty years, people in finance and people in other jobs of equivalent educations made the same money, and then *kaboom!* The fortunes being made by people in the financial industry began taking off like crazy.

JOHN STRAUSBAUGH

When we think of New York City in the '80s, we think of "greed is good," and that's all we think of. But there was a whole lot more going on under the surface.

KURT ANDERSEN

More than government rules changing and laws or deregulation, I would say it was the cultural norms changed. There was this focus on material things. It was all about the money.

"Show me the money." In a way that hadn't been true until very recently. So much that became America, it really happened during the 1980s.

JOHN STRAUSBAUGH

It became very evident that there were two New York Cities. There was the wealthy New York City, which was a small minority of the people . . . and then there was everybody else. We can think of it as the cocaine New York and the crack New York. Greed, hedonism, complete lack of self-control became hallmarks of that Wall Street, Financial District, cocaine New York.

HOWARD BRYANT

The attitude of the '80s, the greed of the

'80s, the conservatism of the '80s . . . just the money grab of the '80s. I hate to be a traitor to my generation, but I really, really hated the '80s.

JOHN STRAUSBAUGH

Underneath that surface, that glittering "greed is good," piles of cocaine next to the piles of caviar surface, there was a lot being swept under the rug.

GREG PRINCE

By late June, the *Daily News* was running a graphic every day of what the Mets' magic number was to clinch the National League East. Newspapers didn't run magic number countdowns until September, traditionally. This was June. Whitey Herzog said, "If I were Davey Johnson, I'd be drinking champagne every night." And they did.

JEFF PEARLMAN

The '86 Mets would stay after games and tap a keg—after every home game—and they would sit around and talk while drinking beer. They just did things together.

SID FERNANDEZ

A lot of guys would go to the ballpark at two just so we could hang with each other.

BOBBY OJEDA

The locker room can be the great barometer of what a team is about. It's so vital to whether it wins or loses. The clubhouse guys become part of it.

VINNY GRECO

People said to me, "What did you do?" I said, you know, "I worked in the clubhouse." The first thing you think is, okay, all I'm doing is washing some cleats and dirty underwear.

BOBBY OJEDA

They're always watching. They know where you want your glove hung on the wall. At the end of a game, I want my cigarettes, I want my beer right here. Whatever you needed, the clubhouse guys could get it done for you.

VINNY GRECO

We were the ones who hid the greenies. We were the ones who had drinks in their lockers. We were pulling girls out of the stands. That was part of what we did. If they trusted you, you weren't gonna go tell anybody what was going on. So the players would tip you. And the more you got trusted, the more you got. I had that trust amongst 'em all. The partyin' was constant. Especially in New York City.

BOBBY OJEDA

You're young, you've got a pocketful of money, you're high profile, got a lot of free time. It's just a recipe for debauchery.

KEVIN MITCHELL

Being in New York was like, oh, man, I fell in love with this place. I couldn't even walk down the street without a guy calling me, "World, come on in and have dinner. Free. On us."

ED LYNCH

In the city, you could do anything you want. I mean, I really couldn't do a lot. I was a turd, so to speak, but Keith was a star. I remember walking into restaurants like, the whole restaurant would stop and he'd get a standing ovation, and I'm like, man, this is something.

Like, "Mex, let's go to the China Club Saturday after the game." "Okay!" So we go there and the line's going around the block fourteen times, and he just walks right up to the front gate, and next thing you know we're at the owner's table and everything's free.

VINNY GRECO

The China Club was the spot. That was like the party place. You would see celebrities there, all the players went there, and the club wanted them there.

DWIGHT GOODEN

That's where my problems started . . . I mean, in New York. The China Club. Darryl and me had the same thing all the time. Jack and Coke. Grey Goose. Then scotch. Then whatever they had left.

SID FERNANDEZ

It was electric because we were doing well, and we were treated well. Almost too well.

VINNY GRECO

You would walk in the club, you'd never get a bill. But it was nonstop. You were out, there *was* places you'd be out till after hours; you'd be out till six, seven o'clock in the morning.

TAMA JANOWITZ

New York in the '80s was just this really rough, different, funky city, but it was all

happening. You know, the nightclubs: You'd go to them at three in the morning and just see people dressed in these costumes and performances. We'd go up to the Russian Tea Room, Maxwell's Plum, Le Cirque, Texarkana, or the Odeon, like we had every place from uptown to downtown.

WALLY BACKMAN

We didn't have just one hangout. Hey, we went to all of them. That's why I'm glad I didn't live in the city back then, because my career would've been shortened probably by a few years.

TAMA JANOWITZ

At the time, the riffraff, the socialites, everybody, was fascinated by everybody else. Everybody would be in there, from artists, from fashion, musicians, actors, socialites, high finance businesspeople. Nightclubs were a blending of people from all different social strata. And baseball was a unifier in some ways.

ED LYNCH

It's hard to try and explain what life was like in the mid-'80s in New York, you know, when you're playing for the Mets.

JEFF PEARLMAN

The Mets just oozed New York. They were grimy and gross and disgusting and slimy, and you were gonna be at a bar and Lenny Dykstra was gonna hit on your sister with your sister sitting next to you, knowing it was your sister.

DWIGHT GOODEN

At the time in the '80s, during that era, partying was the thing to do.

VINNY GRECO

Dwight Gooden would take us in a limo into the city; he'd have a couple strippers in the limo for us.

JOHN STRAUSBAUGH

Darryl and Doc in the limo, riding along, and they're just tossing hundred-dollar bills out of the back of the limo as they're going down the street. It kind of says everything about what boys they were in this period. You know, a hundred dollars, to either one of them, just a few years earlier would have been a whole lot of money, but now they're rolling in it.

JEFF PEARLMAN

I think there's a reason Darryl Strawberry doesn't drink anymore.

TAMA JANOWITZ

I remember, I went to this party, and Darryl Strawberry was there. "Darryl, Darryl, this is Tama. Tama, this is Darryl. We want to take your picture together." And I was like, "Oh my God, I get to meet Darryl Strawberry, this is so cool." They took the picture and then Darryl looks at me with such a, like, horrified look and he's like, "You're really weird." And he walked off, and I was just, "Aww." I don't say he destroyed my life; it's just one of those moments you remember forever. I never got over it.

BOBBY OJEDA

A lot of the guys were married, so you lived out in the suburbs. I lived in Port Washington, Long Island. There was like seven, eight of us who lived there. Sid lived there. Rick Aguilera lived there. Straw. Doc was around the corner. My house was two blocks from the little main strip. The chief of police stops and he turns and he goes, "Say, I heard a bunch of you guys moved to town." I go, "Yeah, great town, love it." He goes, "Well, I'm gonna tell you something. We don't want no trouble here." [Laughs] I didn't even know the guy.

LENNY DYKSTRA

Not everyone's in the city, no. You gotta be smart, see. You get home, you gotta recharge the batteries, see. I lived in Long Island with my family, you know? On the road, you go out and you fuckin' get after it and you do what you gotta do, you know?

BOBBY OJEDA

When it came to our plane, you talk about blowing off steam, that was where that happened. There was a little bit of a society. First class is gonna be the coaches; they're up there doing their thing. Then the first rows behind that are gonna be the nerds. Then the middle of the plane was the gamblers. And they're drinking and gambling and hooting and hollering. And then we had the guys in the back. It was chaos back there. You know? Chaos. Anything went.

KEVIN MITCHELL

All the crazy guys was in the back. The kinda religious guys was in the front. I was a back-plane guy. If I want to say somebody corrupted me, it was these guys.

SID FERNANDEZ

Jesse [Orosco]. Danny Heep. Doug Sisk. They were the founding fathers of the Scum Bunch.

JEFF PEARLMAN

They were kind of the sewer rats of the Mets. They would drink and mock people . . . and throw food at people.

DARRYL STRAWBERRY

I was always in the back, you know; loud music, cigarettes, and all kind of craziness going on.

WALLY BACKMAN

If we played cards, you get a red card, you had to drink a half a beer before the cards got back to you. And if you didn't drink that half a beer then, you had to chug a whole beer. You got to realize, flying from the West Coast back to the East Coast, a lot of guys didn't last very long. There was a lot of guys that had to use the restroom and got sick, but it was good times.

LENNY DYKSTRA

The pussies sat in the front.

JAY HORWITZ

I know I used to sit in the front coach.

BOBBY OJEDA

I'll never forget, Davey came back one time, and it was like he came into our world. And we started just killing him, like, "What are you doing here? You don't belong back here! Get up there where you belong!" It was this whole jock thing. He goes, "I am never, ever coming back here again." We said, "Good, get out of here!"

DAVEY JOHNSON

It didn't bother me what they did between innings. What I was worried about was if they were late getting on the field, if they weren't prepared, if they couldn't do their job. Then I worried about the other things that might be interfering. None of that was interfering with

anything, so why should I worry about it? You know? You want me to nitpick on everything? That's not my nature.

JOHN STRAUSBAUGH

Every town they got to, it was like Mardi Gras had come to town.

DARRYL STRAWBERRY

I lived a life on the road. Go to Montreal, I could be out all night partying, you know, drinking, and girls.

KEVIN MITCHELL

I'ma tell you one thing: I wasn't a drinker before I got with the Mets. Never had a drink in my life. On the road, I hung out with Straw, Doc.

DWIGHT GOODEN

The front office always felt that Kevin Mitchell was a bad influence on me and Darryl. That was the farthest thing from the truth that I can imagine.

KEVIN MITCHELL

They took me out one night, got me so drunk in Montreal.

DWIGHT GOODEN

We would force him every night to have a shot. "You had a big hit tonight, get a shot, get a shot!"

KEVIN MITCHELL

I was like, man, of tequila, too.

DWIGHT GOODEN

Later in the night, we couldn't find him. We thought that he left. And the guy's saying, "Hey, your teammate's outside asleep." Well, so, there's Kevin. He's there, outside of the club on a bench sleeping.

KEVIN MITCHELL

And guess who had to play the next day? I ended up getting three hits that day, off Floyd Youmans.

KEITH HERNANDEZ

For me, I could close the bar at two, get in bed, hotel bar, elevator, up, sleeping by 2:30—I'm fine. But if I stayed up after three, that was asking for trouble. Roy Majtyka, my first manager in A-ball, Florida State League, [when] I was eighteen years old, I remember . . . called a meeting and he said, "Guys?" He goes, "If you can't get it by midnight, it's not worth staying up to two, three in the morning." He goes, "Get to bed." [Laughs] "Don't leave your game in the sheets."

DARRYL STRAWBERRY

The girls keep you going. You know, knowing that you gotta play, but they want a piece of you. And it's not just one, it's like many.

JEFF PEARLMAN

The '80s were the era of the hotel groupie. Waiting for ballplayers at hotels. It was the golden age of that. And the '86 Mets, they were definitely your traveling rock stars, coming to town. Women threw themselves at 'em.

WALLY BACKMAN

I mean, what do you want me to say? Do you want me to say that you could go into a hotel without checking in, and take somebody upstairs and then come back down after you'd checked in and then go back upstairs with somebody else? Yes, that could happen.

DARRYL STRAWBERRY

My mom, she told me, "You need to just focus on your baseball career and leave those girls alone and stop drinking." [Laughs] Wish I would've listened to Mom.

JEFF PEARLMAN

It's kind of amazing, at least that we know of, none of those guys wound up being tested positive for HIV. Or AIDS.

LENNY DYKSTRA

This is how far ahead of the curve I was: I took five amoxicillin a day, every day. Dude, I had a sniper at the end of my fuckin' cock; no fuckin' STD for me, bro.

JAY HORWITZ

I never met any of 'em. There were not Jewish PR groupies around. I missed the boat on that part of it, except for the one time—that's why probably the boys in Montreal wanted to fix me up with a lady of the night.

BOBBY OJEDA

Jay was a . . . okay. I'll tell this story; this is how much I love Jay.

JAY HORWITZ

In '86, in one particular scene in Montreal— you spoke to Ojeda, I guess, before, right?

BOBBY OJEDA

Me and one of the guys go, "Let's get Jay a hooker."

JAY HORWITZ

I was in my room, and they got a lady of the night to come to my room.

BOBBY OJEDA

We're over on the side, we're laughing our asses off. We don't know what he's gonna do. Opens the door. Lets her in. Then we go over and lean on the door. We're listening.

JAY HORWITZ

And I said, "I can't, my knee hurts."

BOBBY OJEDA

"My knee hurts."

TAMA JANOWITZ

The ballplayers at that time, they seemed primarily to be out there alone, almost as if they were looking for love. But certainly, it wasn't in my direction, you know?

LENNY DYKSTRA

Leading off on the road, I'd always take a wide, looping walk. I always picked one chick out, and I'd say, "I'm gonna play for you." And I'd incentivize myself, you know?

DARRYL STRAWBERRY

There was girls, you know, that would be in the stands; they'd look at you, and you'd point 'em out to the kids, and you'd tell 'em, meet you down underneath the tunnel somewhere, and . . . do whatever, I guess. I don't have nothing to be ashamed of, you know; it was life. It was just the way it was, it was fast. Girls wanted to have fun, you know, we wanted to have fun at the ballpark when you're playing—between innings.

VINNY GRECO

That was the norm then. You know, it's not the norm now. But that's what guys did.

JOHN STRAUSBAUGH

There was an awful lot of that that went on then, and that was accepted. They're not supposed to be men, they're supposed to be boys, and boys will be boys. And I think people allowed them all sorts of leeway with that kind of attitude.

JEFF PEARLMAN

In general, women were quote, unquote "pieces of ass." They were bragging rights.

JOHN STRAUSBAUGH

There was no such thing as "Me Too" in the '80s. It was part of the hedonism of the '80s, part of the so-called sexual revolution that started in the '70s but was very much out there in the '80s.

BOBBY OJEDA

The '80s were a wild time. Society as a whole played it pretty loose, you know? There's an accepted behavior that transcends whatever you do for a living, and that changes over the years, as it should, and we start to look back and, "Man, that really wasn't cool." We evolve and kind of get it, that that was kind of horseshit.

JEFF PEARLMAN

The stuff they were doing then does not work now. No way.

DARRYL STRAWBERRY

Just the way the '80s were, you know? It was a

different time. It's women, it's drinking, and staying out. I think we all knew we had problems, but we were performing. But you don't realize that it's gonna catch up to you. I don't think anyone realizes that.

JEFF PEARLMAN

The drug, obviously, was cocaine. Not just in New York. Cocaine was a huge Major League Baseball problem. Gooden and Strawberry are the two most famous, or notorious, Met users, but they weren't the only ones.

WALLY BACKMAN

You know, cocaine was a party drug, and it happened, you know? You know, I'll admit, I did it. It was an everyday part of life when people went out. It was something that people did at that time, you know?

JEFF PEARLMAN

Access is easier in New York, and people love celebrity. If you were famous and you were a Met, you got it cheap and you got it plentifully. So, if you have an addictive personality and you're a celebrity, I don't think New York, especially in the '80s, was the best place to be.

GREG PRINCE

Doc's game kinda took a step down. He's still the ace of the staff, but he's not having a 1985 season. And we didn't know exactly why. We'd

gotten used to the idea of the Mets being completely indomitable. How is it that Doc isn't completely indomitable?

By mid-June Dwight Gooden's record was 8–3, and his ERA had risen to 2.58.

ROGER ANGELL

I think he lost the fastball a little bit.

JOE McILVAINE

He might've been starting to think a little bit too much.

GREG PRINCE

There was some talk: "Oh, he's conserving pitches."

JEFF PEARLMAN

The thing that I think was overlooked in hindsight was he was a drug addict. You know? He was a new drug addict, but he was a drug addict.

DWIGHT GOODEN

I remember that off-season before '86, I was honestly mentally drained. I'm twenty-one, dealing with the media in New York City of all places; a lot of expectations for myself: physically, mentally, everything. I was drained. Now the off-season you come back to Tampa, getting away from all the expectations, getting away from everything, so you have all this free time. I think that's when my

drinking increased, and obviously the drugs came in.

One day, hanging out with the guys I grew up with, my friends, I was partying all night, everybody's doing drugs. Unfortunately, I tried it, and when I tried it, at first hit I thought, "Oh wow, this is what I want to feel all the time." I became addicted at that moment. "Wow, this is the best thing I've ever felt." Unfortunately, that's where it started.

VINNY GRECO

Doc couldn't say no to anyone. Interviews, signings, people borrowing money, he couldn't say no. But that's who he was. One day he just gave me his car—not as a tip, 'cause I liked it—and he said, you know, "Hey." He gave me the keys and said, "Take it." Just gave it to you. He said, "Hey, just take it." You know, but that was Dwight.

JEFF PEARLMAN

"Man, everyone loves you. You're the biggest thing here, everyone loves you. Oh, you got to come to my party, you got to come so-and-so, here. Have coke, here, have this, have that." It was people forgetting that they were twenty-something-year-old guys.

DWIGHT GOODEN

Because of the success I had in '84 and '85, anything under that is unacceptable.

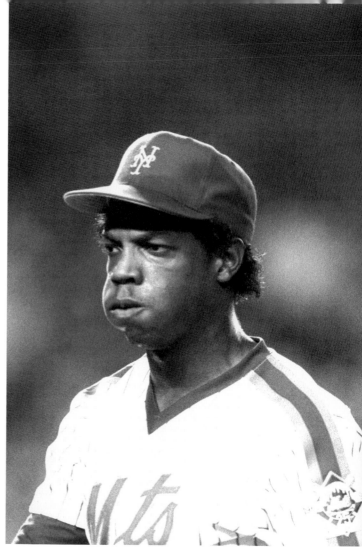

HOWARD BRYANT

There are outs, and then there are strikeouts. Dr. K. Right? You come to see Dr. K strike out people, you don't come to see Dwight Gooden throw twelve ground-ball outs.

DWIGHT GOODEN

Nothing against nobody, it was expectations I put on myself. In my mind, every time I pitched, it was like, it was a good game, but it wasn't '85. Good game, but it wasn't. . . . And I didn't really know how to deal with

that. So to find that release, unfortunately, as sad as it may sound, was to self-medicate. Drugs.

JEFF PEARLMAN

Cocaine was just a big, big drug at that time. And it made you feel indestructible. That's the thing. It makes you feel empowered.

DWIGHT GOODEN

In 1986, during the season, I never pitched high. I never got high before a game, anything like that. Not to say it wasn't a problem, because the problem was right there, and it was just a matter of time before it took over. When you're pitching, you have more time. You pitch every fifth day, so the day that I would pitch, I was drinking no matter what that night, because either I'm celebrating, or I can't sleep because I pitched bad, and I want to drink it out of my system. 'Cause I always felt like I had to keep dominating because of the expectations that others had of me, and the expectations that I had of myself as well.

The more and more I got into the season, I still wasn't matching '85. It became the night I pitch, that night, then it became the next day and then the next day. I took it three days before, then it became two days before, and so it started to get worse and worse and worse.

VINNY GRECO

With Dwight, you knew. The way he would show up to the stadium: He was lackluster, he didn't sleep, you knew he was partying. You just knew it.

JOE McILVAINE

I did not hear any rumors. Nothing.

JAY HORWITZ

Are there things I'm not telling you? Well, listen . . . Frank was not happy with some of the stuff that went on.

GREG PRINCE

Whatever whispers were going on behind the scenes, Mets fans kind of looked at it and said, "Well, if he was anybody else, we wouldn't be the least bit critical, because this is still a really good season in progress." He won most of the starts he made, and the bottom line was, the Mets were in first place by a lot.

DWIGHT GOODEN

I think probably half the team knew, they just didn't know how bad I was on it. And I had some guys come to me, and say, "Doc, you know, this is what we're hearing," and obviously I was embarrassed and I denied it, but that was right on. That was when it really took over. The shame, guilt, now you're trying to self-medicate . . . and then through

good times, bad times, it didn't matter. Tuesday, Saturday, it didn't matter. It had me. I was gone.

ED LYNCH

I'll never forget June 30, 1986. The phone rang in my room and I go, "Hello?" and it was my father-in-law. He goes, "Ed, you might want to check today's *New York Times*." I open the sports page and I see "Lynch Trade Expected Today," and right then the phone rang. I was absolutely in shock. I was there five and a half years. I had some very close friends on that team. It's like living with a family all year and getting the boot on Christmas Eve.

Later, one night when I was in Chicago, I went out with my wife to eat dinner, nice restaurant. They had some TVs on, and I think the Mets were playing Monday night baseball. And they're just dominating the division, and I'm not ashamed to say I sat there with my wife and I cried. It was really hard to handle. We didn't have cell phones back then or anything, so I didn't really hear from my teammates. Then one night I was in my apartment and the phone rang, and it was all the guys in the clubhouse—Ray Knight and all the players. They said, "Ed, we're sorry we couldn't find you. It's hard to get your number, but we just wanted to tell you how much we miss you and how much we appreciate you," and that meant a lot to me. But hey, you know what? That's the business, the business of baseball, and you know, players get traded all the time; and who were you not to get traded? It's not like the Tom Seaver trade, it's not like the Midnight Massacre. You know, I was the eleventh pitcher on a ten-man staff.

GREG PRINCE

Shea Stadium was loud, even if there was nobody there, because Shea Stadium is next to an airport. But it was at full-throated shout by 1986.

DARRYL STRAWBERRY

Oh, I loved playing at Shea Stadium. Shea Stadium home cooking was the best cooking. There was not a day that year where we didn't look forward to coming to the ballpark.

JOE PETRUCCIO

Nobody liked that the Mets were winning. It disturbed all the baseball lore. The Mets aren't supposed to win. You know, they're good, as long as they lose and stay in their little place, but that year, they weren't good. They were *bad good*.

HOWARD BRYANT

When you go to New York, the expectation is not just victory, but victory with style, because that's the standard. You come here, and you do it on the biggest stage in the biggest way.

DARRYL STRAWBERRY

We was a showtime team. And I think what they hated more than anything, they hated the curtain calls.

KEITH HERNANDEZ

You had to stand up and do the bows after a home run, to the crowd at Shea.

DARRYL STRAWBERRY

The crowd wouldn't stop until the player had come out to take the curtain call.

KEITH HERNANDEZ

They didn't like that . . . and I don't blame 'em. I never liked doing that. Carter loved it.

SANDY CARTER

I've heard Gary is the first to take curtain calls. I don't know if that's true or not. But a lot of it was because they wouldn't stop cheering. And it was just Gary. That was just his personality. He loved it.

DAVEY JOHNSON

He didn't mind smiling to all the cameras, and there were a lot of 'em. He loved the stage. Some guys don't relish that.

JOE PETRUCCIO

No one loved the Mets. Except Mets fans. People do not like winners. Especially when you're winning at their expense.

DARRYL STRAWBERRY

Every time you looked around, everybody wanted to fight. Throw in on us, you hit one of us, you know, whatever, you talk crazy to us, boom, boom. It's on. We had a vicious team. We were that group of guys. We swung a big bat, but we also swung these too [gestures with fist], you know?

JEFF PEARLMAN

They were hated. They were cocky. They wouldn't respect you. They knew they were gonna beat you; they would tell you they were gonna beat you.

WALLY BACKMAN

The funniest part about it was we would go into those cities and we would talk trash about the city or the team.

JEFF PEARLMAN

It was quote after quote from opposing managers, just slamming the lack of class, the lack of dignity, the lack of grace, the lack of decorum. But the Mets didn't care.

SID FERNANDEZ

I remember there was a shirt they made up:

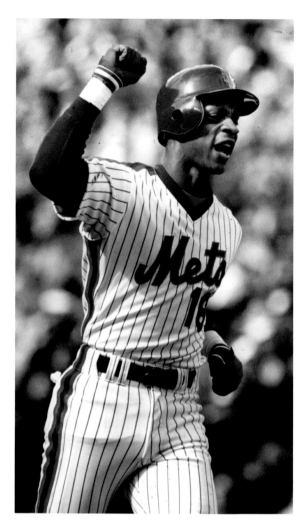

"The Mets Are Pond Scum." And it had a kid peeing in the pond.

DAVEY JOHNSON

Pond scum? I mean, I thought it was hilarious.

BILLY BEANE

There was no insecurities on that team. Particularly as a group. It's not that every individual was like, say, Lenny, who had the ultimate in self-confidence.

LENNY DYKSTRA

Fuck you! Shut the fuck up! See, and remember, I was voted the most hated player in the league five years in a row.

BOBBY OJEDA

A lot of times, the other clubs would be frustrated with some of our antics. But we saw nothing wrong with it. We're like, "I don't care if you don't like it. I'm not doing it for you to like it, I'm doing it for these guys in the dugout who are loving it."

HOWARD BRYANT

When I remember the '86 Mets as a team, even if you hated them when they were playing, there's a piece of you that sort of misses them when they're gone.

LENNY DYKSTRA

No one wanted to come to Shea by the end of that year. Nobody.

DARRYL STRAWBERRY

Hey, we played in New York, man; you know, it, it's the way life is. You know, if you don't like it, do something about it, you know?

MIKE "CHOPS" LACONTE

A lot of times they'd send me down to the visiting clubhouse to get the lineup card from the other manager. We were playing the Astros and [their manager] Hal Lanier's in there. He starts writing out the lineup for me on a card, and he goes, "Gehrig, Ruth, Mantle," because that's what it took to beat us.

JOE PETRUCCIO

They knew they were good. They knew they were unbeatable. They knew if they needed a home run from Strawberry, you could see by the way he walked to the plate, he knew he was gonna come through. They never gave up on themselves. And that gave them that swagger.

GREG PRINCE

I think we as Mets fans fed off it, I think the city fed off it. We deserve this. We've put up with enough, we have the best players. Why shouldn't it be this big?

It didn't matter to us who was on the field playing against us. It was about who we were. We had to take our foot, and we had to put it on that pedal . . . and we had to push down.

BOBBY OJEDA

Our check-engine light was on. We're going at warp speed, and no one's thinking about slowing down. 'Cause we knew we couldn't. We were making things happen. Like, yeah, these lights are on, but never mind. Just floor it, man. You're like, deal with it later. Because it's gonna blow up. This is not gonna last.

So if we don't capture it now, if we don't get the checkered flag, it's over. It's not gonna happen. And that was the mentality. Not the healthiest mentality, you know, but that worked for us.

SID FERNANDEZ

Making the All-Star team meant a lot to me. The managers picked the pitchers. So that means Whitey Herzog respected what you did.

BOBBY OJEDA

Whitey, who was straight-cut, no-nonsense, military-ish, didn't pick me for the All-Star Game. If memory serves me, at the halfway mark, I was 10–2 with a 2.00 ERA. 10–2 with a 2.00 ain't good enough for Whitey. I guarantee it was personal. I don't think he liked my style. But it didn't happen. . . . All-Star Game is a stupid game, anyway.

HOWARD BRYANT

Boston in 1986 was ready to dominate everything in the world of sports. You had a city of champions. Patriots went to the Super Bowl. The Celtics won the NBA Championship. And all during that summer, everybody's energy in Boston was on the upswing.

DWIGHT GOODEN

I remember when Len Bias died.

HOWARD BRYANT

What do you mean, he's dead? He just got drafted two days ago. It was devastating as a die-hard Celtics fan, but it was really devastating as a teenager. I'm still afraid of drugs to this day because of Len Bias. Won't go near 'em. Because of that.

DWIGHT GOODEN

You see that, and for the first four, five hours, it sticks to you, like, wow, that could've been me. But then, the sickest part about it, you'd go to the dealer and say, "Hey, give me that Len Bias stuff." I mean, that's sick, but that's where I was at that time.

Meaning, basically what you're saying is, in street terms, I want the strongest stuff you have. That's how crazy my brain was at that time. You know? "Give me that Len Bias stuff."

Fifth Inning

OUT OF LEFT FIELD

On July 20, the Mets were in Houston. They had a night game on the schedule at the Astrodome.

FRANK CASHEN

I went down to Kingsport, Tennessee, to see my rookie club team. And I got in the bus and rode over the goddamn mountains and went to that game. And that night, we stayed in this motel, and I hope I don't remember the name of it, because I've got all bad thoughts about it. I remember laying in bed and looking at a white wall; there were all dead bugs where people had killed them. But anyhow, in the middle of the night, you know, four o'clock in the morning, I got a call from Joe McIlvaine, and he said, "Frank, we got some problems."

JOE McILVAINE

I was in Houston traveling with the team. And I get a call in the middle of the night from Bobby Ojeda.

BOBBY OJEDA

They said, "You get one phone call," and everybody points at me, like, "You go do it." So, I'm like, "I'll go do it." So, I go down. "Joe? You're never going to believe this."

JOE McILVAINE

I said, "What's the matter?" "There's four of us in jail." "Oh crap."

BOBBY OJEDA

Then I get elected to go talk to Joe Mac in person. Cops take me downstairs, and it's a door, and they slide the little thing open, right? The little slot, like, you know, a secret club. And I'm like *whoosh!* and there's Joe right in front of me, and I go, "Joe, we didn't do nothing."

JAY HORWITZ

You know, I didn't say, "Oh my God, how did this happen?" With the personalities we had on our team, it was just another day in the life of the '86 Mets, you know? What else can you say?

JEFF PEARLMAN

Tim Teufel was a nice guy. He was basically white bread in a baseball player. It makes no sense that he's involved in this story, but he's there. They go to Cooter's in Houston, they start drinking . . . and they drink and they drink more and they get drunk. It's two in the morning, and the waitress says, "Last call," and one of the Mets says, "We're the New York fucking Mets. We'll leave when we want to leave." Then you have this brawl with these Mets, and the cops are called.

BOBBY OJEDA

I'll give you the true story. I swear, I was there. We're in the locker room and the pitchers are getting ready to go out, 'cause that's what we do, and Tim Teufel says, "I want to go out with you guys," and all the other guys in the locker room are like, "Tim, don't go with them. You don't know." But he was celebrating the birth of one of his children. So we go to this club, and he's *that* guy. He has three beers and he's climbing the rafters. It's probably 11:30, and I'm like, "Oh my God," he's climbing in the DJ booth. I'll never forget it. So, I get him. "Come on, Tim, let's go." "I don't want to go." So I said, "Come on." Take him outside and there's two security guys there. They're the cops, and he said something, they said something. Whatever. Open the door to the cab, here they come, the two security guys. "What'd you say?" So I say, "I didn't say anything." They're dragging us both back, and they're, "You're under arrest," to him.

4 Mets Arrested In Fight

By MICHAEL MARTINEZ
Special to The New York Times

HOUSTON, July 19 — Four Met players were arrested today after an early morning altercation with two Houston policemen at a local bar, but the attorney hired by the players said they felt they were "unduly assaulted." The attorney said one, Tim Teufel, contended he was "severely beaten" in the incident.

The four players, who were arrested at 2 A.M., spent 11 hours in a holding cell before they posted bail and were released this afternoon.

Teufel, a second baseman, and Ron Darling, who had been the Mets' starting and losing pitcher Friday night against the Houston Astros, were charged with aggravated assault on a police officer, a third-degree felony. They posted bond of $2,000 each and are scheduled to be arraigned Sunday morning.

Bob Ojeda and Rick Aguilera, both pitchers, who were with Teufel and Darling at the bar, were charged with hindering an arrest, a misdemeanor. Each posted bond of $800. They are to be arraigned next Friday.

All four, who were fined by Manager Dave Johnson for breaking a team curfew, were in uniform for tonight's game against the Astros. On the advice of their attorney, Dick DeGuerin of Houston, they refused to comment on the case. None of their

Continued on Page 5, Column 1

Just then Rick Aguilera opens the door because he had heard something was going on. He comes out, cop gets him, says, "Get back inside or you're going, too," no nonsense. By now there's more cops, it's getting kind of ugly. So he goes back in, we're still doing the thing with Teuf, now they're cuffing him, and oh shit, now Ron Darling opens the door. He didn't do anything. Didn't do a thing. He opened the door to leave. The cop goes, "I told you to get back inside. You're under arrest." They thought he was Aggie, so they cuff him, throw us in the car. I asked the guy, could he move the seat up. He didn't really think that was that funny, but I did. So they haul us to the tank.

JOE McILVAINE

We had to go get a posse together and get down there and get them out. I remember speaking with them through the bars. I never saw them so "ugh, jeez."

I remember speaking mostly with Ojeda 'cause he seemed to be the spokesman for them and he said they got themselves in a little bit of trouble. They said they were framed.

BOBBY OJEDA

We didn't do anything. And Joe looked at me like your father. You do something stupid and your father wants to kick your ass; he just

shakes his head and puts his head down. Just like, "You idiot." [Laughs] I love Joe.

JOE McILVAINE

We had to finagle our way to get these guys out of jail because we needed them to play, so we had to get some money for bail.

JAY HORWITZ

I forgot what the bail money was, but we didn't carry around like $20,000 dollars spare cash at that time to get the boys out of jail. That wasn't part of the things we had to carry around, so we had to get the money from the Astros to get all the players bailed out of jail.

BOBBY OJEDA

They bail us out, and we came back to the locker room the next day and they taped bars on all our lockers and put out a bar of soap and a razor. So, it was like we were heroes. We were heroes to our boys. I think the front office felt differently. They're like, "We finally lost this group. We knew it was going to happen." Not us.

JOE McILVAINE

I think they thought they were invincible.

BOBBY OJEDA

It was just like another log on the fire. You know, let's go; this was that year. You know,

the check-engine light . . . Another light came on. Doesn't mean we're stopping.

JOE McILVAINE

Nobody was gonna beat them. In their minds they were unbeatable.

BOBBY OJEDA

It just added to the flavor of the season. It really upped the ante. We weren't like, "Oh boy." No. It was like, "Yeah. Let's do that again. That was fun."

In Houston, the Mets lost three of four games, and with the distraction brought on by the Cooter's brawl, it was hard to blame Mets fans for worrying that the team's golden season was about to fall apart. Instead, they flew to Cincinnati for a three-game series, and on July 22, 1986, they played one of their most memorable games of the year. Down 3–1 with two outs and nobody on in the ninth inning, the Mets rallied, and when Cincinnati's right fielder Dave Parker dropped a fly ball off the bat of Keith Hernandez, the tying run scored. The game went into extra innings, and the stage was set for one of the most memorable fights in baseball history.

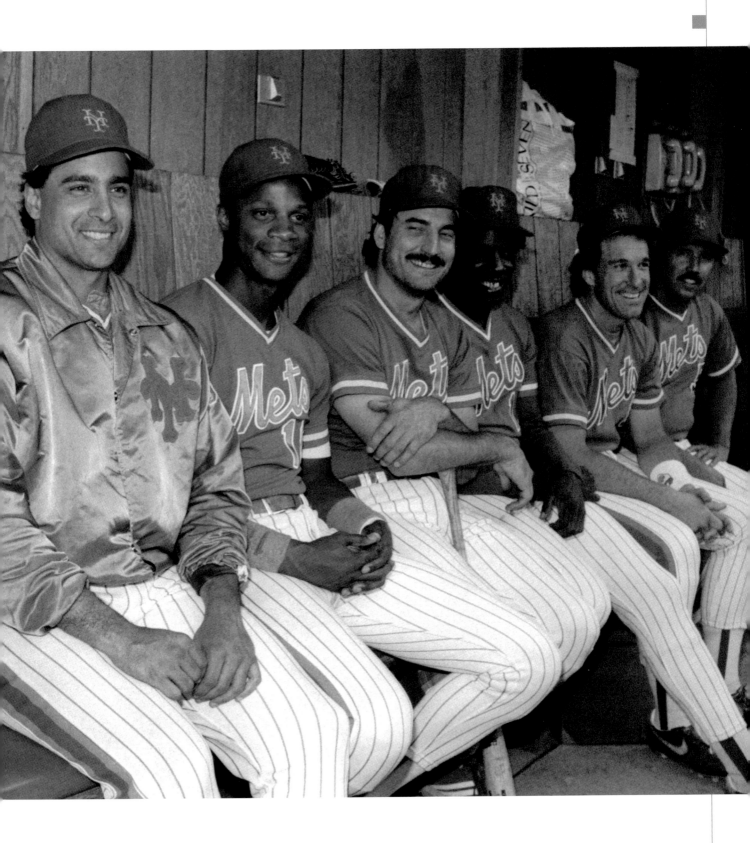

SID FERNANDEZ

The one with the Reds when Ray Knight punched Eric Davis, yeah, that was a fight.

With the game still tied in the tenth inning, Cincinnati's Eric Davis stole second. On the very next pitch, he took off for third.

JOE McILVAINE

Eric Davis came in spikes high to third base. And I don't think that Eric Davis knew that Ray Knight had been a fighter in his previous life.

DWIGHT GOODEN

Ray was a tough guy. He was a Golden Glove boxer.

KEVIN MITCHELL

You know, Ray, he ain't going to back down for nobody. Nobody. You could be Don Johnson, I don't care. Ray ain't backing down.

DARRYL STRAWBERRY

Eric steals second, he steals third; he's safe at third and he kinda leans up on Ray.

KEVIN MITCHELL

Some words was said.

RAY KNIGHT

I certainly didn't push him, but he said, "Don't push me, motherfucker." It hit me wrong.

MOOKIE WILSON

Next thing I know, Ray was doing a one-two punch. Pop, pow!

KEVIN MITCHELL

Ray kind of gave him a two-piece. Gave Eric a two-piece. Spit his gum out.

RAY KNIGHT

I just exploded on him. That simple.

BOBBY OJEDA

Ray's not gonna ask questions. "I'm just gonna hit you in the face." It was not like a shove; it's like a boom.

JEFF PEARLMAN

Pop!

MOOKIE WILSON

Pow!

JEFF PEARLMAN

And Eric Davis's head goes boom. Mike Tyson wound up asking to meet Ray Knight because he loved that punch so much. It is the best punch ever thrown in a ball game by a baseball player.

JOE McILVAINE

Eric, I think to this day if you ask him: "I slid into the wrong guy."

IT WAS ONE OF THE BEST FIGHTS YOU'VE EVER SEEN IN BASEBALL.

JEFF PEARLMAN

RAY KNIGHT

They say that the guy that hits first is the chicken; well, then, you know, I'm a chicken.

BOBBY OJEDA

Hits him right in the face.

RAY KNIGHT

I'm not waiting. If there's gonna be a fight, let's just go ahead and get it rolling.

DWIGHT GOODEN

Benches cleared. We got into it.

KEVIN MITCHELL

All of a sudden [pitcher] Tom Browning and them grabbed me by the neck. Him and [John] Denny. Of course, I got in and started fighting.

JEFF PEARLMAN

The Reds had a pitcher named John Denny at the time, and John Denny studied martial arts.

KEVIN MITCHELL

Denny was some kind of karate dude. He was trying to sweep my legs from under me. That wasn't working. But he and Mario Soto . . . I end up putting knots on their heads.

KEITH HERNANDEZ

It took a while for that to get pulled apart, that fight; and when it was finally pulled apart, big Dave Parker—Parker's huge—

KEVIN MITCHELL

Dave Parker was snatching 'em off like gummy bears.

KEITH HERNANDEZ

Parker's six foot six; he's around 240 . . . and he's a monster. Parker said something to Ray . . . Ray said, "Why don't you just shut up and come on over here."

RAY KNIGHT

I wasn't afraid to fight, even if I lost. I don't care how big they are or how strong they are—that doesn't even come into play.

KEVIN MITCHELL

You know, Ray's always been a fire plug. You get those cheeks going . . . it's over with. He's ready to take somebody's head off.

RAY KNIGHT

I never thought I was a badass. I just wasn't afraid of those people that did think that they were.

KEITH HERNANDEZ

Then Parker said, "Are you that tough?" Ray said, "Why don't you come over and find out?" And Parker said, "All right." And that was it. It was over.

ERIK SHERMAN

That game with the Reds exemplified the craziness and the magic, all in one, of that '86 season.

BOBBY OJEDA

Everything's back to normal. We're back to fighting. . . . We got our arrest records over here, we're all good. The band plays on.

GREG PRINCE

The way things worked, there were more ejections of Mets than Reds. Not only is Ray Knight ejected, but Kevin Mitchell is ejected, Darryl Strawberry is ejected. It's extra innings. You've already used your bench.

DAVEY JOHNSON

I remember I had to put my other catcher in and put Carter at third.

ERIK SHERMAN

Players were just all over the place.

DAVEY JOHNSON

I was already down some outfielders.

GREG PRINCE

He only has so many outfielders; but he's got a couple guys in the bullpen.

DAVEY JOHNSON

Remember I had Orosco and McDowell.

GREG PRINCE

And now Davey Johnson has to get creative.

DAVEY JOHNSON

I knew the rule book backwards and forwards. You have to know that as a manager.

With his third baseman Knight ejected and his backup third baseman Howard Johnson playing shortstop (having pinch-hit for Rafael Santana in the ninth inning), Davey Johnson now moved Gary Carter to third base, a position he had never played before in the majors. With Mitchell and Strawberry also out of the game, he needed a right fielder, so he moved pitcher Jesse Orosco from the mound to right field and brought in Roger McDowell to pitch. Reds manager Pete Rose played the game under protest.

JAY HORWITZ

We were running out of bodies, so when a lefty batter came up, Orosco would come in and McDowell would go to the outfield. When a righty batter came in, McDowell would pitch, and Jesse would go to the outfield.

DAVEY JOHNSON

And I would swap them back and forth.

GREG PRINCE

And somehow it works. The outfield does not give up any runs. And as far as Gary Carter at third base, it led to the most beautiful thing I ever saw on a baseball field.

In the twelfth inning, with the game still tied, the Reds threatened again. With no one out, two men on base, and Reds pitcher Carl Willis up, the situation called for a sacrifice, and Keith Hernandez was ready.

GREG PRINCE

Keith Hernandez charges in from first to the point where he's practically in the batter's face.

KEITH HERNANDEZ

It was a first-and-second clear bunt situation, so I just really put the pressure on.

JAY HORWITZ

He came in, got a ball right by the catcher, threw to third base—

ROGER ANGELL

He fielded the bunt so quickly that he was on the third-base side of the invisible line between the pitcher and the catcher. A play which very few first basemen would likely make or ever did make. Amazing, amazing player.

GREG PRINCE

Gary Carter, who has never played there before, gets the out, and throws it back across the diamond where Tim Teufel is covering.

JAY HORWITZ

Probably one of the best double plays I've ever seen.

GREG PRINCE

And it's just your routine double play, except the first baseman is six inches from home and the third baseman is an All-Star catcher. Almost as an afterthought, Howard Johnson comes up the fourteenth inning and hits a three-run homer.

DAVEY JOHNSON

And we won the game.

GREG PRINCE

If you had any doubts about the Mets after Houston, they were erased. That they got through all of this and they would go on to sweep that series, and that Houston thing just seemed like an aberration. The Mets were back to being unbeatable.

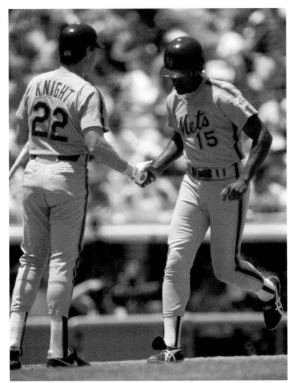

Goodbye, George

DARRYL STRAWBERRY

So, the fighting part of us was, a great spirit of our team, because we loved it.

RAY KNIGHT

There was just so many guys that were just not gonna be denied. The boxing mentality. You got to go in there thinking you can't lose. It ended up causing the fights.

DARRYL STRAWBERRY

We had a group of guys that loved to fight—but George Foster; George wasn't a fighter.

RAY KNIGHT

George Foster was very docile.

KEVIN MITCHELL

Here we go: George Foster.

JEFF PEARLMAN

It's kind of a weird moment from that fight. George Foster, veteran, former Red, fading Met, sat on the bench. Didn't come out.

JOE McILVAINE

George Foster wouldn't leave the dugout.

WALLY BACKMAN

He didn't come off the bench.

KEVIN MITCHELL

I could see him right there when I'm fighting three guys, and all he's gotta do is jump over the little railing.

BOBBY OJEDA

"Uh, we're over here if you want to come over. Come on over, we're having fun." But he goes, "Nah, I'm cool over here."

JOE McILVAINE

There are codes in baseball that you adhere to. If there's a fight and your team is involved, everybody gets up off the bench

and gets out there. You don't have to do anything. You can talk and everything else, but you are on the field. You are part of that team. That's one of the codes. He didn't adhere to it.

WALLY BACKMAN

You know, it's not like a normal thing when twenty-four guys go against one guy. This is the only time that I've ever seen it.

KEVIN MITCHELL

I just didn't understand why he didn't get off the bench.

RAY KNIGHT

Wally was particularly ticked off George did not go out there.

WALLY BACKMAN

It was a bad situation.

RAY KNIGHT

Wally started this kind of campaign, this expression in the clubhouse. He just kept saying that George was a pussy.

WALLY BACKMAN

It didn't sit well with anybody.

JOE McILVAINE

I think that his teammates looked completely differently at him after that.

KEVIN MITCHELL

They lost a lot of respect for George when that happened.

JEFF PEARLMAN

And it really became a snapshot for everything people found frustrating about Foster. He was kind of in it for himself. He didn't really care.

MOOKIE WILSON

Didn't look good for George at the time, but if you know George, you could understand. George is not a fighter.

DARRYL STRAWBERRY

George was a really quiet Christian man.

RAY KNIGHT

George certainly was not scared; it was just his beliefs that, you know, you shouldn't be fighting.

BOBBY OJEDA

He actually didn't want to fit in, and he didn't—by his own hand.

JEFF PEARLMAN

That really was the beginning of the end for George Foster as a Met.

HOWARD BRYANT

When you are the New York Mets in 1986,

you see the future—and it's a big future. George Foster wasn't part of that future.

GREG PRINCE

By 1986, George Foster as a player had really stopped hitting for the most part as summer came.

DAVEY JOHNSON

His bat had slowed down; defense slowed down.

DARRYL STRAWBERRY

He wasn't producing.

GREG PRINCE

Davey Johnson had better options.

DARRYL STRAWBERRY

He had Mookie and Dykstra, and you could play Mookie in left and Dykstra in center. And you also had Kevin Mitchell.

GREG PRINCE

And you had George Foster, who was kind of a legacy at that point.

HOWARD BRYANT

George Foster in 1986 is not George Foster of 1976.

GREG PRINCE

A fifteen-year veteran and former MVP, he was the first great acquisition of the Frank Cashen era, a very important player in terms of what he represented, but the parade had moved on.

HOWARD BRYANT

He's hitting .237. He's not the guy anymore, and George Foster's vulnerable. You got all these young guys coming up. It's time for a new generation.

GREG PRINCE

As we get to August, it is communicated Foster will be on the bench.

DAVEY JOHNSON

And it's the toughest thing in the world, to curtail a guy's playing time.

HOWARD BRYANT

When you're a professional athlete, you're not used to having to confront your own mortality. You would much rather have to decide for yourself than have it be decided for you.

JEFF PEARLMAN

Foster was frustrated, and he was frustrated by limited playing time and perceived lack of respect.

DAVEY JOHNSON

George Foster no longer accepted his role, and he voiced his displeasure. He was hurting the chemistry.

GREG PRINCE

And he doesn't take it quietly.

HOWARD BRYANT

And when you're George Foster in 1986 and you are disgruntled and you're not playing well (and you're vulnerable and the team sees a bright future without you), you don't stand much of a chance.

GREG PRINCE

So George Foster was about to be an ex-Met.

DAVEY JOHNSON

He took it personally, and I understood that because it was more his pride.

GREG PRINCE

He says, in so many words, "This was a racial decision."

GEORGE FOSTER, 1986

I'm not saying it was a racial thing. But that seems to be the case in sports these days. When a ball club can, they replace a George Foster or a Mookie Wilson with a more popular white player. I think the Mets would rather promote a Gary Carter or a Keith Hernandez to the fans so parents who want can point to them as role models for their children, rather than a Darryl Strawberry or a Dwight Gooden or a George Foster.

DAVEY JOHNSON

I had no choice.

WALLY BACKMAN

Yeah, I remember. You know, you try to forget certain things. You know, the Mets were not even close to some of the things George said.

JOE MCILVAINE

I have nothing to say to that. That's so untrue.

KEVIN MITCHELL

I didn't see that. How can they be racist? You got Doc Gooden and Darryl Strawberry on the team.

DAVEY JOHNSON

It mostly was Mookie I was playing in left field, so it wasn't like I was being a racist: I was playing another African American.

HOWARD BRYANT

Just because you bring up Kevin Mitchell doesn't mean it wasn't racial. You replaced one Black guy with another. . . . I mean, that's not a response.

JEFF PEARLMAN

Maybe Foster had a point, but it would be hard to see at least from the surface that they were behaving in a racist way.

MOOKIE WILSON

If you know George, the way he speaks, he

could not be very sensitive in how people are going to receive his words, and most of the time he don't care. He's being genuine.

ANN LIGUORI

Frank Cashen and Joe McIlvaine were not happy.

JOE McILVAINE

All that put together for a guy who wasn't producing was a good way to get yourself sent up the river.

KEITH HERNANDEZ

I don't know what George was thinking, and that's what sealed his fate. That was the straw that broke the camel's back, right there and he was gone.

HOWARD BRYANT

Foster was in the worst possible place that you could be in. If George Foster was saying this in 1977 when he was hitting fifty-two bombs, you'd have to have listened to him. But when you're striking out 120 times and your career is just about over, now you can say it's sour grapes.

JEFF PEARLMAN

Foster was a 1970s player on a 1980s team. He came up with the Reds; there was Rose, and there was Morgan and Perez; there was Griffey and—

DARRYL STRAWBERRY

George came from a different background; old-school players.

JEFF PEARLMAN

And then he comes to this team and they were a bunch of lunatics. They were hard-partying and hard-drinking. He just didn't fit in at all.

LENNY DYKSTRA

Oh no, he was weird.

MOOKIE WILSON

His personality probably did not fit well in that clubhouse.

LENNY DYKSTRA

Very peculiar dude. Like when he'd be in left field, the pitching change would come, and I would go over there . . . He wasn't— There was nothing to talk about. I didn't know what to say to him.

RAY KNIGHT

Good man. Loves the Lord. Cares for people. I just think New York was the worst place George could have gone.

HOWARD BRYANT

We all know that race, class, and gender are the three third rails of this country. By bringing that up, was that a death sentence

for him? It's always been a death sentence for athletes unless you're LeBron James . . . unless you're at the top of your game. George Foster in 1976—he survives this because he's a great player, his talent is going to protect him. George Foster in 1986? Different story.

MOOKIE WILSON

He felt a way that a lot of other African American ballplayers probably felt. That he wasn't being given the fairest of opportunities. People ended up hating George Foster. Why?

HOWARD BRYANT

I don't get upset about it. He felt what he had to say at that time.

MOOKIE WILSON

People always try to avoid any race issues. They always try to avoid the whole conversation. I think today's environment allows you to be a little more vocal about it, but during that period of time, people didn't want to hear it.

During the 1980s, as in the decades before and since, New York City was marked by class and racial divisions, which would periodically flare into view. Two incidents in the fall and winter of 1984 had brought these divisions into the public eye: the shooting of Eleanor Bumpurs—an elderly disabled Black woman killed by an NYPD officer during a city-

ordered eviction from her public housing apartment in the Bronx—and the Bernie Goetz subway shooting, in which Goetz, a white man, shot and wounded four Black teenagers on a subway train, claiming he was the victim of an attempted mugging.

HOWARD BRYANT

Look at New York in the '80s. Look at Bernie Goetz and Eleanor Bumpurs, and all those different things that were happening in New York.

JOHN STRAUSBAUGH

There was a lot being swept under the rug.

MOOKIE WILSON

It was almost as if, "Okay, as long as we ignore it, we don't have to worry about fixing it."

KURT ANDERSEN

There was, on the part of white New Yorkers, an obliviousness to Black people and their oppression.

JOHN STRAUSBAUGH

I don't think race relations were ever worse in New York City than at that time, and I mean even in the nineteenth century.

MOOKIE WILSON

There have always been people that have not been afraid to mention it, and it hasn't ended well with a lot of them.

HOWARD BRYANT

My question has always been: Why is mentioning race always a death sentence? That tells you how much power you don't have if you're African American, and this piece of you can never be discussed without you risking your entire livelihood.

MOOKIE WILSON

He felt that he had to say it for his own peace of mind; and he did, and it cost him an opportunity to be a part of that team for the rest of the season.

JEFF PEARLMAN

And in the greatest of ironies, the Mets release George Foster and sign a white player to replace him: Lee Mazzilli.

JOE McILVAINE

Lee was out there, and we had a chance to pick him up.

DWIGHT GOODEN

The day the Pirates released him, the Mets signed him and sent him to Triple-A, and George Foster told me, "Once Lee gets some at bats they're gonna release me and call Lee up." That's exactly what happened.

HOWARD BRYANT

George Foster's not associated with New York. Lee Mazzilli *is* New York.

JOE McILVAINE

He's a valuable guy because he's been through the wars before and he was a Met.

MIKE "CHOPS" LACONTE

Mazz really worked out for us. Could fit in, could pinch-hit, could run.

JOE McILVAINE

So we knew we were gonna be using him in a part-time role, but in the case with Lee, he was okay with that. You know, he knew where he was in his career, and it worked.

HOWARD BRYANT

He's got the better optics. Let's put it that way.

The Disappearing Owner

MARK HEALEY

Nelson Doubleday pretty much disappeared. The headline was "Wilpon's Role Will Increase." The foreshadowing of doom. What people did not realize was that during the 1986 season Nelson Doubleday was preparing to sell Doubleday Publishing to BMG Bertelsmann, which was a huge German company, and the price tag was going to be $500 million. The team, which was owned by Doubleday Publishing, was not going to be part of the sale, and with the profits from the sale of Doubleday Publishing, Doubleday was going to purchase the team at $81 million for himself. He had grown weary of the partnership with Fred Wilpon.

Fred Wilpon wanted to be more hands-on with the team. Especially when the team started to become successful, because that helped Fred Wilpon's business. It was quite the golden goose to have a Major League team to take clients to, to show off to. That meant Fred Wilpon was all of a sudden in the clubhouse, a place that Nelson Doubleday would never go. Nelson was like, "I'll sell Doubleday Publishing; I won't include the Mets as part of the sale so that I can take the profits from the sale and buy the Mets for myself."

But Fred Wilpon had a right of first refusal built into his original deal with the New York Mets ownership. Because Doubleday Publishing owned the Mets in name, technically it was changing hands—it was going from Doubleday Publishing to Nelson Doubleday. When it came to business, Fred Wilpon is no joke; the guy's a shark. When it was sold, Fred Wilpon's right of first refusal was triggered; otherwise he would have been done. "All right, sorry, Fred, you're out." He would've said, "Oh, here's a check for your measly, you know, cookie money," but instead Fred was able to say, "Oh wait, hold on a second, here's my forty whatever million; I'm now your partner. Hi, partner."

It was a complete shock to Nelson Doubleday because he didn't think Fred Wilpon had the money. Fred Wilpon's real estate empire had grown. This was all being negotiated during the season, but they were able to announce at the very end of this arduous negotiation, which Nelson Doubleday deemed an ambush, the two men had decided to partner up and purchase the team outright from Doubleday Publishing. From then on it became, you know, the Hatfields and the McCoys. And anybody tells you anything

different, they either work for Wilpon or they're trying to sell you a bridge somewhere.

DARRYL STRAWBERRY

Something happened there and that, that relationship went real sour for a very long time.

MARK HEALEY

Nelson Doubleday was devastated because he did not want to deal with Fred Wilpon anymore. He would come to the games, but that was it. He wasn't really involved at all. What Fred had done ruined it for him.

Swagger and Glory

GREG PRINCE

Come August, the world needed more Mets content and "Let's Go Mets Go" was there for them.

JOE PETRUCCIO

I remember that song. I shouldn't remember that song, but I do remember that song.

JEFF PEARLMAN

In New York, that song was a phenomenon.

GREG PRINCE

That was a five-star production.

JEFF PEARLMAN

The players almost walked out because they weren't getting paid enough to be a part of it.

It was a terrible song, but it really took off and they would play it during the games and people would go crazy.

A video was produced that included cameo appearances from celebrities ranging from Melba Moore and Gene Shalit to Robert Klein and Mayor Ed Koch.

JEFF PEARLMAN

That video was kind of ahead of its time.

GREG PRINCE

It was played on Z100, played on PLJ.

TAMA JANOWITZ

The ballplayers were like rock and roll stars.

RAY KNIGHT, 1986

I never really thought that much about being a rock star, but now that it's happened, you know, what can I say?

GREG PRINCE

Video got played on MTV.

DARRYL STRAWBERRY

We were like rock stars.

JEFF PEARLMAN

It's a weird '80s phenomenon. Everyone from Twisted Sister to Dee Snider was in it. It's basically a soda jingle, but it really, really caught on, you know. It became a profound part of that season.

TAMA JANOWITZ

For that time we had the Mets, and they all made the city the place that you wanted to be on the planet. Because they hit all levels of society. They were our stars.

Sixth Inning
FEAR STRIKES OUT

Despite the huge lead—no team came within ten games of the Mets after July 1—there were undeniable cracks in the armor. Darryl Strawberry slumped badly that August, hitting just .176 overall with three home runs. He was even more putrid at home, going hitless in thirty-three August at bats at Shea Stadium.

HOWARD BRYANT

When I think about Darryl Strawberry, I always think about being the one. You're the number one overall pick. You're the one who's supposed to lift the franchise. You have to succeed. You have to be a champion, and more than likely there's no way you can ever fulfill the expectations, because they're so high.

DARRYL STRAWBERRY

Every player that has ever played this game, somewhere along the line they're gonna struggle. I don't care who you are or how good you are, you're gonna hit that wall.

JOHN STRAUSBAUGH

Fans did not see it that way.

HOWARD BRYANT

When you're supposed to be great, there's the pressure, and then you go to your home stadium and get booed.

DARRYL STRAWBERRY

When you're in the slump, people really don't understand. It's not like you're not trying, it's just a slump, and you can't get out of it.

HOWARD BRYANT

What does that do to the individual? What does that do to the one person? Do you ever get used to your hometowns booing you?

DARRYL STRAWBERRY

I sucked up the booing and the way they acted, but I said, "When I'm at the top of my game and they want me to come out for curtain calls after home runs, I'm not going to come out. I'm going to teach you a lesson about me."

HOWARD BRYANT

How do you remain yourself?

DARRYL STRAWBERRY

I never agreed with them when they were booing, but it didn't bother me because I already knew I was nothing because my father said I was nothing.

BOBBY OJEDA

Boy, he was young and had a lot of issues.

DARRYL STRAWBERRY

No matter what I looked like on the outside, I looked like six foot five whatever, I can run, I can hit, I can throw; I can do all these wonderful things. But on the inside, am I well?

HOWARD BRYANT

The pressure on a guy like Darryl Strawberry is huge. It's too much. What happens when it's too much is you break.

BOBBY OJEDA

The off-the-field stuff took over. Took control of him. He had a lot of bad things go on. He had issues with his wife.

Darryl met his first wife, Lisa Andrews, in 1984 at a Los Angeles Lakers game. They were married in 1985.

DARRYL STRAWBERRY

I was young. I thought I was in love. And you have a relationship with somebody and you

get them pregnant, and so the right thing to do is marry them.

JOHN STRAUSBAUGH

Darryl and Lisa knew that they probably shouldn't be getting married. He had tremendous cold feet about it the day of. He had such cold feet about it that they're in the limo, he and his friends and brothers, driving to church for him to get married, and he tells the driver, "No, just drive around, I can't go in there yet," and they ended up being an hour late to the wedding and had some indication

of where things were heading right then and there.

JEFF PEARLMAN

Why are you getting married if you're just going to be on the road screwing people? They weren't mature, and they had a lot of violence and a lot of arguments in their marriage.

DARRYL STRAWBERRY

We'd just fight about everything. I used to drink, and she was . . . You just fight, you know. It was just not a good thing. It wasn't her fault, it just wasn't a happy marriage.

JOHN STRAUSBAUGH

I think he knew in his heart that he wasn't ready to be a father and a husband and responsible individual.

BOBBY OJEDA

He had issues that I did not have firsthand knowledge of other than seeing him sleeping on the trainer's table twenty minutes before the game. Didn't go out for batting practice. You know, something's going wrong.

DARRYL STRAWBERRY

When I got into that dugout at the end of the day and took that uniform off, I always still believed I was nothing because my father painted that picture in my head.

The Candidate

GREG PRINCE

As the Mets built their enormous lead, Gary Carter had shaped up as the leading MVP candidate.

SANDY CARTER

There was a lot of talk about that, and he was on a tremendous streak.

GREG PRINCE

Gary Carter had never won an MVP before. I think Gary Carter enjoyed winning awards and accolades.

ERIK SHERMAN

Gary was very much aware of his legacy.

SANDY CARTER

Gary did want to win MVP that year. He was on the path to, but he got hurt.

ERIK SHERMAN

And no one was as upset about this injury as Gary Carter.

SANDY CARTER

He wasn't a happy camper, being home and disabled, I can tell you that.

GREG PRINCE

The Mets don't miss a step. While Gary Carter is out, Ed Hearn, the backup rookie catcher, steps up.

ERIK SHERMAN

Ed Hearn hit four home runs in a couple of weeks. Did a great job.

GREG PRINCE

And the Mets are perfectly fine.

SANDY CARTER

Yes, Gary cared about his statistics, but not more than giving his all to the team. But I don't think there's anybody out there who didn't care a little about their statistics, you know?

GREG PRINCE

The Mets did win 108 games. Gary Carter did drive in 105 runs. He had a point in retrospect.

SANDY CARTER

You know what, we'll never know if he would've gotten MVP. But it's okay, because he's in the Hall of Fame.

GREG PRINCE

What kind of came into focus while Gary was away: There are a lot of MVP candidates on this team. So many were having very good years, and together it was unstoppable.

ERIK SHERMAN

The Mets are twenty-something games up in first place.

LENNY DYKSTRA

The big lead was fucking great. It's like money. Whoever says money doesn't make you happy doesn't fucking have any. It was nice, okay? Okay? It was nice, but you still gotta play to stay sharp, you know what I mean? There was a crazy end to a game in San Diego. San Diego, what a place to play, by the way. No rain days, fucking weather is perfect, grass is perfect. We're winning by a run, there's a guy on second, Flannery's at bat . . .

On August 27, in the eleventh inning, with the Mets leading the Padres 6–5 with one out and a runner on second base, Tim Flannery batted against Mets reliever Doug Sisk. Flannery lined a hit up the middle, and Garry Templeton raced around third base, headed for home.

LENNY DYKSTRA

Ball comes flying in, dude, I fucking scoop, I throw a fucking rocket, big collision at the plate. Out! But Flannery's trying to go to third; [catcher John] Gibbons gets up, spins out of nowhere, throws the fucking ball.

The throw beat Flannery to third base, and Howard Johnson applied the tag for a game-ending double play.

LENNY DYKSTRA

Out! Bang! Away you go, over. Fucking *no mas.* It was badass, you know? Another great game, man. It's like, that's right, motherfuckers. It comes fast and it comes furious. We're like fifteen games up; we strutted our shit anyways.

On September 4, the Mets visited Boston to play in a rare charity game.

GREG PRINCE

You looked at the schedule and there was a weird little box in early September that said "Boston." There was no interleague play then, so you did a double take.

ERIK SHERMAN

The Mets actually played an exhibition for the Jimmy Fund up at Fenway Park.

GREG PRINCE

What was unavoidable was the thought that this was a World Series preview. It was a foregone conclusion that the Mets were going to win the division; the Red Sox were in first place, and it was all but a foregone conclusion.

CALVIN SCHIRALDI

I think it was destined that we were gonna play the Mets in the World Series. Playing that charity game in September, that was so cool.

With Flushing, Queens now the focal point of the sports world, visitors flocked from all over to see the rollicking, brawling Mets. On September 7, rising twenty-year-old heavyweight fighter Mike Tyson, native of Brownsville in nearby Brooklyn, paid a visit to Shea.

DARRYL STRAWBERRY

When he came to Shea he was about to be the next heavyweight champion, and I was like, "Dude, you're gonna be the next guy," and he was like, "Oh, I hope so." He was just an innocent kid.

JAY HORWITZ

We got a call from Mike Tyson's people. He wanted to meet Darryl and Doc.

DWIGHT GOODEN

Tyson was amazing. He said to me, "I'm gonna be the next champion of the world." I had heard of Mike Tyson, but I didn't really know who Tyson was. Under my breath I'm saying, "Yeah, right. Whatever." Couple months later, he became champion of the world.

DARRYL STRAWBERRY

Then this picture came together where Tyson's got a boxing glove on like he's going to hit Doc and I'm in the middle, and it's the most popular picture around. Tyson, me, and Gooden.

GREG PRINCE

Three young superstar heavyweight athletes at

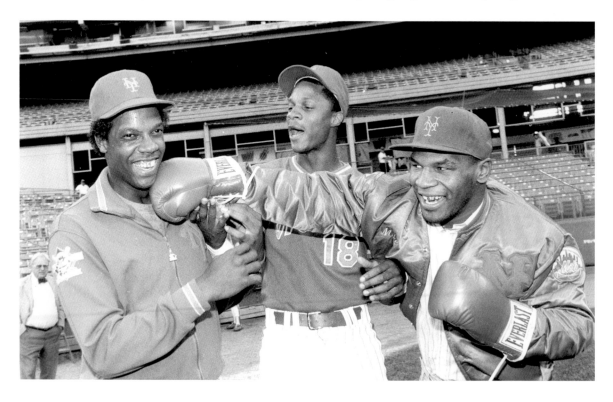

the top of their game. Not going to be stopped. Sky's the limit. It's too perfect.

HOWARD BRYANT

This is what we do to professional athletes. Black athletes especially. When you have ability, people create myths for you. They're creating myths for themselves. But how much do you really know about anybody? We see them in their place of business. You don't know them. You don't know what they're carrying. You don't know what's inside of them. I mean, guys can keep secrets.

GREG PRINCE

Of course, Mike Tyson is a Met in that moment and in that year. I think the only surprise was that he wasn't on the roster.

HOWARD BRYANT

There's always a huge gap between the way we want to see things and how things are. Everything was just under the surface. Eventually it was gonna explode.

)0)0)0

BOBBY OJEDA

I always had a bad elbow. Pitchers have familiar pains that they're okay with. So my pain situation was normal. It's like an ice pick in your elbow. It's like, oh yeah, it's normal pain, so it's good.

JOE McILVAINE

He was one tough nut, and he would never tell you he was hurting.

BOBBY OJEDA

As the season progressed it was getting worse and worse and worse, but I didn't say anything because you can't say anything.

JAY HORWITZ

Bobby wasn't the kind of guy who would say it. He wouldn't let anybody know.

BOBBY OJEDA

I don't care if my arm falls off on the mound, I'm gonna get through this. This is my dream and I'm not going to all of a sudden, "Oh, my arm hurts too much, I'm going to lay down." No. That's not happening.

Ojeda would finish the year with an 18–5 record, and a 2.57 ERA, finishing fourth in the balloting for the Cy Young Award for the best pitcher in the league.

SID FERNANDEZ

Bobby came up clutch the whole year. The whole year.

BOBBY OJEDA

I did. I had a year where everything is just going my way, but I was secretly meeting with the team doctor and with my trainer, Steve

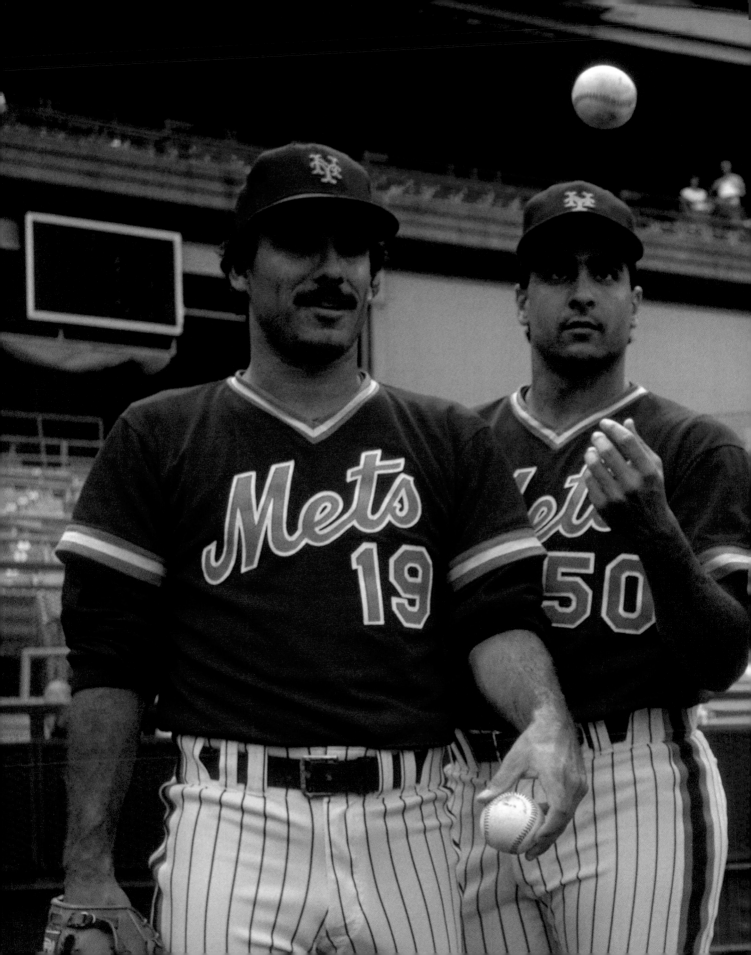

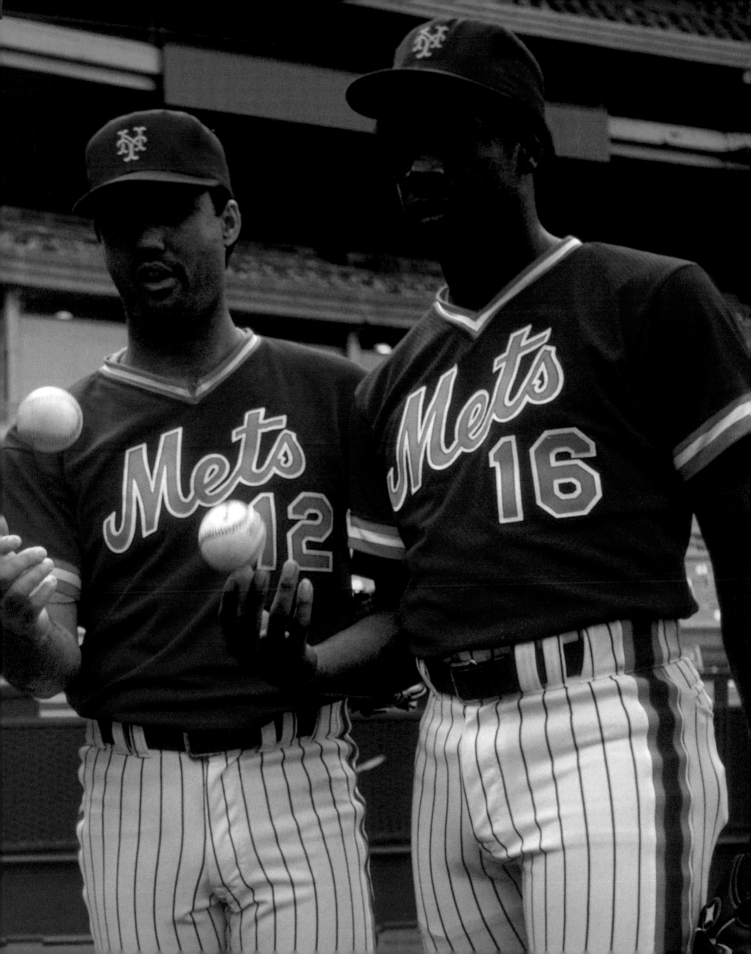

Garland. For me it added to the drama of the whole thing.

With the Mets frolicking their way to a division title, the entire city sometimes seemed to have descended into a kind of mad celebratory realm.

JOHN STRAUSBAUGH

New York in 1986 is a city on edge.

TAMA JANOWITZ

I definitely felt during that time anything could happen.

KURT ANDERSEN

There began to be this sense that anything was possible, for better or for worse.

JOHN STRAUSBAUGH

Crime has gone through the roof.

ANN LIGUORI

You had the Preppy Murder, which gripped New York.

KURT ANDERSEN

I remember that very vividly, the Preppy Murder. . . .

ANN LIGUORI

You had Robert Chambers leaving Dorrian's on the Upper East Side, with eighteen-year-

old Jennifer Levin. She went missing; she was found in the park hours later, dead.

TAMA JANOWITZ

How did this happen? What is going on here?

KURT ANDERSEN

It's in the tabloid quality of the story; it was very much an artifact of that moment, for sure.

TAMA JANOWITZ

Anything could happen to you at any freakin' minute, so if you're brought up nicely, you're just like, this is danger, danger, danger; and if you're brought up to be adventurous, you're just like, this is nuts, this is crazy, this is really fun.

JOHN STRAUSBAUGH

And I think that had something to do with why it was a city that was so in love with the

Mets. The rowdy, raucous, cocaine-huffing, beer-drinking, New York Mets of 1986.

LENNY DYKSTRA

We had fucking fans piss on fucking players out there. Pissing on fucking people in the bullpen. That's a fucking game, man, that's a fucking fan.

JOHN STRAUSBAUGH

I think New Yorkers, part of what they liked about them was that anything could happen at Shea Stadium that night.

)[)[)[

GREG PRINCE

A weekend in the middle of September 1986, the Mets were one win away from clinching the division title that had been in the bag the whole year.

JEFF PEARLMAN

The Mets are rolling along and it's time to clinch, and they go to Philly to play the crappy Phillies.

GREG PRINCE

All they have to do is win one game.

JEFF PEARLMAN

And you think, "This is it."

GREG PRINCE

But the Mets lose Friday night, they lose Saturday night, they lose Sunday afternoon, and nothing is clinched.

JEFF PEARLMAN

And there was maybe half a second of, "What's wrong with the Mets?"

ERIK SHERMAN

You know, they haven't really played serious baseball since April. Could this possibly be a sign of things to come?

GREG PRINCE

They're going back to Shea Stadium. And on September 17, 1986, playing the Cubs, Dwight Gooden on the mound—

DWIGHT GOODEN

I got to pitch that game.

GREG PRINCE

—and Keith Hernandez sidelined with the flu.

KEITH HERNANDEZ

I didn't have the flu. I used to have bad, very bad sinuses. And we were so far ahead, and I had a little fever. It was freezing cold.

GREG PRINCE

Dave Magadan up from Tidewater in spotlight getting a couple hits.

KEITH HERNANDEZ

And Magadan had a big day. He got like three hits and drove in runs. He was a big part of the win.

ED LYNCH

Yeah, I remember the night. It was September 17, 1986.

JEFF PEARLMAN

The saddest part to me is poor Ed Lynch. Ed Lynch had been a Met for a long time, and finally they're good and he gets traded to the Cubs during the season. And he's back at Shea Stadium watching his old team clinch.

ED LYNCH

You know, coming to the ballpark I had a very strong feeling they were going to clinch, so I was getting myself emotionally ready for that, and I really wanted to pitch in that game. I really wanted to be in that game. And I was warming up and I was going to come in that game and it was like first, second, and one out, and things were going badly, and I was ready and I was one hitter away and somebody on the Mets hit into a double play and I sat down. I didn't get in that game.

JEFF PEARLMAN

It was torture for him.

ED LYNCH

I'll never forget when the last out was made.

GREG PRINCE

The Mets carry a lead into the ninth inning. Dwight Gooden is still on the mound.

DWIGHT GOODEN

I wanted to pitch the complete game. I wanted to be the guy on the mound. I thought it would just fit.

ERIK SHERMAN

It wasn't just the fans that were excited about it, but the players as well.

KEITH HERNANDEZ

I went to Davey and said, "Let me go in. Let me play the last inning."

ERIK SHERMAN

Keith wanted to be out there to celebrate with his guys.

GREG PRINCE

Eventually two outs, a 4–2 lead, Chico Walker, Chicago Cubs at bat.

DWIGHT GOODEN

I wanted to strike him out. I really did want to strike him out. I thought that would be the best way to get him, but I'll take a ground ball.

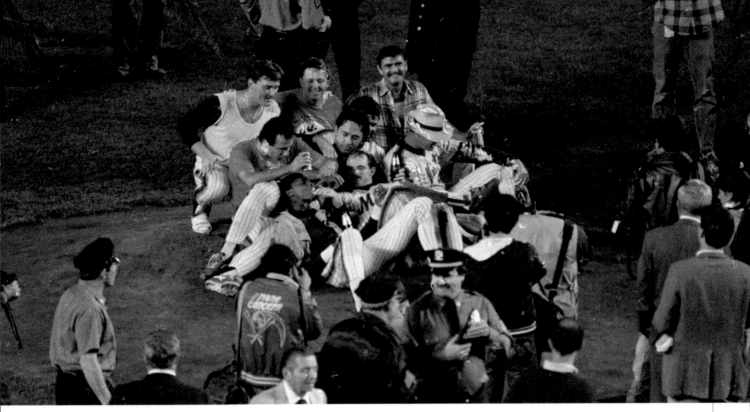

ERIK SHERMAN

A ground ball to Backman over to Hernandez at first.

GREG PRINCE

And Shea Stadium comes tumbling down.

WALLY BACKMAN

If I would have made an error on that play, there would have been ten thousand people that were already on the field that would have killed me, so I'm still alive today to say that I made a good throw.

JOE PETRUCCIO

The fans in the stands—it almost looked like they poured out onto the field.

SANDY CARTER

I remember sitting at home plate, bodies rolling down on top of the screen above us, trying to get on the field.

ED LYNCH

I was standing out in the left-field bullpen with [Cubs pitcher] Lee Smith; here come ten thousand people onto the field—and the whole field, it was like Woodstock.

SANDY CARTER

It was such insanity that moment.

WALLY BACKMAN

People were trying to take your hat and gloves.

KEITH HERNANDEZ

This kid came up and grabbed my glove and tried to take my glove, and I looked at him and I went *Grrrh!*—and he's like, "Oh, okay, okay!"

ED LYNCH

And they're just doing all kinds of destruction; they're tearing grass out of the ground.

WALLY BACKMAN

It was fans being fans.

ED LYNCH

I remember seeing this scrum coming down the left-field line, just ten or twelve guys, and they're around one guy and the guy falls down. They ripped home plate out of the ground and they were carrying it down the left-field line and guys are trying to take it from each other.

WALLY BACKMAN

It's really all about the fans.

ED LYNCH

They had fricking home plate. So much concrete at the bottom of it, they tore it out of the ground. And this one guy had it and they're beating the crap out of him, and me and Lee Smith just looked at each other and said, "New York, New York, here it is."

KEVIN MITCHELL

The best fans in the game in New York.

RAY KNIGHT

They pulled for you, they went to sleep thinking about you. They woke up thinking about you.

JOE McILVAINE

Well, it had been a long time between clinchings—

MOOKIE WILSON

The fans had suffered long enough.

GREG PRINCE

They were destroying the field, which did not look good for the rest of the season.

JOE PETRUCCIO

When they say leave it all on the field, they left nothing on the field.

ED LYNCH

They tore up the entire infield; all the grass was gone off the field. They had these patches.

GREG PRINCE

That would not be allowed again: The Mets took security seriously thereafter.

MOOKIE WILSON

They were coming on the field. All the policemen in New York couldn't have stopped that.

MIKE "CHOPS" LACONTE

Man, that was hair-raising, crazy stuff. I mean, you really got nervous about it.

SANDY CARTER

That's the only time I was really afraid of New York.

DWIGHT GOODEN

That was scary. I mean, it was fun, but it was scary.

VINNY GRECO

And it was crazy intense.

KEVIN MITCHELL

It wasn't crazy, it was just unique, something different I've never seen before. People scampering everywhere.

MIKE "CHOPS" LACONTE

They were on us hot and heavy right away. And it was like, you run out, got to Doc, and then we basically turned around and ran for our lives.

DARRYL STRAWBERRY

And we had a great celebration that night.

ED LYNCH

That was an emotional night for me, watching them celebrate. As a visiting team, you walk right by the Mets clubhouse door, on your way down to the right-field bullpen, where the bus would be.

JEFF PEARLMAN

Lynch hears the celebrating from the Mets clubhouse as he walks through the bowels of Shea Stadium. There's nothing he can do about it. He's not there anymore.

ED LYNCH

And I remember walking by and [pitcher] Randy Myers, who just came up, he's got champagne in each hand and he looked at me and said, "Lynchy man, I'm sorry you're not part of it." And I wanted to strangle him.

WALLY BACKMAN

It's something to remember the rest of your life, but winning the division is only one piece of the puzzle.

JAY HORWITZ

"It's great we won. We were expected to win. We have to have more than this." You know, no one is gonna be happy with just winning divisions.

Seventh Inning
IN OUR HEADS

New York City that October was poised—for what, no one knew. On October 4, CBS anchorman Dan Rather was assaulted on Park Avenue by a man who punched him from behind and asked repeatedly, "Kenneth, what is the frequency?" The bizarre incident—which catapulted the phrase into popular culture, later inspiring R.E.M.'s song "What's the Frequency, Kenneth?"—underscored the unpredictable, all-bets-are-off atmosphere of New York City that autumn.

ERIK SHERMAN

Serious October baseball in New York. There is absolutely nothing like it.

GREG PRINCE

It takes over your life.

ERIK SHERMAN

There's an excitement, and that excitement in October of '86 was off the charts.

JEFF PEARLMAN

The '86 postseason was the best postseason ever.

ROGER ANGELL

The history of postseason baseball is many, many hundreds of games going back to the early 1900s. No team in the postseason had ever made up a deficit of three runs in the ninth inning, ever. It happened three times in 1986.

KEVIN MITCHELL

As a rookie, it was like being at Universal Studios as a young kid. That's how great it was. Coming in there and just looking at, is this really happening and am I here?

ROGER ANGELL

Baseball does this sometimes. It consumes you. And you realize that you don't know what's going to happen, and that some strange and extraordinary things are happening in some way that will seem inevitable in the end, but seem impossible while they happen.

DAVEY JOHNSON

We knew we were gonna have Houston, which I thought was gonna be one heck of a battle . . . and it was.

JEFF PEARLMAN

Astros and Mets series, unbelievable.

Ordinarily, playoff series then alternated between starting at the home of the Eastern Division or the Western Division, and in 1986, the Eastern Division champs were due to start at home. But because the Western Division champion Astros shared the Astrodome with the Houston Oilers, and the NFL had already scheduled a home game for the Oilers when Game 4 was due to be played, the series would start in Houston, not New York.

BOBBY OJEDA

I suppose it was appropriate it would happen in Houston. It was like, of all the towns we go to, we're right back here.

JAY HORWITZ

Kind of spooky going back there after what had happened.

BOBBY OJEDA

People were still amped up about it. I suppose it just adds more spice to this story of the '86 thing. You can't make that up.

DAVEY JOHNSON

The Houston Astros were a tough battle, 'cause they almost mirrored our club.

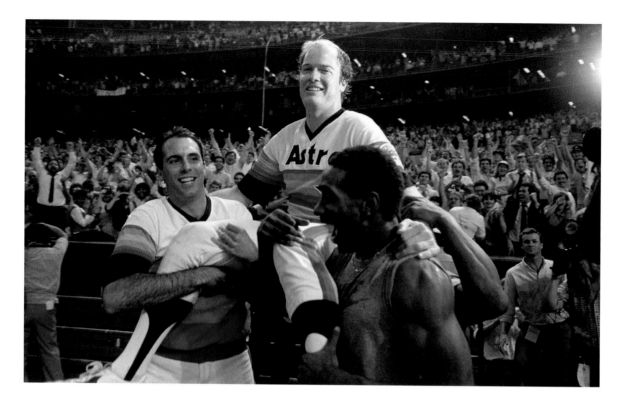

KEVIN MITCHELL

We had that swagger and cockiness, and that team had a lot of swagger.

RAY KNIGHT

All the players on that team, I knew how tough they were. Glenn Davis and Nolan Ryan and Bobby Knepper and Phil Garner, Bill Doran, Alan Ashby, Billy Hatcher . . .

MOOKIE WILSON

They were not gonna just let us win. That wasn't gonna happen. Not that club.

KEITH HERNANDEZ

We knew we had our hands full.

KEVIN MITCHELL

Yeah, you got swag going against swag. Somebody gotta win. [Laughs] Somebody gotta lose.

ROGER ANGELL

Houston was so good and so scary. They had that really terrifying pitcher, Mike Scott.

KEITH HERNANDEZ

Mike Scott.

RAY KNIGHT

Mike Scott.

WALLY BACKMAN

I don't have anything to say about Mike Scott.

ERIK SHERMAN

Mike Scott was like Freddy Krueger, and the Mets were like scared little children.

JOE McILVAINE

Our boys were fearful of Mike Scott. To hear that coming from a bunch of boys who were cocky as can be was really surprising, but that's how good Mike Scott and his splitter were that year. He was dominant.

WALLY BACKMAN

He had us. Scotty had us.

JEFF PEARLMAN

Mike Scott came up as a Met.

ED LYNCH

We pitched together. Mike Scott had a hard fastball that he couldn't command very well.

JEFF PEARLMAN

He was your typical Met: win one, lose two, high ERA.

KEITH HERNANDEZ

When he was a young pitcher, he had a terrible breaking ball. Mediocre breaking ball, and it always got him in trouble.

JOE McILVAINE

We needed some hitting and Mike was a guy that we felt we could sacrifice.

Mike Scott had come up to the Mets in 1979 and compiled a dismal 14–27 won-loss record, with a 4.63 ERA, before being traded unceremoniously to Houston in exchange for outfielder Danny Heep in the off-season after 1982.

ED LYNCH

The thing about Mike Scott, his fingers were about a foot long, they were unbelievable, so he ran into Roger Craig somewhere out in California that off-season, and Roger Craig taught him the split-finger fastball.

JEFF PEARLMAN

Roger Craig: former Met pitcher and the master of the split-finger fastball. And the split-finger baseball at the time was the rage, it was *the* pitch, but it wasn't easy to master. It's an un-hittable pitch. It would [whoosh sound] and you would watch it and the movement on the ball . . . and it was insane.

KEITH HERNANDEZ

The split-finger made him a different pitcher.

JEFF PEARLMAN

Mike Scott went from being a number four starter, maybe, in the majors, to being a Cy Young Award winner.

ED LYNCH

And he just got better and better, and then '86 he was un-hittable.

LENNY DYKSTRA

In '86 he was fuckin' dominant. Meaning, filthy.

WALLY BACKMAN

I'm glad I don't see that splitter anymore.

KEVIN MITCHELL

And he was very confident on that mound. Very confident.

DARRYL STRAWBERRY

It was his year. At the end of the year, I think he threw a no-hitter.

ED LYNCH

He clinched the division with a no-hitter that year. That's how good this guy was.

On September 26, Scott no-hit the San Francisco Giants to clinch the National League West.

GREG PRINCE

He basically became what Dwight

Gooden was the year before—he's an all-world pitcher.

JEFF PEARLMAN

And when the Mets traded him to Houston, he was nothing.

JOE McILVAINE

Little did we know, of course, that three years later he's gonna be facing us in the '86 play-offs and be an un-hittable pitcher.

JAY HORWITZ

Mike Scott was a Met killer.

DARRYL STRAWBERRY

You prepare yourself, brace yourself. We faced Scott during the year, we couldn't beat him. We wasn't easy to get out that year, so you trying to figure inside your head, "How is it that this guy can get us out so easy?" And then you start looking at the baseballs. . . .

JEFF PEARLMAN

He had two things going for him: number one, the split-finger fastball; and number two, he cheated.

DAVEY JOHNSON

"Scuffed Ball Scott," I call him.

LENNY DYKSTRA

He threw a hard fuckin' scuffed ball.

DWIGHT GOODEN

Scuffed ball . . . It was like a Wiffle ball coming in at ninety miles per hour. You don't know what it's gonna do.

DARRYL STRAWBERRY

It was 'cause the ball was cut up; every time you look at it, the ball was moving like crazy.

KEITH HERNANDEZ

And we knew during the season, we got the balls; they'd be scuffed in the same spot. Like chicken scratches. And so: Come on!

RAY KNIGHT

One circle. It was like you take number two sandpaper and it would be like a circle in the same spot.

JEFF PEARLMAN

By the time he was facing the Mets in the playoffs, I'd say 95 percent of players in baseball, at least opposing hitters, believed him to be cheating.

WALLY BACKMAN

It got into certain players' heads.

JEFF PEARLMAN

He was in their heads as much as any ballplayer, in my lifetime, has been inside the heads of other players.

MOOKIE WILSON

He was in the head of some of our key players and that was not good.

GREG PRINCE

And he is the opening game starter in the National League Championship Series, in Houston.

DARRYL STRAWBERRY

Until we prove it, you know, nothing we could do. So, good luck. [Laughs]

GREG PRINCE

Mets send Dwight Gooden, and Dwight Gooden had a great game and only gives up one home run to Glenn Davis . . . but Mike Scott is un-hittable. It's not a no-hitter, but it might as well be. The Mets lose one–nothing, and the Mets don't take it lying down. Not in the usual "Let's charge the mound" sense, but by pointing out their suspicions.

DWIGHT GOODEN

I was kind of pissed at our hitters. It was true that he was scuffing, because, I was pitching against him, 'cause a lot of the balls I see had the scuff all in the same spot. Unfortunately, I couldn't get the ball to do anything. I didn't know how to grip it or what to do, but our hitters were more concerned about catching Scott cheating than actually hitting him.

LENNY DYKSTRA

We couldn't hit him, and at that dome, he really scuffed that motherfucker.

RAY KNIGHT

As we struggled through the first night against Mike Scott, it became evident that they were scuffed.

KEITH HERNANDEZ

I didn't want to make too much of a big deal about it. It really bothered Gary Carter, it really bothered him, and he was a big out. A lot of hitters were big outs for Mike Scott.

RAY KNIGHT

It's not only the evidence you've got on the ball, but you've got twenty years or fifteen years of experience seeing pitches come to the plate, and this is coming to the plate like no other pitch that you've seen.

KEITH HERNANDEZ

It bothered Ray Knight a lot. I was surprised about Ray, that it really bothered Ray so much.

RAY KNIGHT

I can't identify this pitch. They can call it a forkball, or they can call it a split-finger.

LENNY DYKSTRA

When somebody throws a forkball, you can kind of recognize it because it's not as hard.

This thing would look like a fastball and it would just dive.

RAY KNIGHT

It got to a place, and the bottom just dropped out of it.

KEITH HERNANDEZ

I wanted to downplay it and basically say, "Hey, he's gotta throw it over the plate. No big deal."

RAY KNIGHT

Is that an excuse? It's just a fact.

GREG PRINCE

So now you have this extra layer to the postseason that's not just two great teams trying to win a pennant, it's the Mets accusing the Astros' best pitcher of doctoring the ball, and that is going to stay in everybody's heads, including the Mets', for a while longer.

MOOKIE WILSON

But Mike Scott was only one pitcher. If we beat everybody else, we're good to go.

JEFF PEARLMAN

I talked to Mike Scott, and I said, "So were you scuffing the baseball?" And he said, "Well, I'm gonna leave that to write in my book." And I said, "Oh, when are you writing a book?" And he said, "Never."

The Equalizer

KEITH HERNANDEZ

We had our back against it, Game 2. We had to win Game 2.

ERIK SHERMAN

Bobby Ojeda, like he had done all season long, came up big.

BOBBY OJEDA

My arm was hanging on by a thread. Then we get into the postseason and I'm like, okay, just be cool. I get through Houston. A regiment of pills increased, and we have an epic series. I did good in Game 2, I hung in there; the drugs were doing good. It was fine.

In the second inning of a scoreless game, the Astros threatened, putting men on first and third with one out. The next batter, Alan Ashby, topped a squib out in front of the plate. With Kevin Bass of the Astros racing toward home plate, Ojeda hurried in, scooped up the ball, and lunged at Bass.

BOBBY OJEDA

I dive and tag him out, arguably one of the greatest plays ever in the history of the world, certainly for me. To keep them off the board is very important. When a team is looking for confidence and momentum . . . if I can stop you from getting home, that's awesome. And if I could dive and tag you, it's even better. It's not like striking you out, but to actually physically come up with something and dive and tag the dude, that was awesome.

ERIK SHERMAN

He was the ace of the staff that year, and he proved it.

Ojeda pitched a complete game, scattering ten hits, and the Mets won, 5–1.

KEITH HERNANDEZ

The only game we ever won of that six-game series when we were in the lead.

A Nice Steak

GREG PRINCE

Game 3 brought October baseball back to Shea Stadium, first time since '73. Ron Darling, who was one of the top starters in the league in 1986, going up against another great Astro pitcher over the year, Bob Knepper. Ron Darling doesn't really have it early on in that game, and the Mets fall behind, and there's no guarantee that we're gonna beat them, and then Mike Scott, the guy we were complaining about and couldn't touch, he's tomorrow night's starter. So, being down early to the Astros is not a good idea.

DARRYL STRAWBERRY

That's when Hernandez was on second base telling me to keep my shoulder in. I'll never forget it.

KEITH HERNANDEZ

I remember I was telling Darryl to move up on the plate, and he did it.

With the Mets down 4–1 to the Astros in the sixth inning, Strawberry hit a massive three-run homer off Knepper to tie the score 4–4. It was the first Met home run in the postseason at Shea Stadium since Rusty Staub in the fourth game of the 1973 World Series.

DARRYL STRAWBERRY

He said, "See, you did it, you kept the shoulder in."

KEITH HERNANDEZ

"They're gonna see you standing over the plate and they're gonna pitch you in."

DARRYL STRAWBERRY

If I overswung the bat there, trying to kill it, I would be out, the shoulder would be way out here. Instead the shoulder was in and I came through and I just got the wood on it.

KEITH HERNANDEZ

It was a bomb off Knepper. Knepper had another good game and he coughed it up.

GREG PRINCE

As it would happen, the Mets would fall behind and the matchup became Charlie Kerfeld. He was sort of this Jim McMahon wannabe, Brian Bosworth type, to put it in mid-'80s terms.

MOOKIE WILSON

There are a lot of goofy pitchers out there, but he was one of the goofy pitchers out there with the big glasses.

JEFF PEARLMAN

Charlie Kerfeld looked like a guy who was like a reject from a ska band, you know, who didn't cut it as a bass player and now he's pitching for the Astros.

GREG PRINCE

Game 3, Gary Carter was in this miserable slump.

ERIK SHERMAN

After that first game and getting really frustrated with Mike Scott, Gary Carter went into a deep slump and it was exacerbated in that third game.

Leading off the eighth inning with the Mets now trailing, 5–4, Carter hit a ball back to the mound.

ERIK SHERMAN

Charlie Kerfeld fields a comebacker sort of behind his back and then points it in Carter's direction before throwing the ball to first.

GREG PRINCE

You talk about arrogance and disrespect; this isn't something even the Mets would do to an opponent.

JEFF PEARLMAN

Charlie Kerfeld is talking shit to the Mets. I remember it just seemed wrong.

GREG PRINCE

In the ninth inning, Dave Smith, one of the top closers in the '80s, comes in to finish off the Mets.

WALLY BACKMAN

I laid down a bunt down the first-base line and I dove into first base.

Backman's drag bunt was fielded by first baseman Glenn Davis, who raced toward Backman. Backman dove out of the way, and tumbled safe across first base. Astros manager Hal Lanier raced out of the Houston dugout to argue the call, claiming that Backman had run out of the baseline—but the call stood. Replays clearly indicated that Backman had been out of the baseline and should have been called out.

WALLY BACKMAN

I was safe, right? They called me safe, right? [Laughs]

With one out, Lenny Dykstra came to the plate.

LENNY DYKSTRA

Game 3 put me on the map, okay, like the

big map. Remember, we're down by a run and Dave Smith's on the mound—and I owned him, by the way.

KEITH HERNANDEZ

Lenny right from the get-go proved himself to be a postseason player, another one of those guys who was fearless in the post-season.

WALLY BACKMAN

I mean, you could have players who don't want to be in those situations; they'll never admit that.

KEITH HERNANDEZ

And there's a lot more pressure in those games.

LENNY DYKSTRA

It's like putting to win the Masters, you know; you see when they tighten up, they choke a little bit. It's fear, okay. And I said, "Fuck that, man."

WALLY BACKMAN

You have players who thrive being in those situations and Lenny was one of them.

LENNY DYKSTRA

You see, baseball's a game of failure. You fail or succeed. You either fuckin' make a hit and get a high five or get an out. That's how it works, it's about the result. Like life, okay, you make an out, fuck it, they don't remember the out. I want to be a fuckin' hero when it matters.

WALLY BACKMAN

I'm sure that he was thinking, "I can win this game right now."

LENNY DYKSTRA

Game on the line, what else is there?

On the first pitch of the at bat, Lenny swung mightily—and fouled the ball off. He had hit only eight home runs all year. But the next pitch he lofted toward right field, and it sailed into the Met bullpen for a home run, giving the Mets a 6–5 victory.

MARK HEALEY

In 1986, my sister needed a kidney transplant, and me and my dad watch the Mets, you know, that's what we do, and he was the one who gave my sister her kidney. He was still all hooked up to machines and I was sitting in the room with him and we had snuck in a TV. My dad was a big Lenny Dykstra guy, and when Dykstra hits the home run, me and my father start screaming. And all the nurses come in: "Oh God, what's the matter?"

LENNY DYKSTRA

I barely swung, man, just got extended by the baseball gods, dude. Somehow pushed it over the fence and then it went out of the park and I was like floating around the bases. That was like surreal. That means *surreal*, not *real* kind of. *S-U-R-R-E-A-L*. It really was, man, it was really something.

MARK HEALEY

You know, when people say "Lenny Dykstra," I always smile 'cause I just think about that guy who came up and became this folk hero.

LENNY DYKSTRA

By the grace of God, which god I don't know, but I was put on the earth to play baseball.

JOE McILVAINE

We will be shouting the name of Lenny forever and ever.

LENNY DYKSTRA

Destiny or whatever. I knew a chick named Destiny once. Yeah, so that was Game 3, man. After the game, me and my wife and my kids, we went to Peter Luger's and walked in, and all the people in the restaurant gave me a standing ovation. Yeah, it was pretty cool. Yeah, bought a nice steak.

)()()(

GREG PRINCE

Game 4 was another reality check because Mike Scott is back on the mound. Sid Fernandez started for the Mets. He was not Mike Scott.

SID FERNANDEZ

I knew it was gonna be tough against Mike Scott, 'cause we could just not hit him.

RAY KNIGHT

There was a Mike Scott factor, no doubt about it.

KEITH HERNANDEZ

He was just good. Was he in Carter's head or Ray's head, I don't know.

RAY KNIGHT

Mike Scott was in a lot of folks' heads. You know what a four-seam fastball does. Two-seam fastball, it's got one kind of rotation to it. A slider has got another kind of rotation to it. Mike Scott's split-finger forkball, or whatever it was, it is coming to the plate like no other pitch you would see. The ball would do all kinds of funny things, and you would say something to the umpire and they would go, "I don't know, kid." I don't know how you could get that stuff out of your mind, 'cause so many people were talking about it.

MOOKIE WILSON

Players are so consumed with trying to figure out what he was doing that they couldn't concentrate on the job at hand.

RAY KNIGHT

"They're cheating, they're scuffing it, come on, they're scuffing it. What are you gonna do about it?"

ERIK SHERMAN

So they actually start collecting baseballs and they put them in a bag.

JEFF PEARLMAN

The Mets were collecting the scuffed balls, and there was scuffs on all the balls and they thought they had this proof that Mike Scott was cheating.

DAVEY JOHNSON

I sent twenty-six balls to the commissioner's office; they didn't believe it. They said it could be anything.

LENNY DYKSTRA

What the fuck, dude?

RAY KNIGHT

You have no chance.

DARRYL STRAWBERRY

There was no way we were gonna beat him.

ERIK SHERMAN

And the Astros win again. And really, the Mets never had a chance.

The final score was only 3–1, but it seemed worse than that. The series was tied.

GREG PRINCE

And everything that you heard from the Mets was very discouraging, this team that didn't give anybody else any credit. I don't remember reading one quote that said, "We'll get him." Which made Game 5, the last game at Shea Stadium, all the more important.

KEITH HERNANDEZ

We have got to win Game 5.

Rain pushed the game back a day.

GREG PRINCE

So Game 5 is rescheduled for Tuesday afternoon. Some people couldn't use their tickets—not a lot of people were there.

ERIK SHERMAN

Game 5 was one of those pitching duels of the century. You had the old veteran Nolan Ryan, sure-shot Hall of Famer.

KEITH HERNANDEZ

Ryan threw as hard as [Aroldis] Chapman: He would throw a fastball that was lightning.

WALLY BACKMAN

If somebody could intimidate a player, Nolan Ryan was one of those guys.

KEITH HERNANDEZ

Wally says in the paper, "Oh, we're gonna kick Ryan's ass." Why would you do that?

WALLY BACKMAN

What I meant was: The New York Mets were not going to be intimidated by anybody in baseball.

KEITH HERNANDEZ

Wally's locker is next to me and I said, "What the fuck, what are you talking about?"

GREG PRINCE

Nolan Ryan is a legend.

ERIK SHERMAN

Going up against the new generation's superstar, Dwight Gooden.

JOE McILVAINE

Ryan against Gooden, I mean, it doesn't get any better than that.

GREG PRINCE

The old master, the young gun.

DWIGHT GOODEN

For me, the biggest game of my career, I'm facing my childhood idol and now it's real. You're facing Nolan Ryan in a big game, a playoff game.

GREG PRINCE

It's one of those games that lived up to what you hoped for. Both pitchers were masterful.

DWIGHT GOODEN

Normally, when I'm pitching, I'll go in the clubhouse, get some water, and go out. But watching Nolan, I stayed in the dugout the whole time 'cause I wanted to watch him.

KEITH HERNANDEZ

He threw bullets.

DWIGHT GOODEN

I became a fan when I wasn't on the mound, just watching Nolan. Going toe-to-toe with Nolan, it was amazing.

In the top of the fifth, the Astros pushed across the first run of the game on a ground out. In the bottom of the inning, with one out, Darryl Strawberry stepped to the plate. Ryan hadn't allowed a hit, and he'd struck out eight Mets.

DARRYL STRAWBERRY

We've got to win, and in all honesty we wasn't touching him, you know; but it was that one pitch, one pitch that I did not let pass.

FOR ME, THE BIGGEST
GAME OF MY CAREER, I'M FACING
MY CHILDHOOD IDOL AND NOW
IT'S REAL. YOU'RE FACING
NOLAN RYAN IN A BIG GAME,
A PLAYOFF GAME.

DWIGHT GOODEN

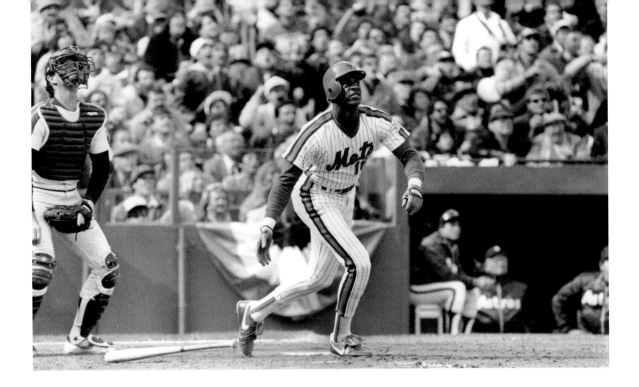

DARRYL STRAWBERRY

You know what Nolan said? He said, "His talent beat my talent on that pitch." That's pretty cool.

DWIGHT GOODEN

I'm telling you, Strawberry always hit home runs in my games. Some people say, "Who's the most talented guy you've ever played with?" And I say Strawberry. When he wanted to play, there was nobody better, hands down.

DARRYL STRAWBERRY

He threw me a fastball down and in, I just got the bat head out. And it stayed fair, and we tied the ball game up.

GREG PRINCE

Darryl Strawberry coming through again like he did in Game 3: He hits a home run, that's

the Mets offense; Gooden only gives up one run, Gooden goes ten innings. Ryan and Gooden lived up to the hype, but in the end, Ryan was a no-decision and Gooden was a no-decision—and we get to the twelfth inning.

ERIK SHERMAN

The Mets up once again against this kid, Charlie Kerfeld.

MOOKIE WILSON

Even though he had a good arm, no one took him serious.

With one out in the bottom of the twelfth inning, Wally Backman slashed a ball toward Astros third baseman Denny Walling. The ball caromed off Walling, and Backman was aboard. Then, with Backman leading off first,

Kerfeld threw a pickoff attempt wild, and Backman scampered to second. With an open base, Astros manager Hal Lanier had Kerfeld walk Keith Hernandez intentionally.

ERIK SHERMAN

The Astros walk Keith Hernandez to get to Carter, the ultimate insult for someone with the ego of Gary Carter.

GREG PRINCE

And if you don't think Gary Carter took that personally, then you weren't paying attention.

ERIK SHERMAN

You had Gary Carter facing Kerfeld, who he desperately wanted revenge against.

KEITH HERNANDEZ

Gary had been struggling in that series; I believe he was hitless or had one hit or something like that.

Carter was 1 for 21 in the series at that point.

DARRYL STRAWBERRY

So like, Carter, come on, might have been struggling, but everybody struggles, and I told him, "You da man, you da man, you da man in the right spot."

JOE McILVAINE

He lived for moments like that.

KEITH HERNANDEZ

I was kind of glad they put it on Carter to show us what he's made of.

Carter hit a bullet up the middle. As the ball scooted into the outfield, Carter raised his hands in exultation as he raced to first, and Backman scored easily. The Mets had taken a 3–2 series lead.

JOE PETRUCCIO

Gary had a spark in him and joy in him that, that's something you don't teach, that's something that's born in you, and there was a light that was in him.

JOE McILVAINE

Carter was the one that ultimately proved to be the hero, going up with his hands up in the air to first base and all. He was just so exuberant.

JOE PETRUCCIO

He was a bright light of that '86 team.

GREG PRINCE

The Mets win 2–1 in not only one of the greatest postseason games you'll ever see, but perhaps the most instantly forgotten great postseason game you'll ever see.

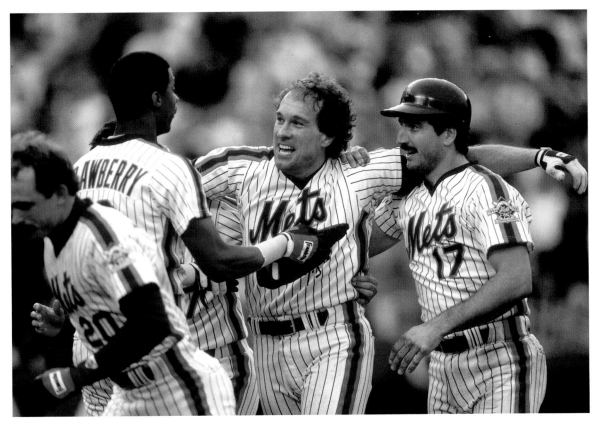

The Greatest Game Ever Played

The Mets starting pitcher for Game 6 was Bobby Ojeda.

BOBBY OJEDA

In a season like that, people play hurt. People play through things. My situation was different because I had a structurally damaged elbow. A chip the size of my thumbnail, in the ulnar groove. I am not a doctor. It wasn't that I was tired, it wasn't that I was worn out, it was that I was damaged. I was taking all kinds of pills. Prednisone. They had all these anti-inflams, and it wasn't really helping.

It reached a crescendo before Game 6. I almost couldn't take the mound. Our trainer, Steve Garland, he'd known all year what was going on, and I went to him when it was getting so bad and I said, "Steve, I gotta have something, 'cause if I don't do something different, then I'm not gonna be able to go out there." I said, "We gotta shoot it, call the doc. I'm gonna nuke this thing." I said to Steve, "Where's the doc?" He said, "He's in

Washington." The doc was down there on a conference.

I jump on a Delta Shuttle down to Washington, I take a cab to his hotel—and this was before cell phones, so you had to have everything lined up. So I meet him there, we go into the bathroom, I take my jacket off, he's like, "Okay, here, here." He manipulates my arm, and [makes a squirt noise] does the shots in my elbow. "Thanks, Doc, I'll see you later." Back to the airport, I get on a plane, fly back to New York, then we fly out to Houston.

No one knew nothing. That's not acceptable today, nor should it have been, but he didn't say nothing because I said, "Doc, if you say anything, I'm gonna deny. I'm gonna call you a liar and I'm gonna say I didn't do it. It's a lie." Some guys put their career ahead of these experiences; I wasn't gonna do that; and especially me, a kid from five hundred bucks, lucky to make it to the big leagues. Now I've got a chance to go to the World Series, I'm not missing the World Series no matter what. I knew I was risking my career, and I'm cool with it. If I'm going down, I'm going down hard, and I'm going down my way.

Get the shots, I get to Houston. I go out to get loose for Game 6 . . . and I can't get loose. I felt like there were sandbags in my elbow. I was like, man, that's nasty. I go back there and

the bell rings and I gotta take the mound and I'm still not where I need to be; this could be a problem—so I go out there, the first inning goes to hell. I'm having trouble, base hit, walk, they've got three runs on the board and I'm like, "I'm about to get knocked out of this thing."

Five of the first six Astros batters reached base, and the score was 3–0.

GREG PRINCE

Bobby Ojeda, the equalizer from Game 2, is the rock of this rotation, and if they get to Bobby Ojeda then you have to question what's gonna happen to us the rest of this afternoon.

BOBBY OJEDA

That's the flip side of this: Do I want to be Johnny Hero and cost us the thing? Am I self-fish for wanting to not quit—or am I a gamer?

Ojeda made it out of the first inning, limiting Houston to three runs.

GREG PRINCE

Bobby Ojeda stops the bleeding, almost as soon as it started.

BOBBY OJEDA

A little more fluid in there, a little more motion, and then it worked itself out, but I guess I'm a gamer, 'cause I did well. I threw up five

zeros after that, and it was the coolest, the greatest feeling; the game turned epic.

ERIK SHERMAN

In baseball history, Game 6 of the NLCS in '86 has to go down as one of the greatest games ever.

MOOKIE WILSON

It's still the greatest game I ever played in, and that's counting the '86 World Series. That game was unbelievable—unbelievable game.

ED LYNCH

I did watch Game 6 when they were trying to beat Houston. I remember saying, "Boy, if they don't win this game, they're in deep doo-doo because they got Mike Scott going the next night and he's virtually un-hittable."

GREG PRINCE

This was Game 7 in all but number and name. If they lose this game, it's Mike Scott time.

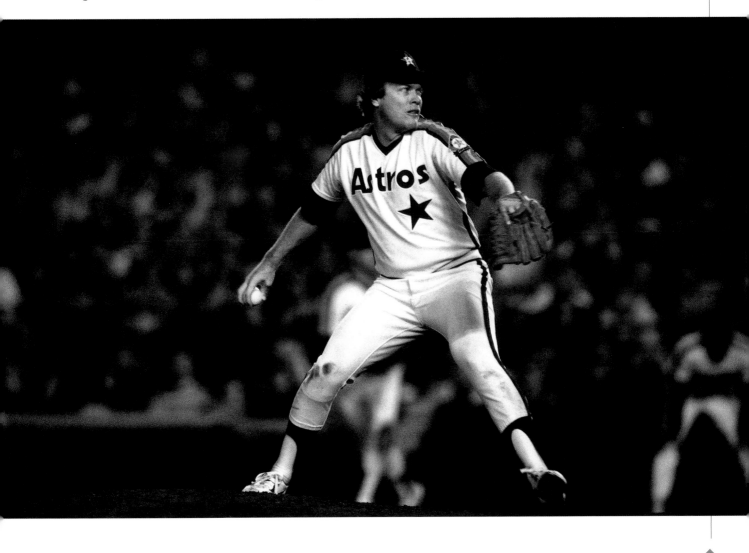

DWIGHT GOODEN

We didn't want no part of Mike Scott.

LENNY DYKSTRA

Look, let's just call it as it is, if we get to Game 7 against Mike Scott, we've got no fuckin' chance.

)()()(

ERIK SHERMAN

It was reported that prior to Game 6 of the NLCS against the Astros that Darryl Strawberry and his wife got into an altercation and he broke his wife's nose in the hotel room.

JOHN STRAUSBAUGH

It did devolve into physical abuse.

DARRYL STRAWBERRY

I was just like my father, abusive and drunk. What I said I wouldn't do, I ended up doing.

JOHN STRAUSBAUGH

When he was being physically abusive, there must have been something in his brain saying, "I'm acting like Henry."

DARRYL STRAWBERRY

You know, 'cause he did the same thing to my mother, his voice was always in my head. It's a learned behavior, it's something kids see in the household and you turn out to be something like you don't want to be. A nightmare.

JOHN STRAUSBAUGH

He doesn't use Henry as an excuse for his mistakes, but it is an explanation.

DARRYL STRAWBERRY

I ended up hurting a lot of people because of my own self not being well. There's not a whole lot you could say; I was just not a good man. . . . You put a uniform on and excel, people think you should have it all together, but that doesn't fix the brokenness.

)()()(

GREG PRINCE

There's every incentive for the Mets to win, which is swell, except the Astros starter, Bob Knepper, isn't giving up anything for two innings, four innings, six innings

KEITH HERNANDEZ

Knepper's a pretty good pitcher.

LENNY DYKSTRA

A little fuckin' lefty.

KEITH HERNANDEZ

And he's got us shut out through eight.

The score stayed Houston 3, Mets 0 into the ninth inning.

GREG PRINCE

And it's almost a foregone conclusion that we're going to see Mike Scott in Game 7.

DARRYL STRAWBERRY

Oh my God, are we going to have to go to a Game 7?

KEITH HERNANDEZ

And something happened in the top of the ninth inning that never would happen today with analytics.

LENNY DYKSTRA

I'm not playing, Davey benched me, whatever.

KEITH HERNANDEZ

All the right-handers are on the bench, and Davey sends [left-handed] Lenny Dykstra to go lead the inning off to pinch-hit.

DARRYL STRAWBERRY

Who would think that in that situation?

KEITH HERNANDEZ

Would never happen in today's game, but Davey played a hunch.

LENNY DYKSTRA

He walks down to me and says, "You're leading off the ninth." I said to him, "You finally want to fuckin' win, huh?" Fuck.

Dykstra hit a deep fly ball into the cavernous Astrodome, just out of the reach of center fielder Billy Hatcher, and he scooted all the way to third for a triple.

KEITH HERNANDEZ

Lenny gets the triple, lead-off triple, gets the ball rolling. Who followed next? It was Mookie and it's a soft-liner. Lenny scores, Mookie's at first, Kevin Mitchell comes up; he hits a high chopper to third and advances Mookie to second.

With one out, a man on second, and the score now 3–1 Houston, Keith Hernandez came to the plate.

KEITH HERNANDEZ

I'm 0 for 3 and Knepper's pretty much stuck it up my fanny. In the eighth inning I called my brother. I got the operator and I said, "This is Keith Hernandez and I'm calling my brother in San Francisco, San Carlos, California, here's his number. Get him quick." I got my brother on the phone, and Gary said, "What?" He about dropped his pants, and I said, "Gary, I got to hit in the ninth inning." He said, "Keith, you're

swinging the bat great, just rip the bat, you're gonna get 'em." I said, "Okay."

Hernandez ripped a double in the gap, scoring Mookie and knocking Knepper from the game. The Astros brought in Dave Smith, who walked Carter, and then, after a tremendously deep foul ball by Darryl Strawberry . . .

KEITH HERNANDEZ

And it was foul by a foot or two feet. I mean, third deck.

Smith walked Strawberry as well, loading the bases for Ray Knight. What followed was one of the tensest at bats of the season.

RAY KNIGHT

Dave Smith started me off with a fastball and I thought it was a ball away. And they call it a strike. I'm thinking, "Whoa, that pitch is outside." I didn't say anything, I just scuffed the ground a little bit and moved about probably two inches a little closer to the plate to make sure that the next time that pitch came in there, I was gonna swing at it. Because I'm not gonna take a pitch on the corner of the plate if that's what his strike zone is.

The count went to one and two.

RAY KNIGHT

He comes back with that fastball and I'm in that same foot hole, and it felt like it was too far away. That's with me making that adjustment, and it was close. But my mind said it was outside. And [Astros catcher Alan] Ashby jumps up and he says, "That pitch is a strike, that pitch is a strike! Gosh dang it, that pitch is a strike." And [umpire] Fred Brocklander said, "That ball's outside." And I stepped on the plate and I said, "Alan, you get back there

and catch, let him umpire; that doggone ball's outside. Just because he called that first pitch a strike doesn't mean that pitch is a strike!" Then Dickie Thon came in from shortstop, and he and I were good buddies, and he tells me to shut up. Then Alan got back down, and the next pitch he threw me was a fastball out up and away, and I crushed it to center field . . . and in that ballpark, it was just a long out, but it was an RBI sacrifice fly. [Laughs]

KEITH HERNANDEZ

Three runs in the ninth, that's pretty remarkable to tie that game.

The Mets finally made three outs, the Astros failed to score against Roger McDowell in the bottom of the ninth, and the game went into extra innings.

GREG PRINCE

The game was going on in rush hour in New York, and people had a choice: They could go home or stay wherever they were, and New York basically came to a standstill.

ANN LIGUORI

Time stood still in Manhattan. It was just incredible—grabbed the whole city.

ROGER ANGELL

This was the extraordinary thing: It's five o'clock, now hours into the game, they don't want to go home. A lot of people stayed in their offices or went to a nearby bar; they didn't go home. The subways were not crowded that night. A friend of mine described his path home that day from 43rd Street, walking downtown: You could pick up the game everywhere, starting with the TV store with the TV set on inside the store.

TAMA JANOWITZ

The shops had TVs in the windows and people would just gather in front watching this.

ROGER ANGELL

I had one friend with a radio, then he gets down to Herald Square and there's a stretch limo parked on the side of the road with the doors open with a little tiny TV set, a big crowd gathered around listening to the game on this little TV.

GREG PRINCE

'Cause you didn't really care if you were getting home; you had to stick with this game.

DARRYL STRAWBERRY

I just remember it was long.

KEITH HERNANDEZ

How many hours was that game?

MOOKIE WILSON

It was an emotional roller coaster, up and down, up and down.

DARRYL STRAWBERRY

Back and forth, back and forth, on and on, what's gonna happen?

GREG PRINCE

It felt like it would never end, and it felt like there was no movement for inning after inning.

KEITH HERNANDEZ

Every inning we went out there after the ninth, the intensity was never more heightened.

RAY KNIGHT

The concentration level somehow elevates.

KEITH HERNANDEZ

Knowing that if they score a run, it's over, they get to play a Game 7, and they got Mike Scott.

GREG PRINCE

The time. Roger McDowell pitches the ninth to thirteenth innings; he gave up only one hit, he gave up no runs. Probably the greatest moment in the career of Roger McDowell.

KEITH HERNANDEZ

Roger went five innings of scoreless ball, which was just unbelievable.

GREG PRINCE

Unfortunately, the Mets had stopped scoring since the ninth. Up to the fourteenth inning.

WALLY BACKMAN

We were doing everything we could do to try to win that game.

Finally in the fourteenth inning—by now, it was longer than any other postseason game in Major League Baseball history—the Mets pushed across a run as Wally Backman singled in Strawberry. The Mets took a 4–3 lead into the bottom of the fourteenth inning.

DAVEY JOHNSON

We were one run up. I remember telling [pitching coach Mel] Stottlemyre, "It doesn't get any better than this, Mel. Relax, it doesn't get any better than this."

Jesse Orosco struck out Bill Doran, and the Mets were two outs away from winning the pennant for the first time since 1973.

DAVEY JOHNSON

Then Hatcher hits a home run off Orosco, and I said, "Forget what I said. This is terrible."

WALLY BACKMAN

I thought I was going to be the hero. And then Hatcher hit the home run. Goddamn him for that.

JOE McILVAINE

I have one memory of that game that forever sticks in my mind. It was when Billy Hatcher hit the home run for Houston. It hit the left-field foul pole in extra innings, and it's like the ball was suspended against that foul pole. It's like time stopped and the ball is sitting, adhering itself to the foul pole, and then it dropped down. It was such a battle. It was just, like, hand-to-hand combat.

ROGER ANGELL

A tie being broken in the fourteenth inning, then a re-tie in the fourteenth inning. When does that happen?

MOOKIE WILSON

I remember the uncertainty. We got it; no, you don't. You got it; no, you don't. My chest was hurting. And I wanted someone to win, even if it was the Astros, to get the thing over with, because I knew you'd be exhausted for the next day. And I knew if we lost we'd play Mike Scott, and you can't play Mike Scott exhausted. The only time I can ever remember my thinking, "Somebody just get it over with, I'm tired!"

JOE McILVAINE

I was in the game for fifty years, and I don't think there was ever a game more tense than that sixth game of the playoffs against Houston, that sixteen-inning beauty.

ERIK SHERMAN

There are just so many highlights from that game that you could spend an hour talking about, but for all the significance of that game, what really stands out, of course, is the final inning, which was nothing short of epic. Two teams have been battling for fifteen innings, for over four hours, and now you have this sixteenth inning.

Strawberry led off the sixteenth with a towering pop fly that fooled center fielder Hatcher, who thought the ball was hit deep, then raced in too late to catch it. Strawberry was on board with a bloop double, bringing up Ray Knight.

RAY KNIGHT

We needed to win that game badly. And I

was physically worn out. As I'm going out to the plate, Davey calls me back, and he says, "I want you to take a shot to right field." I had a raised sense of concentration. Complete concentration is the ability to think of nothing.

Knight poked a single to right field, Strawberry raced home, and the Mets had the lead again.

RAY KNIGHT

I'd gone up to the plate thinking about nothing but hitting the ball hard to the right side. Even if you're tired mentally, you still have ability to get to a level where you blank everything out. You're just quiet, and you're just looking for the ball.

A walk, a couple of wild pitches, and a base hit by Dykstra followed.

GREG PRINCE

Mets put together three runs and take a 7–4 lead.

ROGER ANGELL

At the Metropolitan Opera, they're about to have a performance of *The Marriage of Figaro*, but there's a Mets fan who goes outside, where he picks up the score, and just as the music starts up, he sits down in the front and he goes, "Seven. Four. Mets." Like this [thumbs-up gesture]. And all around there's a great hum and sigh. People are caught up; now they can watch the opera.

ERIK SHERMAN

And you think, okay, well, they're gonna win the pennant now.

GREG PRINCE

It's only three outs. And Jesse can certainly get three outs. 'Cause he's Jesse Orosco and we trust him.

SID FERNANDEZ

Jesse was gassed. He pitched three games in that series, and he was gassed. His fastball just didn't have the life it did.

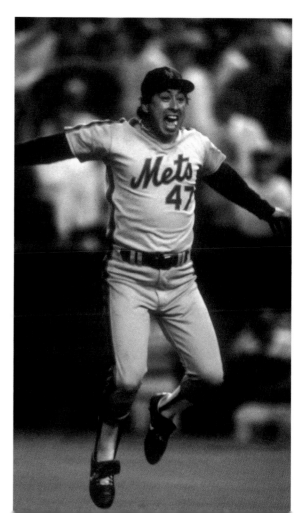

ERIK SHERMAN

And the Astros, they come battling back. They score two runs, and then they put the tying and winning runs on base.

RAY KNIGHT

Runner on second base and Kevin Bass is hitting. There was a meeting of the minds at the mound, led by Keith.

JAY HORWITZ

Probably the most famous mound visit in the history of baseball.

DAVEY JOHNSON

I didn't know anything about it. I didn't send him in.

KEITH HERNANDEZ

There has to be a team leader on the field. Someone there to help the pitchers.

DAVEY JOHNSON

That's why I say Keith was one heck of a leader, in ways you can't even imagine.

KEITH HERNANDEZ

I looked at his eyes, and I could see that he was gassed, and I just said, "Jesse, if you throw another fastball, we're gonna fight."

JAY HORWITZ

Keith said to Jesse, "If you throw another fastball, I'll kill you."

KEITH HERNANDEZ

He started laughing, which was what I wanted. And then Carter came in and I went to Gary, and I went, "He can't throw another fastball." And Carter says, "I know, I know, calm down, Keith. Calm down. I got it."

Bass struck out. The game was over. The Mets were National League champions.

LENNY DYKSTRA

It was a special year, man, like special, not like special like just special, no, special like the real special.

RAY KNIGHT

Giving so much of yourself physically and mentally to try to win a baseball game, the emotion that came out of me, never had I experienced this emotion.

LENNY DYKSTRA

Can't explain the feeling, you know, there's no drug that can replace it. There's no drug. Okay?

RAY KNIGHT

As I'm running to the mound, I mean I just . . . suddenly, tears are running down

my face, and that's not something that I'd ever done before.

WALLY BACKMAN

Such a hard-fought series.

DWIGHT GOODEN

Does anybody ever really talk about the Houston series? They all talk about Game 6 from the World Series, about the Buckner play, but to me, personally, I think the Houston series was bigger than that.

BILLY BEANE

The Houston series was one of the greatest series of all time.

DWIGHT GOODEN

'Cause if we don't win that game, there's no way we beat Mike Scott in Game 7.

RAY KNIGHT

It wouldn't have been a piece of cake. But hey, we don't have to worry about it, do we? [Laughs]

WALLY BACKMAN

We won. The rest was history.

ROGER ANGELL

Somebody was running around the reservoir, in New York, and he said there was something, there was a murmur all around,

a murmur from the city. Just this strange sound came up; the Mets had won. The Mets had won. Undefinable sound, not cheering, but some mass New York sound. Quite extraordinary.

Seventh-Inning Stretch: The Plane Ride

GREG PRINCE

Pouring champagne over one another in the clubhouse after jumping all over one another on the field wasn't enough. They get on their flight back to New York from Houston, and the flight became the stuff of legend.

JEFF PEARLMAN

The flight back from Houston is one of the great moments of American aviation.

DARRYL STRAWBERRY

Our flight back home was remarkable.

SID FERNANDEZ

Yeah. It was insane.

DWIGHT GOODEN

Picture the scene when we beat the Cubs, the clinch, and how everybody piled on the

pitcher's mound. Just picture that, but put it on the plane.

DARRYL STRAWBERRY

It's like a movie or something, like *Animal House*.

SID FERNANDEZ

Like *Animal House*. For three hours.

JEFF PEARLMAN

There's vomit everywhere. And there's food everywhere. Seats are broken.

KEITH HERNANDEZ

We had to get home.

SID FERNANDEZ

What do you call it? When you commit a crime, the statute of limitations? What we did to that plane, I mean, there was no doors on the plane when we came off.

SANDY CARTER

I knew you were going to ask me that. I was on that plane.

JEFF PEARLMAN

The Mets never had wives on the plane. And that was a rule from Frank Cashen, who was an old-school baseball guy. No wives allowed. And the Mets asked Frank Cashen, "Can the wives fly back with us if we win?"

KEITH HERNANDEZ

"Because they've been there all year, Frank. They've got to take care of the kids. They've got to cook all the off-hours, get the kids to the ballpark, they deserve to be on the flight."

JEFF PEARLMAN

"Okay, that seems fair."

KEITH HERNANDEZ

They got a real eye-opener. We had a couple wives that thought they could drink with us.

JEFF PEARLMAN

You know, the Mets are used to drinking on airplanes. The wives are not used to drinking on airplanes.

SANDY CARTER

The alcohol was flowing. . . .

SID FERNANDEZ

Wives are drinking like crazy. Throwing up everywhere.

KEITH HERNANDEZ

And they wound up selling Buicks on the carpet. They couldn't get to the bathroom on time.

JEFF PEARLMAN

The wives vomiting . . .

DAVEY JOHNSON

All the wives were on. The wives trashed it.

WALLY BACKMAN

There ended up being a whole row of chairs torn out of the airplane. It wasn't a player that tore those chairs out. It was a wife that tore those chairs out.

KEVIN MITCHELL

I'm not going to say who started it, I'm not going to say who finished it.

WALLY BACKMAN

Yeah, it was definitely a wife. Hundred percent.

KEVIN MITCHELL

I'm not gonna sit up here and burn nobody. I'm not going to do it.

JEFF PEARLMAN

That flight was a "Holy crap, we made it to the World Series" expression of pure joy.

JOE McILVAINE

And we weren't gonna interfere with them at all, because they deserved it. What they had just gone through, it was really something. It was a little unruly. . . .

JEFF PEARLMAN

It was like this endless stream of alcohol and celebration and bending seats back and breaking the seats.

KEVIN MITCHELL

I don't care if it was the wives or the players. I'm not gonna burn nobody. I'm just not gonna do it.

SID FERNANDEZ

Guys were coming out of the bathroom with cocaine. You got guys snorting coke in the bathroom.

WALLY BACKMAN

Everybody had a good time on the plane.

DWIGHT GOODEN

One guy's in there, you know, he's chopping it up or whatever, whenever he sees the door open, he just kicks the door closed.

WALLY BACKMAN

I mean, I can't imagine nobody not having a good time on the plane.

KEVIN MITCHELL

Food fight!

BOBBY OJEDA

We threw a lot of food around.

DARRYL STRAWBERRY

And wives were throwing food at people—

SANDY CARTER

The food was flowing—

KEVIN MITCHELL

I know some green peas was being thrown around, and some mashed potatoes.

DWIGHT GOODEN

You know, fruit, and food fight, all this stuff, crazy. Totally destroyed the plane.

JEFF PEARLMAN

The Mets had a charter company, and there were certain expectations when you use a charter company. You're going to return the plane in decent shape, you're going to treat the staff respectfully, you're not all going to do coke and throw food and vomit everywhere. And the Mets violated all of those conditions.

DWIGHT GOODEN

I don't think most of us realized when we were actually on the plane how high it was up in the air, and probably the pilot had to get it to land, trying to get rid of us.

VINNY GRECO

I was back in New York waiting for the team to get back. They were fucking drenched in beer, and their suits stunk, and it was just food shit everywhere. My brother was the batboy, and he was on that trip, and my brother was juvenile diabetic, never had a drink in his life. He got off the plane, and I remember looking at him like, "Paul, what the fuck happened?" And he was still in high school, and he had a test and he actually had his books on the plane doing homework, and when it started he just closed his books and he was, like, "Okay, I'm not gonna be able to do this." He goes, "I was scared. They were just throwing shit anywhere, they were pulling up seats, they were taking food off platters, they had cake, they were just whipping it out." I said, "What do you mean?" He goes, "One of the wives started it!" Still to this day, he tells his kids he was petrified that night.

BOBBY OJEDA

So we broke a couple seats. Threw some food around. We didn't burn the plane up, you know; what do you expect from that group?

JEFF PEARLMAN

The aviation company sends a bill to the Mets. About destroying the plane.

ERIK SHERMAN

Five thousand dollars' worth of damage to the plane.

KEITH HERNANDEZ

There was $18,000 in damage.

DARRYL STRAWBERRY

Pretty sure the bill was over, maybe, who knows, $100,000, $150,000 of damage done to the plane.

LENNY DYKSTRA

We must've ripped that fucker up pretty good, dude.

DWIGHT GOODEN

And the next day we're having our workout, and Frank Cashen, I remember him handing Davey Johnson the bill before the meeting, the bill for the plane-wrecking there . . .

BOBBY OJEDA

Davey's here, we're all sitting around, and Frank comes in. And he's pissed.

VINNY GRECO

Frank Cashen came down, and the team was together, all hungover, they were fucked up. And Frank goes, "That was a disgrace, what happened to that plane, and you guys are gonna wind up paying the damage there."

JEFF PEARLMAN

Frank Cashen was horrified by the '86 Mets. He thought ballplayers were supposed to be professional.

JOE McILVAINE

So he was not too happy with that.

JEFF PEARLMAN

You're representing the team, and you're representing the organization, and in a way, you're representing him, because he brought you here.

WALLY BACKMAN

Davey Johnson said, "You picked these players, not me."

BOBBY OJEDA

Frank stormed out of the room.

JEFF PEARLMAN

Davey Johnson is standing in front of the team with the bill. Telling the team, "Listen to me. You ruined the plane. And the organization says that we have to pay. We, the coaches and players, have to pay."

LENNY DYKSTRA

And Mookie stood up. "I ain't paying a goddamn thing," he said, because Mookie didn't drink nothing, you know what I mean?

MOOKIE WILSON

I wasn't paying a dime for nothing. Nope. Wasn't happening. [Laughs]

JEFF PEARLMAN

Davey Johnson, he said, "This is bad. This is really bad. But you know what? Fuck 'em. We're about to win a fuckin' World Series and we're gonna make them a shitload of money."

WALLY BACKMAN

So Davey Johnson ripped up this check.

DARRYL STRAWBERRY

He tore it up and said, "We ain't paying for nothing. We're going to the World Series."

DAVEY JOHNSON

I said, "I know you guys didn't do it. I know it had to be your wives." I said, "Don't worry about it, you deserve to celebrate, that was a hell of a series. Congratulations."

JEFF PEARLMAN

"Let's go fucking win a World Series." The place goes crazy. Players are like, "Yeah!"

DARRYL STRAWBERRY

Pretty cool of Davey. He just backed his boys.

RAY KNIGHT

Talking about a man that would back his players, that's a man that would back his players.

GREG PRINCE

The Mets are gonna do what they're gonna do, and right now they're gonna go to the World Series.

JEFF PEARLMAN

Davey Johnson's finest moment as a manager. If there were a movie about that team, it probably either starts or ends right there, with that moment.

Eighth Inning
WHERE WERE YOU?

The World Series was scheduled to begin on Saturday, October 18, a little more than two days after the Mets' plane arrived back at LaGuardia Airport in Queens in the early morning hours on Thursday.

DARRYL STRAWBERRY

That series against Houston just completely drained us.

GREG PRINCE

But the World Series beckoned.

DARRYL STRAWBERRY

Going into the World Series, we were just totally exhausted.

GREG PRINCE

I don't think the Mets were prepared for the fact that there was more baseball.

JEFF PEARLMAN

I mean the Red Sox were good, so I think part of it was a little hangover, and part of it was Boston was good and ready to go.

Enter the Red Sox

JEFF PEARLMAN

The Red Sox were good. The Red Sox had a very good lineup, and the Red Sox had a dominant starter in Roger Clemens. They had Wade Boggs, they had Jim Rice, they had Dwight Evans. They were a really, really, really good baseball team.

HOWARD BRYANT

The thing to remember most about the '86 Red Sox is that they were not the most likable team. It was the twenty-five players, twenty-five cabs Red Sox. They weren't a real warm and fuzzy, lovable Cinderella team. They were a bunch of hard-asses.

CALVIN SCHIRALDI

The Red Sox were loaded—and I think we were picked like fourth in the division that year. I mean you have Wade Boggs and Jim Rice and Dwight Evans and Don Baylor and Rich Gedman and all these guys, and it's like, "How can we be picked fourth or fifth with this group?" Dwight Evans leads the season off with a home run, first at bat. Okay, that's some kind of omen. We were pretty freaking good.

HOWARD BRYANT

Obviously Roger Clemens was the guy. I remember listening on the radio to the twenty-strikeout game against the Mariners, and Clemens '86 was Gooden '85, where you watched him just mow down hitters. He took on the persona of the entire team.

CALVIN SCHIRALDI

Roger was amazing.

HOWARD BRYANT

You had Jim Rice, who was still a legend; he still drove in 102 runs that year. And of course you had Wade Boggs, one of the best hitters in the game. It was a complete team.

ROGER ANGELL

And Bill Buckner was this great older player. Everybody respected him, he had a great career.

Dennis "Oil Can" Boyd was the Red Sox mercurial third starting pitcher.

JEFF PEARLMAN

The Can was kind of a throwback. I hate to use a crude comparison, but kind of in a way like Satchel Paige, the Negro Leagues, high-socks look. There was something oddly classic about Oil Can, in his delivery and his mannerisms.

HOWARD BRYANT

What I remember most about that season was Oil Can. He had a good year, and he seemed to have real difficulty with the fact that Roger Clemens was a better pitcher and was starting to become "the guy." And then, when he didn't make the All-Star team, then came the drug stories and everything else and that he had disappeared and had pulled a tantrum, and it was sad because it was a good team and they were really going places; and that's why I felt really happy for him when he was the one who pitched the clincher at the end of the season.

JEFF PEARLMAN

He was eccentric and quirky and weird, and talked a fair amount of trash. Definitely thought he was a little better than he was.

The Red Sox had just survived a gauntlet of their own—beating the California Angels in a taut seven-game series, highlighted by an amazing Game 5 in Anaheim. The Angels, leading three games to one in the American League Championship Series, took a 4–1 lead into the ninth inning, needing just three outs to clinch their first World Series appearance.

HOWARD BRYANT

What happened for the Red Sox in Anaheim is definitely cosmic.

CALVIN SCHIRALDI

We were down three runs in the last inning, and Don [Baylor] comes up with a runner on base, hits a two-run homer to get us within one, and then that's when all hell broke loose, because then they bring in the lefty to face Gedman. He hits Rich on the first pitch; they bring in Donnie [Moore]. Just a phenomenal at bat. The sound was deafening before then, from the fans. You literally couldn't hear somebody talking. . . . If you were talking to the person next to you, you couldn't hear in an open-air stadium. That's how loud it was. The horsemen were on the field getting ready to run out to keep the fans from running on, and we're in the dugout just screaming to get the F out of our dugout. Get the F out of our bullpen.

ROGER ANGELL

The Red Sox were on the verge of elimination. They were three runs down. The Angels were gonna qualify for the World Series. Looking over, I could see Reggie Jackson

there, taking his glasses off because of the impending celebration. They're getting right there on the field, celebrating the world—most certainly that didn't happen.

CALVIN SCHIRALDI
When Dave [Henderson] hit that home run, you could've heard a pin drop. It was the most awesome sound of silence I'd ever heard.

HOWARD BRYANT
And you win Game 5 the way you win Game 5, and you win Game 6, and then Roger Clemens just destroys the Angels in Game 7. You went into the World Series with enormous confidence. You weren't afraid of the Mets.

CALVIN SCHIRALDI
We were confident we could beat anybody.

KEVIN MITCHELL
Boston, man, you can't be confident against Boston, man. You can't do that.

MOOKIE WILSON
I think we were a little bit too relaxed going into that game against the Red Sox. We knew they were a good club, but I don't think we took them as seriously as we did the Astros.

ERIK SHERMAN
Hangover. The Mets' bats really looked slow.

Game 1 of the World Series was an odd affair. The weather was cold, the Shea Stadium crowd was subdued, and neither team could mount much of a threat until the seventh inning, when Rich Gedman hit a grounder that went through second baseman Tim Teufel's legs, scoring Jim Rice with the only run of the game.

GREG PRINCE
The Mets couldn't touch [Red Sox pitcher Bruce] Hurst. Darling was very good, but the ball went through the legs of Tim Teufel. John McNamara, the Red Sox manager, made a point every game the Red Sox had a lead: taking Bill Buckner out for defense and bringing in Dave Stapleton. His legs had gone bad.

ROGER ANGELL
And at this point in his career, Buckner's legs were so bad and ankles were so bad that it took him two hours of icing and preparation to get ready for every game.

GREG PRINCE

He could still hit, but he could barely bend down to tie his shoes, as they say.

Calvin Schiraldi came into the game in the ninth inning and retired the Mets without incident to save the game for the Red Sox.

CALVIN SCHIRALDI

Pretty exhilarating, especially being in New York had its benefits for me personally. Not to say anything bad, but I was doing it against a lot of guys that I knew; I mean, I pretty much knew everybody on that team, and so it was pretty gratifying.

Ray Knight had gone hitless in Game 1.

RAY KNIGHT

My dad took the two days off, and he and my mom took a train up there and saw the first two games, and I didn't do a thing in either game. In fact, in Game 2, Davey played HoJo.

DAVEY JOHNSON

I was giving Ray a little more playing time, but I loved Howard, and HoJo was a great left-handed hitter. In fact, a fastball hitter. So bringing him in was an easy platoon.

RAY KNIGHT

If you'd have been around me when I went into the restroom when I saw my name not on the lineup, tears just came down my eyes, 'cause I was so angry because I felt like I was the best person for the job. I went out to center field to talk to Davey during batting practice, and like an immature young man, I went out there and said, "Hey, I want you to know something," I said. "I love you, but I hate you today."

ERIK SHERMAN

Game 2 was one of those highly anticipated pitching duels.

GREG PRINCE

In a postseason that seemed to have a lot of incredible pitching matchups, this one was prepared to blow them all away.

In Game 2, Dwight Gooden squared off against Roger Clemens. But neither pitcher had good stuff. The Mets scored three off Clemens, knocking him from the game in the fifth inning. But Gooden fared even worse, giving up five runs and eight hits in just five innings. By the time he left the game, the score was 6–2 Red Sox.

DWIGHT GOODEN

I had nothing left. Going into that game, I had nothing. My fastball was flat, the curveball didn't have a good break. Location was off.

GREG PRINCE

The invincibility attached to Gooden was all

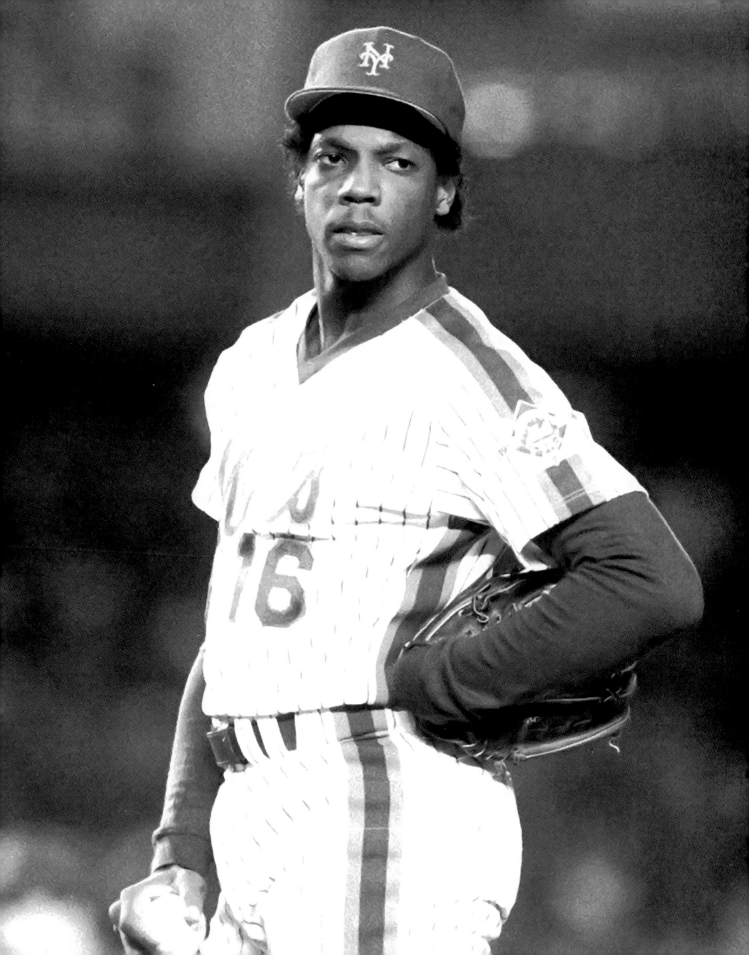

but gone now, but he was still Dwight Gooden. Still, I don't think anyone was expecting Dr. K to suddenly emerge. Shea Stadium, which had been so loud for so long, had kind of been on mute, and there was talk, well, these aren't the real fans, these are World Series fans and businesspeople who get the tickets.

HOWARD BRYANT

Suddenly, this was the place where the hedge funds and the bankers and the rest of those folks were starting to go to the game because it was the cool place to be; great for baseball, but totally changed the dynamic of what the ballpark feel was supposed to be like.

The final score was 9–3. The Red Sox had taken command of the series.

LENNY DYKSTRA

It happened so fast. I mean, we're down 0–2. What the fuck happened?

Genius

DAVEY JOHNSON

The manager's job is to sense the feeling on the club. I don't think you could ever be flat for a World Series, but I think you could be a little bit beat-up, emotionally. I mean, this game isn't that much about physical, it's emotional, mental. Six games against Houston, that took a lot out of the ball club.

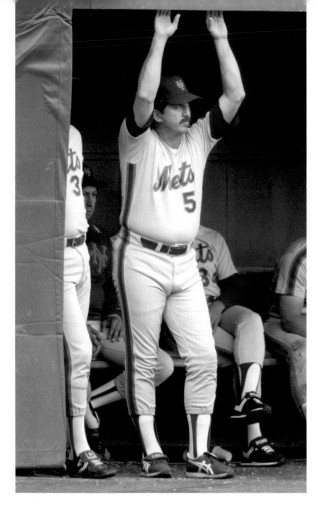

GREG PRINCE

Down two nothing, going on the road, Davey Johnson saw that you had to shake things up.

ERIK SHERMAN

Davey Johnson does something that you could never do today.

DAVEY JOHNSON

We had a workout day scheduled for Boston and it's a press day, and I said, it's an off day.

RAY KNIGHT

Davey came back on that bus and said, "Just go

to the hotel room, get yourself something to eat with your wives, we're not gonna work out, and let's just go get 'em tomorrow."

MOOKIE WILSON

It surprised me, but what a brilliant move.

WALLY BACKMAN

Giving the off day was a genius thought by Davey, I think.

RAY KNIGHT

That's the genius of Davey Johnson as a manager. Always tuned in.

JEFF PEARLMAN

I mean, genius is kind of a strong word for making a decision to give guys a day off, but it was a very smart move in a season with very smart moves from him.

RAY KNIGHT

Oh my gosh, it was like Christmas. It was like your birthday. It was like Daddy coming in the morning and saying, "You don't have to go to school today, I want you to go with me fishing." It was the greatest feeling in the world.

DARRYL STRAWBERRY

That's not something you're supposed to do in postseason because you gotta be there at the ballpark and practice and deal with the media.

MOOKIE WILSON

If we had to go to the ballpark, we would have been bombarded with the press.

DARRYL STRAWBERRY

He was like, "No, they can fine us, they can do whatever, you guys take the day off."

KEITH HERNANDEZ

The press was like, "Oh, the cocky Mets, they're down 0–2, they lost at home, and they don't have to take BP." Boston papers were killing us, and we didn't have to go to the park and talk about it.

DARRYL STRAWBERRY

I think a lot of us didn't do anything.

SID FERNANDEZ

It's not like we could roam around the city, because people knew who we were and Boston fans, I think, are worse than Yankee fans. [Laughs] They're very vocal.

GREG PRINCE

Bobby Ojeda showed up at the ballpark to answer questions because he was the next night's starting pitcher, but otherwise, nobody was obligated to come.

BOBBY OJEDA

The night before Game 3, I go out and have dinner, come back to the hotel, and I'm by

myself. There's two Red Sox, the top guys, general manager and another front-office guy: Haywood Sullivan and John Harrington. They hated me, I hated them. Remember, I did not enjoy my time in Boston. They've got cigars a foot long and they're laughing, joking around, patting me on the back. "Good luck tomorrow night." Laughing at me. So I'm just kind of taking it 'cause what am I gonna do? I just have to take it. But I'm thinking: This is *driving* me.

LENNY DYKSTRA

I told my wife, honest to God, "I'm gonna hit a home run to change the momentum."

BOBBY OJEDA

I had zero confidence going into that game.

LENNY DYKSTRA

I think it was important to help Bobby O. I needed to put a crooked number up just to kind of take the crowd out of it.

BOBBY OJEDA

But I was like: "With my ball club that I'm on I'll give us a chance to win."

LENNY DYKSTRA

That was cool, playing at Fenway Park too, man. Like, that was bitching 'cause seeing it as a kid, I'm like, I get there real early. Like, I'm in the World Series in fuckin' Boston, this is fuckin' crazy, you know.

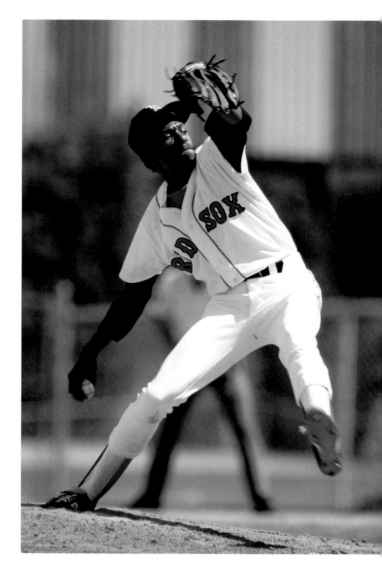

The Red Sox' starting pitcher was Dennis "Oil Can" Boyd.

JEFF PEARLMAN

And the Mets thought they could get into his head.

As Dykstra stood in the on-deck circle, the Mets players hurled a stream of invective at the opposing pitcher.

DARRYL STRAWBERRY

No doubt about it. We got a pitcher on the mound that we know we can hit, Oil Can.

JEFF PEARLMAN

"Shit Can, hey, Shit Can. You're a piece of shit."

HOWARD BRYANT

Baseball players, they're absolutely ruthless because they have so much time on their hands. They're all hanging out in the dugout; they're only playing half the game.

LENNY DYKSTRA

I literally tried to hit a home run, but when you try to hit a home run in baseball you fuckin' pop up or top it.

On the third pitch of the game, Dykstra hit a line drive to deep right field, a ball that circled just inside the foul pole at Fenway Park for a home run.

RAY KNIGHT

One swing of the bat. Instant, automatic, complete turnaround in the series. From "We gotta win today, we gotta win today, we gotta win today," to "Oh baby, all right, yes sir, here we go."

LENNY DYKSTRA

Right when I stepped on home plate, I look in their dugout and said, "Fuck you."

DARRYL STRAWBERRY

Let's go!

ERIK SHERMAN

Before you blink, the Mets have put four runs on the board before Oil Can settled down.

GREG PRINCE

And that's all Bobby Ojeda needed to push the Mets toward the victory they desperately needed.

By the end of the night, behind Ojeda's seven strong innings, Dykstra's four hits, and Gary Carter's three RBIs, the Mets had won 7–1.

BOBBY OJEDA

We got the win, and it was a pretty amazing win.

DARRYL STRAWBERRY

It was gonna be a race to the end.

The next night, Ron Darling took the mound for the Mets.

ERIK SHERMAN

Game 4, the Mets picked up where they left off in Game 3.

GREG PRINCE

Ron Darling grew up in Massachusetts rooting for the Red Sox, and now he's pitching against the Red Sox. So he's got family, he's got friends rooting against him because they're

Red Sox fans. In the best-case scenario for the Red Sox, they'd be starting Tom Seaver. Unfortunately, Tom Seaver is on the disabled list and they have to use Al Nipper, who had one of the highest ERAs of a starting pitcher in World Series history. But John McNamara, the Boston manager, figures, "We're gonna save our two big guns": Bruce Hurst for Game 5, Roger Clemens for Game 6. "Full rest, and maybe we'll get lucky."

KEITH HERNANDEZ

Nipper wasn't gonna beat us.

ERIK SHERMAN

Lenny hit another home run.

GREG PRINCE

Ron Darling had one of the best games of his life.

ERIK SHERMAN

And Gary Carter, who's really starting to heat up now, clocked two homers.

Game 5 saw Dwight Gooden face Bruce Hurst in a chance for Gooden to redeem himself after his poor showing in Game 2.

GREG PRINCE

If reputation meant anything, the Mets had an advantage going into Game 5 because they had Dwight Gooden going. But reputation wasn't what it used to be.

KEITH HERNANDEZ

He didn't help us. He got hit hard that series.

GREG PRINCE

Dwight Gooden did not look like himself.

MOOKIE WILSON

I was a little concerned. I mean, hey, that's our best pitcher.

DWIGHT GOODEN

I'm just off, I'm just not there, and those types of teams, all it takes if you're off a little bit, you're gonna get it.

GREG PRINCE

It wasn't just that he was giving up runs; he just looked uncomfortable out there.

KEITH HERNANDEZ

I didn't know what was going on, and it was a little deflating that he got hit.

MOOKIE WILSON

The only thing that I could remember thinking was, he's just not right.

GREG PRINCE

He was kind of *schvitzing*, if you will. Just there was something off about the guy.

ERIK SHERMAN

In hindsight, watching Doc Gooden pitch in

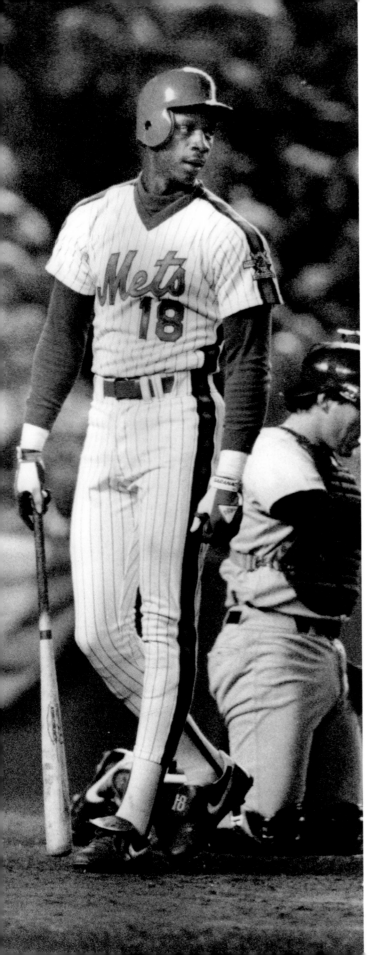

the World Series on a cold October evening
with sweat just pouring down his face, maybe
we should have known that something was up.

DWIGHT GOODEN

What everybody was saying, that really hurt
me, because I never used drugs before a start.
Here I'm out there, I'm finally getting into a
position where I want to be, and my team's in.
I want to win just as badly as anybody. I will
not jeopardize anything to hurt that.

*One of the game's highlights was provided by
Boston's aging first baseman, Bill Buckner. In
the third inning he was on second base with
Dwight Evans at bat.*

ROGER ANGELL

Even after all the icing and preparation, even
then he wasn't too spry. There's a moment
when Buckner's on second base and there's a
base hit. And he's rounding third, and he's
running as best he can and panting. He looked
like Walter Brennan, the old actor, coming
down, and everybody is cheering for him and
it's all falling apart. And he falls on home plate,
everybody's laughing. Dying laughing and
cheering for him, and he falls on home plate,
lies there. [Deep breaths] Just extraordinary.

*Game 5 also saw the birth of a chant that
would follow Darryl Strawberry the rest of his
career—the singsong "Dar-ryl, Dar-ryl," as*

serenaded by the Red Sox fans that night. It became so popular it would turn up in a Simpsons *episode a few years later.*

ERIK SHERMAN

Game 5, the fans at Fenway, they want to make a difference, so what better way to get under the skin of Darryl Strawberry?

JOHN STRAUSBAUGH

Boston fans can be even ruder than New York fans, I think.

ERIK SHERMAN

Chants of "Dar-ryl!"

GREG PRINCE

Dar-ryl!

JOHN STRAUSBAUGH

Dar-ryl!

DARRYL STRAWBERRY

Dar-ryl!

ERIK SHERMAN

—were just echoing throughout Fenway Park.

JOHN STRAUSBAUGH

He didn't like to be the center of attention. But he certainly did not want to be the focus of that sort of attitude and attention, and it must have been horrible for him.

DARRYL STRAWBERRY

People said, "Did that bother you?" And I said, "No, it didn't, it didn't my whole career. At least they know I'm in the ballpark."

ERIK SHERMAN

Then something brilliant came to his mind.

DARRYL STRAWBERRY

I used to let them know, "I'm here. How you doing?"

Darryl tipped his cap to the stands. The fans at Fenway roared.

JOHN STRAUSBAUGH

That's pretty ballsy. You gotta give him credit.

GREG PRINCE

Bruce Hurst was still on top of his game, and in the final game at Fenway Park, it was a party for the Red Sox.

The Red Sox won Game 5 by a score of 4–2. The Mets were one loss away from elimination.

GREG PRINCE

This team that had won 108 games, that had taken its division by 21½ games, was not going to be World Champions without a win on Saturday night.

Game Six

Game 6 was back at Shea Stadium the night of October 25, 1986. With his full rest, Roger Clemens would pitch for the Red Sox against his former teammate Bobby Ojeda.

MIKE "CHOPS" LACONTE

I remember for Game 6, against the Red Sox, the team was outside taking BP and there was nobody inside, and I walked into the clubhouse and I was picking up stuff to throw into the laundry, and Bobby was sitting in his chair, slumped back. He was already in the game. I got chills. He had all our hopes and dreams on his shoulders.

BOBBY OJEDA

I had to block that part out. For me, the trick was, this was just another game.

ERIK SHERMAN

Game 6 is obviously one of the most epic games in World Series history, on so many fronts.

GEORGE R. R. MARTIN

There's something about shared emotions in large crowds, which can be such an intense, emotional experience for the people there—they are feeding off of each other's emotions. I know about this as someone who reads history and studies these kinds of things, but I've really felt it in my life only a handful of times; and two of them were at Game 6.

GREG PRINCE

Game 6, as if it wasn't going to be crazy enough and intense enough, had a man tumble out of the sky.

In the first inning, with one out and a man on first base, Bill Buckner was at bat for the Red Sox. Suddenly, a Met fan came soaring out of the sky, wearing a parachute and trailing a banner that said GO METS.

BOBBY OJEDA

I'm on the mound, and you can read the crowd, and crowd noises, when you do this for a living. Before you know it, the whole stadium is cheering and I'm like, "Wow, they're

really into this game," but then out of the corner of my eye I see the guy floating down.

RAY KNIGHT

When I looked up it was that—*unh*! I don't know what that is.

WALLY BACKMAN

He flew over my head.

KEITH HERNANDEZ

It was pretty dramatic, really, if you think about it.

DARRYL STRAWBERRY

I thought, wow, this is gonna be a wild night.

JEFF PEARLMAN

Such a thing couldn't happen now.

MOOKIE WILSON

It was like, I hope you don't get hung up in the lights.

JEFF PEARLMAN

It's this great, made-in–New York moment. Like, "Oh my God, it's like an angel falling from the sky."

JOE PETRUCCIO

I turned to my wife and I said, "What more could you ask for?"

KEITH HERNANDEZ

They got him off the field right away, he just wanted to do his thing and he got off the field.

JEFF PEARLMAN

Ron Darling gives him a high five.

WALLY BACKMAN

Then I heard they arrested this guy, and the guy's a hero.

GREG PRINCE

Michael Sergio, an actor in New York, had seen what happened in Game 5 from Boston, which was that somebody had let out a bunch of balloons with a little sign that said "GO SOX." Sergio sees this and says, "I've gotta answer that pathetic display of balloons."

JOE PETRUCCIO

He was the epitome of a Mets fan.

Stubble

GREG PRINCE

The Mets are facing Roger Clemens, and he's on his game tonight. This is his Cy Young/ MVP year, and this is going to be the crowning glory. The chance to pitch the Red Sox to their first World Championship in sixty-eight years. The Red Sox had a bit of a lead; the Mets fought back. Then Ray Knight, who had

been at the heart of the Mets' success all year, threw a ball away.

RAY KNIGHT

The field started to get wet, misty. I fielded a ground ball and I brought it up to my glove; it took a little funny hop on me, but no big deal. I got it and I brought it up and got it in my glove and it was wet. I grabbed it right on the wet thing and like I always do, I don't think about it, I just grab the seams best I could and gunned it over there, and it just sailed on me.

GREG PRINCE

Keith Hernandez, the Mets' great Gold Glover infielder, can't handle it, and suddenly the Mets are in a hole again.

Knight's seventh-inning error gave the Red Sox a 3–2 lead.

RAY KNIGHT

After that inning, I went down to the clubhouse tunnel and I sat on the bench. I was so devastated and I said a prayer. I said, "Dear Lord, if this is a game of redeeming features, if there's any way, give me a chance to redeem myself."

DARRYL STRAWBERRY

Clemens was tough.

RAY KNIGHT

Roger had good stuff. He was throwing the ball really well.

ERIK SHERMAN

Roger Clemens develops a blister, but still he's pitching a four-hitter through seven. So, heading into the eighth inning is when one of the more controversial moves in baseball history was made by John McNamara.

In the top of the eighth inning, with the Red Sox still leading by a run, John McNamara pinch-hit for Roger Clemens.

DARRYL STRAWBERRY

I was really shocked that he came out of the ball game.

KEITH HERNANDEZ

I thought, "Why did you take Clemens out, with your bullpen? He's Cy Young."

KEVIN MITCHELL

God is good. They took Roger out, we got a chance now.

JEFF PEARLMAN

John McNamara did a very bad job. Clemens was rolling. Took him out, said Clemens asked him to take him out.

CALVIN SCHIRALDI

I have never known Roger to say that he wants to leave a game. He could have been on one leg, and he would have went back out to the mound.

GREG PRINCE

The Red Sox carry a lead into the eighth inning, but the Mets load the bases. Gary Carter, ready to be the hero, swings mightily, and he gets a sacrifice fly.

ERIK SHERMAN

On the New York side, Davey Johnson made some questionable moves. Darryl Strawberry getting taken out of the game in the eighth inning . . .

Davey Johnson brought in Rick Aguilera to pitch. Lee Mazzilli, who had pinch-hit and started the Mets' rally with a base hit in the top of the eighth inning, stayed in the game to play right field. The double switch meant that Darryl Strawberry was out of the game.

KEITH HERNANDEZ

I don't know what Davey was thinking of.

MOOKIE WILSON

I was shocked. Shocked that Davey made that move.

DARRYL STRAWBERRY

Never been taken out of the game before. Never.

JEFF PEARLMAN

For that to happen in a World Series, for the first time of your life, has to be a shocker.

DARRYL STRAWBERRY

I was so pissed at Davey.

JEFF PEARLMAN

Strawberry was furious. You don't take out Darryl Strawberry late in a game that needs to be won.

DARRYL STRAWBERRY

I didn't say anything; I just wasn't happy.

DAVEY JOHNSON

It's part of the game, you know. Having a degree of mathematics, I look at all the options that I have, and I choose the best-percentage option available.

ERIK SHERMAN

And then in the bottom of the ninth, with runners on first and second, Davey Johnson has Howard Johnson come up and sacrifice. Howard Johnson was not a bunter, so he failed to move the runners over; eventually he struck out, so the game moves into the tenth.

The tenth inning began badly for the home team.

GREG PRINCE

Rick Aguilera is pitching for the Mets.

ERIK SHERMAN

And Dave Henderson—we didn't know who Dave Henderson was before the playoffs started—leads off the tenth inning with a home run.

GREG PRINCE

Shea Stadium goes silent and it's not over yet, because Aguilera's still on the mound and before he can get the outs he needs, they cobble together one more run and it's 5–3, and at this point, three more outs and the Mets lose the World Series . . . and all that swagger was for nothing.

Magic Carpet Ride

GEORGE R. R. MARTIN

The gloom, the silence of that stadium when we went to the bottom of the tenth, it would have been wrong to speak. I've never felt such intense gloom.

MOOKIE WILSON

I didn't feel like all was lost, because we had Wally leading off, and we had Keith coming up. That's a good one-two punch to start with.

KEITH HERNANDEZ

Clemens always pitched with a growth, five-day growth. When he came back out of the club-house, I saw him on the Diamond Vision up there: "Look at that son of a gun!" He shaved.

GREG PRINCE

He decided he wanted to look good for the postgame celebration, which is amazing that somebody would think about that.

KEITH HERNANDEZ

That was kind of a rallying cry for us.

HOWARD BRYANT

That undermines the idea that you are completely focused on winning. That tells me that you think you've got it in the bag.

GREG PRINCE

In Game 6, unlike other games, Bill Buckner stayed on the field for the bottom of the tenth with the Red Sox up by two runs. John McNamara may have thought, "You know what, Buckner deserves this." Buckner was that important to the Red Sox and had such a long career and never won a World Series before. So Bill Buckner took the field in the bottom of the tenth inning to play first base.

CALVIN SCHIRALDI

I was very confident. I felt strong because I hadn't thrown in almost a week.

WALLY BACKMAN

He was a good pitcher. But I knew Calvin for years through the minor-league system before we traded him. The advantage that I had . . . I flew out to left field.

BOBBY OJEDA

Every play they made, they're counting down the outs. Each out was, "Yeah, we got this thing."

KEITH HERNANDEZ

I hit a fly ball to fairly deep left center field. I didn't hit it well, and it wasn't going anywhere.

BOBBY OJEDA

Dave Henderson, that stands out in my mind.

HOWARD BRYANT

The Dave Henderson freeze-frame pose was kind of awesome.

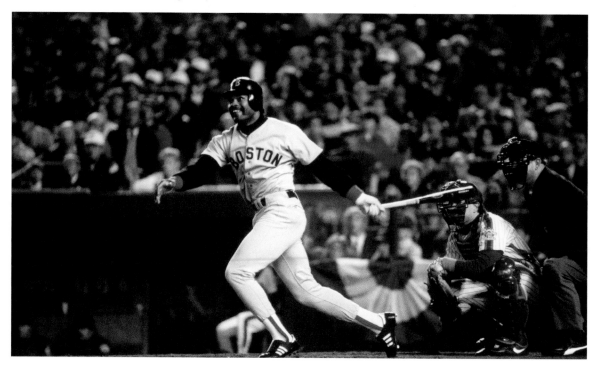

BOBBY OJEDA

Now, I get you're happy, I get the emotion, but you got work to do. There's still a game to play. And they're all on the top step.

DAVEY JOHNSON

When I saw all of them up on there, I said, "Boy, now it's a little early for that. It ain't over yet."

DWIGHT GOODEN

You're taught as kids, and I tell kids this, the game's never over till it's over. But unfortunately, I thought it was over.

KEITH HERNANDEZ

We're gonna lose. We are facing elimination after 108 wins and 98 wins the year prior, and it ends on a sour note. We were a failure.

MOOKIE WILSON

You're in panic mode. We in trouble right here.

GREG PRINCE

You're at the abyss and you see your entire season that you've been waiting your whole life for, essentially, and you see it fading away.

JEFF PEARLMAN

"Holy crap, I can't believe the Mets are going to lose the World Series. This is ridiculous."

MOOKIE WILSON

I look at the expression on Davey's face and I look at the expression on Mel Stottlemyre's face and it's like, we done blew this thing, man.

GREG PRINCE

Davey Johnson getting up, sitting down, trying to make something happen . . . and he can't.

LENNY DYKSTRA

I told HoJo, I said, "Man, I can't believe we're gonna lose the World Series."

BOBBY OJEDA

All this for nothing. You know? All this for not winning, for second place, which meant nothing to me.

MOOKIE WILSON

People say, "Well, you shouldn't have gave up. . . ." I hadn't given up. I was just looking at the odds, you know. The odds were *not* in our favor.

KEITH HERNANDEZ

When was there ever a Met team that was such a clear favorite? The Mets were never a favorite! We won 108 games. Only fourteen teams in the history of the game, over a hundred years old, won 108 games. And now, a disaster.

GREG PRINCE

We're seeing one dugout ready to explode in ecstasy and another ready to slink away into infamy.

KEITH HERNANDEZ

I'm very territorial. I don't want to see the Red Sox having fun on our field. So I go up, and I wind up in Davey's office. I should've been in the dugout. To the very end, no matter if we win or lose, I should have been on the bench watching it right there from the dugout instead of up in Davey's office watching on TV. I'm not proud of it.

DWIGHT GOODEN

I was in the clubhouse. Some guys are making their plans for their flight to go home, some guys are drinking beer, some guys are smoking cigarettes, some guys are getting undressed.

BOBBY OJEDA

I had a towel on. I wasn't in a hurry to take a shower because I wasn't in a hurry for the season to end.

DARRYL STRAWBERRY

I was in the clubhouse. I was with Hernandez and I was watching the game unfold.

JOE PETRUCCIO

I was at home on my couch, and I got a call

from my cousin. We were both in tears and we were like, "I can't believe this season is over. I can't believe that this is the way it's gonna end."

JEFF PEARLMAN

You hear people in hindsight, and you certainly hear Mets fans in hindsight, all like, "You gotta believe, you always gotta believe, I always believed." No, you didn't. I didn't.

MIKE "CHOPS" LACONTE

Somebody told us that we had to send our champagne down there to the visiting side. You know, the home team provides champagne for the celebration. And it's like, "Oh man, that sucks." You know, it's like, they're taking our champagne now, too.

VINNY GRECO

NBC at the time brought in the World Series trophy. Camera crew came in, set up. We took World Series Champ hats and T-shirts, hung 'em out in every locker. Then took the clear plastic and covered each locker around the thing, brought in the champagne.

KEITH HERNANDEZ

I sat down on one of Davey's chairs for his guests, and we're watching the game.

ANN LIGUORI

So I'm in the press box. It looked bleak for the

Mets, right? So all the reporters gathered their things to get down to the locker room, and all of a sudden George Foster appears. He's wearing a business suit. He must have been at that game for a business commitment or a sponsorship commitment, but he said, "Don't go anywhere, Ann. It's not over."

DAVEY JOHNSON

You never think it's over, but you can't—

MOOKIE WILSON

And the rest of it—you probably know the rest of it. . . .

Not So, Boston

There were two out and no one on base. The Mets trailed, 5–3. Gary Carter was due up.

RAY KNIGHT

I felt for sure that I was gonna get a chance to redeem myself.

SANDY CARTER

Gary hated to make the last out. He used to say, "I don't want to be the trivia question, 'Who made the last out?'"

RAY KNIGHT

I'm in the hole, and as he walks by me, Gary says to me, "I'm not making the last out."

SANDY CARTER

I don't think I've ever been more nervous in my life for him to be up. He just said, "I'm not saying that God's more of a Mets fan than a Red Sox, but I knew that God was gonna give me some extra strength," and he was still up at bat and they flashed by mistake across the scoreboard, "Congratulations Boston Red Sox, World Series Champs," for just a few seconds.

RAY KNIGHT

They had on the board, "Bruce Hurst, MVP"; they flashed that up there on the board.

CALVIN SCHIRALDI

With two outs and nobody on, instead of thinking the right thing, you go, "Man, one more out. One more out." That was the mindset I had, instead of, "Who am I facing, how do I get him out." It's like, "One more out."

Carter slapped a soft single into left field.

JEFF PEARLMAN

Bill Robinson used to do the two-finger five instead of the— He wouldn't slap with a hand, he would slap with two fingers. So they do the thing; Gary Carter, Mr. Clean, Mr. Sugar Free Bubble Gum, Teeth Carter, says, "I wasn't gonna make the last fucking out in this World Series."

GARY CARTER, 2003

I might not have dropped an F-bomber, but I said I wasn't going to make the last out.

SANDY CARTER

And of course it wasn't over yet, but that was the start.

JEFF PEARLMAN

They call for Kevin Mitchell to pinch-hit.

KEITH HERNANDEZ

Kevin Mitchell is in the clubhouse at his locker. Buddy Harrelson, our third-base coach, comes flying by me. I hear the door open, whack, and Buddy runs in: "Kevin, what the hell are you doing? You're pinch-hitting! Get your ass down there!" And Kevin grabs his hat, runs down onto the field—

JEFF PEARLMAN

Mitchell comes running up to pinch-hit. His fly is still undone; he doesn't have time to zip up his fly.

KEVIN MITCHELL

I mean, I'm a young rookie; you send me up with two outs, tenth inning in the World Series? C'mon, man. I mean, my mindset said that set me up for failure. Don't make the last out. I gotta be negative before I can be positive. That's the only way I'm going to get

aggressive and pissed off. It's the last out of the World Series; I'm not finna be the zero. I'm finna be a hero.

ERIK SHERMAN

Kevin Mitchell was roommates with Calvin Schiraldi in the Mets minor-league system.

KEVIN MITCHELL

Schiraldi always told me, "Mitch, I'd get you out, throw you fastballs in, sliders away." Always told me while we were sitting up there, laying down how he would pitch me.

CALVIN SCHIRALDI

None of this stuff ever occurred to me when he came up to the plate, about what I'd said two years before, all this kind of crap.

KEVIN MITCHELL

He started me with a fastball in; the next pitch I was looking for a slider.

CALVIN SCHIRALDI

Told him I'd throw a frickin' slider 'cause I know he can't hit it.

KEVIN MITCHELL

I said, "I'm going to go out here and hook this ball." He threw me a slider.

CALVIN SCHIRALDI

Well, I hung it and he freaking hammered it.

Mitchell lined a clean single to left.

JEFF PEARLMAN

Mitchell gets to first base, Bill Robinson [two-finger claps]. Mitchell says, "No way I'm making the last fucking out in this World Series."

DWIGHT GOODEN

Things started happening. I felt like we got a chance here.

KEITH HERNANDEZ

After Mitchell got the second hit, I said, "I'm not leaving this chair. This chair's got hits."

JEFF PEARLMAN

Hernandez is like, "Nobody move," because you don't mess with a rally, ever.

KEITH HERNANDEZ

Darrell Johnson [Mets scout] looked at me and said, "You stay right where you're at."

BOBBY OJEDA

And I'm like, I'm not gonna miss this, even in a towel. I put on my shower shoes and I run down the tunnel, so I'm like this [mimes peeking his head out], 'cause I'm in a towel, you know.

DARRYL STRAWBERRY

We knew Schiraldi could be tight. You say a guy gets a tight booty, you know, in those type of situations, can't close it, can't finish it out. You got a chance to finish it out, you got two outs, right?

WALLY BACKMAN

It's something that the players know: You can look into the face of somebody.

CALVIN SCHIRALDI

Things have been said: "The fear in your eyes," like they could see the fear in my eyes. We were winning, so how is there gonna be fear in my eyes? So that was all a crock of shit.

HOWARD BRYANT

NBC zoomed in and they showed Calvin Schiraldi's face, and he had a baby face anyway, but he looked scared. And you can't read into somebody's face: Was he scared? I don't know. I was scared.

ROGER ANGELL

My friend Allan Miller, who was a genius palindromist, called me during the game, and this palindrome suddenly occurred to him: "Not so, Boston."

Ray Knight strode to the plate.

RAY KNIGHT

I looked up on the on-deck circle at Nancy [*Lopez, his wife*] in the stands, and she had her hands buried and I could tell she was crying because she didn't want her husband in that situation, and I said, "It's okay. I got it. I got it." I was so positive because I had a chance. This is my chance, and Calvin wasn't somebody that caused me a lot of consternation or worry. Failure never came into my mind. So when I get up to the plate, I didn't do anything but think about the ball.

CALVIN SCHIRALDI

Ray comes up and I get ahead 0–2, and I'm trying to throw the ball up and I get it . . . not up as high as I wanted it or it needed to be.

RAY KNIGHT

It was a fastball that was kind of running in and I just inside-outed it.

CALVIN SCHIRALDI

I don't give up 0–2 hits, so that's what really pissed me off, was the fact that it was 0–2.

Knight's hit plopped onto the grass in center field. Carter scored from second base, and Mitchell scampered to third base. The score was 5–4, and suddenly Shea Stadium was rocking again.

JEFF PEARLMAN

Knight gets to first base: "No fucking way I'm making the last out in this World Series." Robinson told me that before he died—he said all three guys told him, "No fucking way I'm making the last out in the World Series."

RAY KNIGHT

That is exactly what I said.

VINNY GRECO

Stuff is all still in the locker room. They get the first run back and we're like, "Tony [Carullo, the visiting clubhouse manager], what do we do?" 'Cause if you make the wrong move and you're not set up . . . so we don't make no move.

JAY HORWITZ

After Gary scored, he went in the dugout. He put his shin guards on. That was Gary, he went back and got dressed. We weren't gonna lose. Either we'll tie the game up or we're gonna win.

KEVIN MITCHELL

Ray Knight got the base hit; I went from first to third with two outs on the little *dinker* he hit. I'm not looking at the third-base coach, Buddy Harrelson, I'm going on my judgment how that ball was hit.

ERIK SHERMAN

That was a risky play and is often overshadowed. So now you have first and third.

With the score now 5–4, Red Sox manager John McNamara came out to change pitchers. There were still two outs.

CALVIN SCHIRALDI

I knew he was coming out to take me out. He had to, that's a part of baseball, shit happens. Nobody's perfect in this game; nobody will ever be perfect in this game.

Schiraldi departed. Reliever Bob Stanley came trotting in from the bullpen. The batter was Mookie Wilson.

JEFF PEARLMAN

Bob Stanley was a good Major League pitcher. He was a good closer, but he wasn't an intimidating closer.

MOOKIE WILSON

My bag is all packed. I'm not even thinking I'm gonna get a chance to hit. Now I gotta regroup, I gotta go up there to hit. I gotta get ready to hit.

GREG PRINCE

Mookie Wilson liked to say his philosophy of hitting was "Thou shalt not pass."

MOOKIE WILSON

"Thou shall not pass without an offering." That was an old thing, when you pass the collection plate in church. That really describes the type of hitter I was. I was a free swinger. My stats showed it. I think I had six-hundred-something at bats one time—and had eighteen walks. It was just ridiculous, but that was me. That was who I was.

GREG PRINCE

He's gonna foul off one pitch after another if he can handle it.

MOOKIE WILSON

Wouldn't you know it, I get two strikes on me right away. One thing I'm not gonna do: I'm not gonna take third strike. You can forget about that. So I'm up there battling, man. I'm swinging at everything he throws up there— the kitchen sink, I'm swinging at it, too.

JEFF PEARLMAN

There are a couple of things about Mookie Wilson that are really important in that moment. Number one: He wasn't gonna choke. Now, he might strike out, he might line out, he might ground out, whatever. It wasn't gonna be because the moment was too big for him.

MOOKIE WILSON

I wasn't nervous at all. I was not nervous during the whole at bat.

JEFF PEARLMAN

Number two: He was ridiculously fast. He had incredible acceleration out of the batter's box. He got out super quick, which meant people felt more pressure to get the balls quicker.

MOOKIE WILSON

I was so focused on one thing and that is, "Hey, you gotta put this ball in play."

KEVIN MITCHELL

Buddy said, this is his exact words, man, he said, "Mitch, be ready, because he's always bouncing balls." Sure enough, Stanley bounced the ball.

With the count two and two, on the eighth pitch of the at bat—the thirteenth pitch that could have ended the Mets season—Bob Stanley threw a pitch that got by catcher Rich Gedman and went all the way to the backstop. Kevin Mitchell bounded home with the tying run. Shea Stadium was in delirium.

JEFF PEARLMAN

Mookie leaps out of the way and he's doing this [windmills arm]; he's doing this.

RAY KNIGHT

All heck broke loose after that.

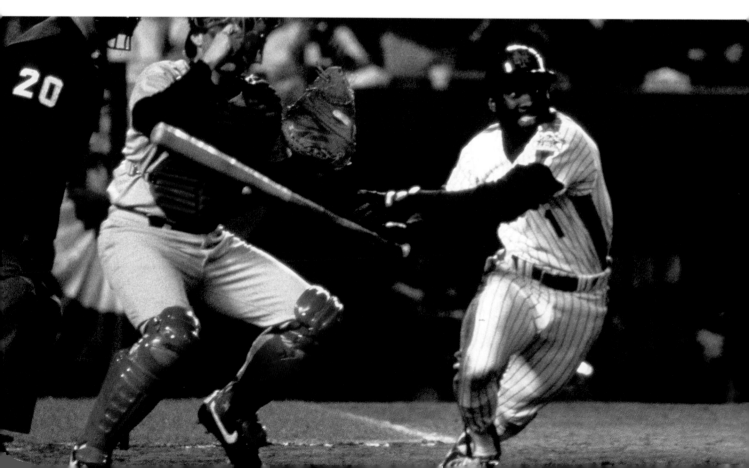

JEFF PEARLMAN

The place goes crazy.

BOBBY OJEDA

The place is electric. The building was shaking.

KEITH HERNANDEZ

The foundations of the stadium, and we were underneath the box seats. Shaking.

JEFF PEARLMAN

You're like, "What the—? Wait, what?"

DAVEY JOHNSON

I mean, that wild pitch—the momentum shifted.

HOWARD BRYANT

I was like, okay, this is gonna be an epic collapse. You could feel that.

MOOKIE WILSON

I don't care what happens now. I'm off the hook. I can't lose the game now.

One more foul ball, and then finally, on the tenth pitch of the at bat, Mookie topped a dribbler down the first-base line.

MOOKIE WILSON

It was a good pitch for me to hit, and when I rolled over it, I said something I shouldn't have said, and I never said it; it's a four-letter word. But now once I hit it and I done said what I had to say, I got to run.

JEFF PEARLMAN

Mookie's acceleration out of the box is just exceptional, right?

MOOKIE WILSON

Well, I'm running, and the ball is like taking forever to get to first base, and when it gets by him, I said that same thing again. [Laughs] I said it again, and it's getting to be a habit.

KEITH HERNANDEZ

If it's anybody else in our lineup, Buckner makes that play. But Buckner played in the National League, and he knew Mookie could fly.

GREG PRINCE

It went through his legs, and that was that.

KEVIN MITCHELL

Those are the hardest balls. You'd rather have a 110-mile-an-hour hit at you than them little short lazy ones, man. Those are the hardest ones for an infielder 'cause you don't know what type of hop it's gonna take.

JEFF PEARLMAN

It was a bad combination, or a good combination, of an exceptionally fast player, an exceptionally damaged first baseman, and just a moment frozen in history.

MOOKIE WILSON

That's the question I get a lot of: "Do you think you would have beat Buckner to the bag?" . . . Yes!

KEVIN MITCHELL

It would've been close, I'll tell you that.

MOOKIE WILSON

Not knowing the game is over, I'm going to second base like I'm about to get in scoring position, for what? [Laughs] It's something that I grew up doing. It's running hard.

RAY KNIGHT

I knew it was a routine ground ball, and I knew Buddy was not gonna try to send me home, so I would be stopping at third, so as I get about three quarters of the way to third, I heard Buddy say, "Come on, come on," and I just looked over my shoulder and I saw the ball trickling to right field; and from that point on I felt like I was on a magic carpet. I didn't feel like my feet were touching the ground. I had this overwhelming sensation that I'd never had before, never had since. I can't even explain it. It seemed like I just floated to home plate. I remember the whole thing, but it was an unbelievable feeling of elation that just went all through my body, and I jumped on home plate so hard that I didn't bend my knees and thought I might have hurt my back. Then, when everybody jumped on me, I knew I had hurt my back.

SID FERNANDEZ

"What? What just happened? What the fuck?"

ROGER ANGELL

It was a feeling of weird things happening around you, that baseball had burst its bounds, basically. We were all experiencing stuff that hadn't been experienced before.

LENNY DYKSTRA

It was so surreal, so unbelievable.

JAY HORWITZ

It was just an amazing feeling, coming back from the dead.

GEORGE R. R. MARTIN

The love—that total strangers were hugging each other and dancing, and I was right in the middle of it, you know. Soaking it all in. It was so intense. It's a kind of emotional high you just can't get most of the time in life.

JOE PETRUCCIO

I called my cousin back and we were still crying.

VINNY GRECO

My boss Tony goes, "Get it all out." We start ripping the shit down, plastic, taking the T-shirts, throwing them in, we had the laundry bin, just filling it up, throwing it out the back door, because you only had seconds

IT WAS
SO SURREAL, SO
UNBELIEVABLE.

LENNY DYKSTRA

before that first Red Sox player walked in. By the time the first player walked in that door, there wasn't a single thing in that locker room. No champagne, no trophy, no camera, no T-shirt, no nothing, and you looked at the players and you're like, "This team is done." It was like a morgue. I remember the lights even being dim, and these guys just sat in their lockers, not throwing shit, just demoralized.

CALVIN SCHIRALDI

It just wasn't meant to be that night for us.

JEFF PEARLMAN

It's so freaking heartbreaking for Bill Buckner. The humiliation of the ball going between his legs. Between his legs. Watching Bill Buckner walk off the field in defeat is crushing.

ED LYNCH

Ed Romero was an extra infielder on the Red Sox team, and he told me the story. They're getting ready to go on the field. One of the coaches turns to John McNamara and says, "Want to put Stape in?" And McNamara turned around and said, "No, I want to win it with my guys." That's why you play the game like you play every other game until the last out.

LENNY DYKSTRA

When you get feelings involved in business,

and baseball is business, the baseball gods come down. McNamara wanted him to be on the field to win the World Series, you know? No-no-no.

VINNY GRECO

I remember Buckner coming in, and I felt so bad for that guy. Guys were trying to console him, saying, "All right, man, we'll get 'em tomorrow, we'll get 'em tomorrow." That guy was like his spirit came out of him.

HOWARD BRYANT

They remember him for one thing. And I remember Johnny Pesky, because Pesky was always the one blamed for holding the ball in Game 7 of the '46 World Series, and Pesky said, "Even to this day people look at me like I'm a piece of shit." That would be Bill Buckner's fate, and it would undermine everything Bill Buckner ever did in his career, which was completely unfair and it's what we do to people.

ROGER ANGELL

It was terrible. The fate of the World Series has obscured all of this.

VINNY GRECO

We had a valuable box, we called them, in the trainer's room, with a lock, and Don Baylor said, "I need my valuables," and he was

yelling. So I went to go get the key, and by the time I went to get the key there—it was a double door—he took his hand, and he was a big guy . . . he took the top of the thing and ripped it off the hinges. Took the door and just threw it, took his valuables, and left.

BOBBY OJEDA

And everybody floods out, and I fled up the tunnel. I gotta get out here and get a towel. So I head up and then the locker room was just euphoric.

RAY KNIGHT

The elation of sharing it with my teammates was as strong a feeling as I've ever had emotionally. I mean, it's like, you love these guys so much and it's just, "We're here tomorrow. We're still in this thing, and we can play this game." And now you start talking trash.

MOOKIE WILSON

I didn't celebrate. I went in the clubhouse, then I went to the training room and I sat on the table and I said, "What just happened?" I could not believe what had just happened. 'Cause we, in all statistical data in the world, we'd lost that game, we should have lost that game, but we didn't. We won that game. Somehow, some way, we won that game, and it took me a while to digest the fact that we did really win that ball game.

MIKE "CHOPS" LACONTE

My job then, after the game, was to bring out the cart for us to load all the bats and all the clubhouse stuff to go back into the clubhouse. I waited in the dugout, exhaled, and I just started bawling. And the commissioner walks by, Don Johnson was there, and Bill Murray, one of my heroes, walks by, and I'm crying. And I think everybody got it.

MOOKIE WILSON

Man, I still get chills. It never gets old, man. Never gets old.

LENNY DYKSTRA

When I go back to New York, this is thirty-something years later, they all talk about it like it was yesterday, they remember it so vividly.

BOBBY OJEDA

I know where I was when we won Game 6. I was in the tunnel in a towel, shower shoes, with a beer in my hand, but over the years I've heard thousands, literally thousands of stories from fans who come up to me vividly recalling, smiles you couldn't believe, so lit up to tell me the story, to share their story of where they were. It was one of those moments. It was an instant and it changed all our lives.

The Fans Speak

JOHN S. I'm sitting in row 4, Loge section 12.

ADAM P. I was in Ojai, California.

JIMMY P. I had a big body cast on.

STEPHEN V. We lived across the street from Shea Stadium. So close that you could smell the hot dogs.

MATT V. I was watching it in my bedroom; it was a Saturday night.

JEREMY S. We were firmly, firmly Red Sox fans, to the point where none of us were shaving.

JOHN K. A couple of my buddies from college called me up that night and they said, "Hey, we have a couple tickets to go see Journey, I think at the Meadowlands, you wanna come?" And I'm like, "What, Journey?"

KERRY C. I was working at a bar, the bar that I hung out at, at the time, called Dorrian's.

JOSH M. I was outside Shea Stadium with a live truck.

RICHARD H. I had a TV set that I had gotten down on Canal Street.

KEVIN C. Watching the game on our brand-new Mitsubishi Diamond Vision television set.

JENNIFER P. My boyfriend had called me up: "I have Series tickets—and the seats are really good!"

JOHN T. I was behind home plate, at the Loge level.

MATT S. One place I wasn't, was in Shea Stadium.

MELISSA M. We were at the Cafe Carlyle, listening to Bobby Short.

MICHAEL D. Wandering the parking lot, looking for a ticket.

DAN M. I find an old man who's looking for a ticket as well.

MIKE S. I'm watching the game in the barracks.

PETER D. I was in Barbados.

SAL L. I was surrounded by Red Sox fans.

HILLARY E. [sings] "Roger Clemens, Roger Clemens. Roger Clemens, Roger Clemens."

FRED B. My daughter Julia had just been born, and she wasn't sleeping that well; she must have known something was up, because I had her in my arms during that famous tenth inning.

JOHN Q. And I was thinking to myself, "Here it is, the Red Sox are finally gonna win a World Series."

JEREMY S. And that coincides with my roommates all lathering up and putting on shaving cream, ready to shave our beards.

RICHARD H. We had lost, I thought.

ERIC G. Being a lifelong Mets fan is about pain.

EDGAR L. I got moisture, I got moisture coming out of my eyes, okay.

DAN M. I remember Shea being so quiet that I could hear the Red Sox cheering in their dugout.

STUART H. We're watching the game almost in silence, in shock.

MANU S. My mom was sitting over to the side with my sister. She tried to make us feel better. I still remember her saying, "It was a great season, everybody."

STUART H. Disbelief gave way to despair.

ANDREW M. And instead, moment by moment, I was hearing how that inning progressed.

VICENTE C. I'm hiding the radio under the table. I've got Bobby Short in one ear, [Mets radio broadcaster] Bob Murphy in the other ear.

TIM D. I was with a young woman, and we were together that night in Santa Monica. But we had the game on, and I could hear what was happening. . . . Clearly, I wasn't very present for this young woman. Or for the Mets.

FRED B. I turned to her mother and said, "It doesn't look good, but the game ain't over."

JAMES G. I'm at Eddie Carroll's in Bay Ridge, Brooklyn. 67th and 5th. It ain't there anymore, but it was a great place to hang out. Eddie Carroll's was packed. And one of the regulars there was a guy I'll call Red. Red had some passing connection to

Boston. He decided that he was not just gonna cheer for Boston, but be a jerk about it in a whole bar full of Mets fans. Anyway, Game 6 is unfolding, and he is just being a dick. And one of my friends — Rick, I'll call him — came up to me and said, "I've had it." Tenth inning rolls around. We're down two outs, nobody on. I see Rick kind of standing next to Red and I'm looking at him, he's looking at me, and I know something's gonna happen. Fortunately, at Shea, something was happening.

RICHARD T. And sure enough, Gary Carter hits a single.

JOHN K. And I remember, my thought was, "Can you just get this over with so I can be miserable and start my winter?"

MARK P. You know, and then it all happened, and there was a hit and a hit.

FRANCIS P. I turned to my brother-in-law: "I think we're gonna single them to death."

PETER D. Up comes Mookie Wilson.

MATT V. Mookie Wilson, the one player in this lineup that went through all the years that they sucked.

MICHAEL D. And I looked at my father and said, "If he throws a wild pitch, I'll kiss your feet."

FRED B. And you know the rest of the story.

LEE B. The rafters above me were shaking up and down.

JOSH M. Outside Shea Stadium, you could feel the ground vibrate like it was an earthquake.

JENNIFER P. That's one of my memories that stuck in my mind: Mookie, waving, waving, waving.

MARK P. Waving to Kevin Mitchell to come home, yeah, yeah, yeah. Mookie was special.

JOHN K. My mother tried to come into the living room to jump up and down with us, and I started screaming at her. I threw her back in the kitchen and said, "Don't come out until the Mets win this game."

MATT V. Tenth pitch of the at bat.

MITCH B. Mookie hits the ball.

FRANCIS P. I turn to my brother-in-law and I say, "I think he's got this beat."

HILLARY E. And then, that thing happened. Bill Buckner.

KEVIN C. Obviously, the rest is history.

ALLAN M. The ball goes through Buckner's legs!

JENNIFER P. It was like a cartoon.

FRANCIS P. It goes through Buckner's legs, and Ray Knight scores from second base.

DAN M. It almost took us a second to realize: The game's over.

RON C. It was unbelievable.

DOUG E. And while I was talking to my mom, the error happened, and it was like disaster.

RON C. The place was over the top.

RON M. Everybody says it. We looked at each other and said, "Did that really happen? Are we still alive?"

RON C. Shea Stadium shook more than it's ever shook, and I've been to a lot of games.

RON M. Then you hear this roar outside and you realize everybody was watching.

RICHARD H. I have to admit, as a Mets fan, while I was exhilarated, I actually felt something tragic for Bill.

ERIC G. That was an aberration, that was a disruption in the fabric of space-time.

JOHN K. My father, who had been a lifelong Mets fan, he used to take his religious medallion, that hung on a chain, and he would put it in the middle of his forehead and press it there and leave it there for good luck. And I remember him jumping up and the chain came down and we just hug each other and not letting go of each other.

VICENTE C. Boom, the whole thing is over, Mets win. Somebody goes over to Bobby Short and lets him know what just happened.

MELISSA M. And there was like a moment, there's a moment between Bobby Short and my dad and the audience in the club and it was like, you know, we won!

DAN M. Running down the ramps at Shea Stadium, those ramps from the upper deck, and people, strangers, hugging and kissing one another.

FRANCIS P. We make our way up to the roof of their apartment. We share in the joy

and jubilation that was emanating from Shea Stadium.

VICTOR L. It was like a mini V-J Day.

STEPHEN V. You could feel all of Queens rocking. It was palpable.

JAMES G. In that turn of events and the bedlam at Eddie Carroll's . . . Everybody's drunk. Everybody's going crazy and I turn around to look at Rick and he's not doing anything, he's just standing there. But he's got this shit-ass stupid smile on his face. And all of a sudden I look down and he's holding his dick out and he's pissing on Red's leg. Red's so drunk and the place is going crazy; he never knew. Rick's just hosing down his leg.

RICHARD H. I was so excited that I went into the kitchen and got a pot and wooden spoon and I opened the window and I leaned and I banged my pot out onto 72nd Street.

KERRY C. And in the back of my notebook, which I've scribbled all over, there is this poem that I wrote: "It's two thirty-nine a.m., I can't even think about what the day is, I'm drunk, but the news is, colon, 'AHHHH!'"

RICHARD H. And then we walked down toward Columbus Avenue and we walked into a bar and stayed up for hours.

ERIC G. But it was never gonna happen again: You know it, I know it, every Met fan knows it.

JOHN K. And P.S., those four schmucks came back from the Journey concert.

KEN S. The Mets have put me through so much crap in the last thirty-plus years, but you know what, I wouldn't trade what happened that night for anything.

RON M. It was the best game of the best season of the best team.

MELISSA M. It was New York. It was all okay.

Ninth Inning
THE END OF THE WORLD

There was still another ball game to be played.

DAVEY JOHNSON
You can feel momentum and when it's going your way, you ride it.

WALLY BACKMAN
We had all that momentum, but that momentum's lost when you have a rainout.

ERIK SHERMAN
The Red Sox caught a major break between Games 6 and 7. There was a rainout. Now this allowed the Red Sox to throw Bruce Hurst at the Mets for a third time.

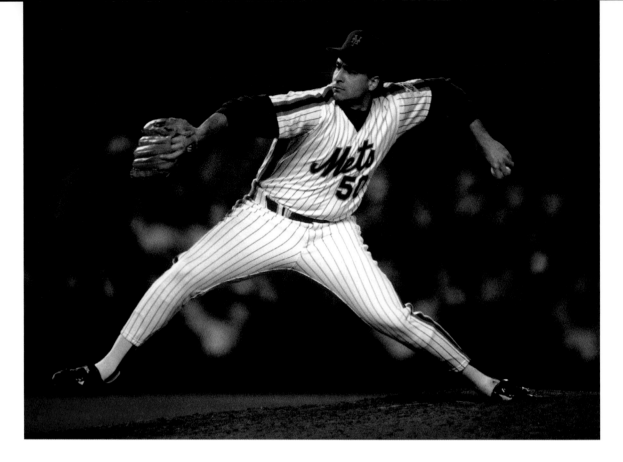

RAY KNIGHT

We had our work cut out with him.

WALLY BACKMAN

If we didn't have the rainout, it was gonna be a blowout. That was my feeling. So it was back to fighting and digging and scraping.

On Monday night, October 27, Game 7 was played at Shea. Only 1981, a strike season with an extra round of playoffs, had ever seen base-ball played at a later date. It was as if the sport didn't want to go away for the winter.

CALVIN SCHIRALDI

I thought for Game 7, it was an eerie feeling.

GREG PRINCE

Ron Darling is pitching for the Mets, and he doesn't really have it early on.

The Red Sox started the second inning with two home runs, the second hit by Rich Gedman, a fly ball to deep right field that tipped off the glove of Darryl Strawberry and over the fence.

DARRYL STRAWBERRY

First time that ever happened. Usually I could climb the fence, get over the fence, and make that play.

GREG PRINCE

Karma is not necessarily on the Mets' side.

BOBBY OJEDA

How many times can you come back? Right?

With Darling ineffective, and the score 3–0 Boston in the top of the fourth, the pitcher's night came to an end.

BOBBY OJEDA

So, thank God, Davey pulled him out. But then comes the cult hero Sid—he was sort of the forgotten man in the postseason; he was taken out of the rotation. It was almost like he was the kid in the back, [raising his hand] "I can play, coach, pick me."

SID FERNANDEZ

I do remember jogging in, nervous as hell. I'm also just cotton-dry. Keith said to me, "Hold them here, we're gonna win this game."

Fernandez got through the fourth inning, then retired the side in order in the fifth, striking out Rice and Evans to end the inning.

SID FERNANDEZ

You could feel something change in that stadium.

BOBBY OJEDA

He saved '86. Without Sid, the game is over.

SID FERNANDEZ

When I came off the field, from the second inning I was out there, it was pretty much pandemonium already.

BOBBY OJEDA

And then our guys went to work.

Fernandez struck out two more batters in the sixth, and then in the bottom of the sixth, the Mets' bats finally awoke. With one out, Lee Mazzilli pinch-hit for Fernandez and singled. Mookie Wilson singled. Then Tim Teufel drew a walk, loading the bases for Keith Hernandez.

KEITH HERNANDEZ

I'm going, "You want me? You're gonna pitch around Teufel and you want me?"

ROGER ANGELL

The extraordinary thing is that this was the exact recapitulation of 1982 against the Brewers.

KEITH HERNANDEZ

I'm in the on-deck circle and it's loud as hell, and I'm going, "Oh man, it's on me." I was feeling it: I got to come through. Think about all the sequences that had to come up in that game where it fell on me. The roulette table and you roll that thing out there and it fell on 17.

DAVEY JOHNSON

He shined in those moments. He lived for those moments.

KEITH HERNANDEZ

My brother, my talisman, my best friend, Gary, was there, going all the way back to when we were kids. Gary was sitting behind home plate, and we caught each other's eyes as I was walking to the plate, and he just gave me a power sign, and that calmed me down and I got in the box.

Hernandez family home movie

KEITH HERNANDEZ

Hurst led me off with that curveball, first pitch, nasty curve, and he buckled me and I went, "Oh boy, strike one." So I choked up a little more because all that was needed was a base hit.

Hernandez lined the next pitch into center field, scoring two and drawing the Mets to within one run. Shea Stadium was roaring.

KEITH HERNANDEZ

And there's my brother—and with a big smile on his face. I don't think I would have gotten a hit if he wasn't there.

ERIK SHERMAN

Then Gary Carter follows Keith Hernandez.

Carter plunked the first pitch toward shallow right field. As Red Sox right fielder Dwight Evans came racing in, Hernandez was unsure if the ball would drop, so he hesitated just a few feet off first base, to avoid being doubled off the bag if Evans caught the ball.

ERIK SHERMAN

The umpires couldn't tell immediately if Dwight Evans had caught the ball, or if it had hit the ground.

Evans dove for the ball and tumbled over on it before the umpires ruled he had not caught it. Hernandez, who had raced back toward first when it appeared the ball would be caught, was out at second when Evans picked up the ball and fired it there for a force-out.

ERIK SHERMAN

Both Keith Hernandez and Gary Carter were very upset about how that play went down, but for two different reasons. Keith was upset with the umpires for not making the call quickly enough so he could get to second base safely,

and for Gary Carter it's a force-out, so that hurts his batting average in the World Series.

KEITH HERNANDEZ

Gary came up to me after the game and said, "You cost me my .300 batting average," and I said, "You gotta be kidding me. How about if he caught that ball and I get doubled up?" He goes, "I know, I know, I know." But that was Kid. He couldn't help himself sometimes.

Still, the Mets had tied the score, 3–3.

GREG PRINCE

And now the Mets have the momentum and the Red Sox have none of it.

RAY KNIGHT

Anytime that the New York Mets were even, I felt we were gonna win.

In the bottom of the seventh, with the score still 3–3, the Red Sox brought in a new pitcher: Calvin Schiraldi.

CALVIN SCHIRALDI

The mindset after Game 6 was to shake it off; I'd had success the entire year—and why would one game change that? Baseball is a sport of failure, and how do you deal with that?

ERIK SHERMAN

The first batter he faces: Ray Knight.

DAVEY JOHNSON

Ray Knight is a really good, dead fastball hitter. He could hit hard heat.

RAY KNIGHT

I was free and easy leading off that inning.

Met fans, echoing the serenade of Darryl Strawberry at Fenway Park, began a mocking chant of the twenty-four-year-old Red Sox reliever: "Cal-vin! Cal-vin!"

CALVIN SCHIRALDI

I would have expected nothing else.

Schiraldi threw a 2–1 fastball down the middle of the plate. Knight smacked it, hard. The ball sailed into the air, thwacked the blue tarp behind the fence in left-center field, and the Mets had the lead for the first time all night, 4–3.

CALVIN SCHIRALDI

I just didn't have it. I got lit up.

A Dykstra single was followed by a wild pitch, and then a hit from Mets shortstop Rafael Santana to score Dykstra with the fifth run.

DARRYL STRAWBERRY

Guys knew that he could get rattled a bit; he can get into trouble; you can get into his head.

By the time Schiraldi left the game, the Mets led 6–3 going to the top of the eighth inning.

CALVIN SCHIRALDI

I tell my kids that pressure is what you put on yourself; it's not life or death, so have some fun with it. That is all learned through my experiences, when I didn't take my own advice, because for me, it was life or death.

ERIK SHERMAN

Now the tide has turned. It was truly the first time in the entire World Series where the Mets had the advantage over the Red Sox.

Roger McDowell was now pitching for the Mets. But it seemed his busy October had finally caught up with him.

ERIK SHERMAN

The Red Sox come storming back against Roger McDowell.

The first three Red Sox in the eighth inning got hits, with Dwight Evans's two-run double making it a 6–5 game.

ERIK SHERMAN

So the Mets were forced to bring in their closer early—Jesse Orosco.

With the Mets clinging to a 6–5 lead, Orosco came in with the tying run on second and no one out. Rich Gedman hit a bullet that Wally Backman caught for the first out. Then Orosco struck out Dave Henderson, and Don Baylor grounded out.

GREG PRINCE

Orosco closes the door on them for the eighth. But it all still felt perilous.

Darryl Strawberry led off the bottom of the eighth.

GREG PRINCE

Darryl Strawberry had not had a great World Series to this point.

DARRYL STRAWBERRY

No, I didn't have a great series. I struggled, a lot.

GREG PRINCE

Darryl Strawberry hasn't really gotten over being taken out of Game 6 in a double switch.

DARRYL STRAWBERRY

I was still mad, you know; there was just something as a player to your manager, you just don't believe.

RAY KNIGHT

He was so mad at Davey that he didn't even speak to him that day.

Now Red Sox reliever Al Nipper threw an 0–2 curveball. Darryl let loose his gorgeous swing, connecting for a majestic bomb, high and deep into the Shea Stadium night. The ball cleared the fence in right-center field under the scoreboard. Trotting toward first and watching the arc of the ball, Strawberry thrust his arm into the air and continued his slow and deliberate circuit of the bases.

DARRYL STRAWBERRY

Finally came through in that series with a big hit.

GREG PRINCE

And he takes one of the longer trots around the bases you'll ever see.

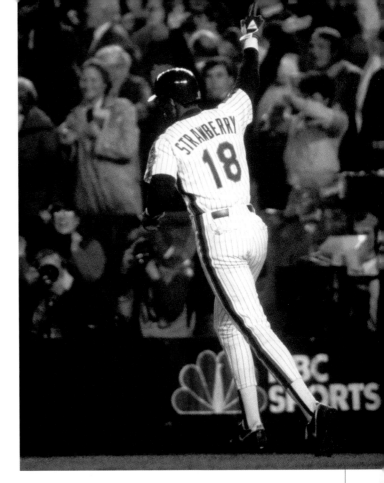

DARRYL STRAWBERRY

Well, that's what they say, you know. I just took my time. It wasn't something I had ever done before.

DAVEY JOHNSON

Maybe he was showing me, you know. "You shouldn't have done that to me, Skip, you see what happens, if I'm still there."

DARRYL STRAWBERRY

It wasn't about getting back at Davey; I just wanted to be a part of what we were doing, what we were trying to accomplish as a team.

RAY KNIGHT

When he touched home plate, I said, "Darryl, I want you to go hug Davey's neck, man, and tell him you're sorry, because he was just trying to win the ball game," and he says, "I will, I will."

DARRYL STRAWBERRY

He told me to go shake Davey's hand. "Be a man, stand up, and go shake his hand," and I did.

JEFF PEARLMAN

Darryl Strawberry was kind of a jerk, to be polite. I just think he was a guy who got lost and eaten up.

DARRYL STRAWBERRY

You know, with the fans, it doesn't matter if you cheer or boo; I always believed that I was nothing. It stays with you, it never leaves you just because you excel and play well in a baseball game.

GREG PRINCE

And the Mets are still at bat, by the way, and the Red Sox are still hopeless in the bullpen, and Jesse Orosco comes up.

With two runners on base, Orosco faked a bunt, then took a full swing and bounced a single into the outfield, scoring yet another run. It was 8–5 Mets, and Shea Stadium was now, finally, ready to exhale.

GREG PRINCE

We got to the top of the ninth.

But the Shea Stadium fans weren't ready to say goodbye to the season just yet. A smoke bomb was thrown onto the field, its orangey-pink haze swirling around Mookie Wilson in center field. Play was stopped until the smoke could dissipate, its mist hanging in the air for several minutes.

MOOKIE WILSON

When you're in New York, things like that don't faze you.

JOE PETRUCCIO

It was almost like a symbol to me. Sometimes you have this beautiful painting and someone throws a little something on it and it turns out totally different than everybody thought, and I think that's what the Mets did. Not only to that series, but to that season.

GREG PRINCE

We come down to two outs in the ninth inning, and it's Marty Barrett at bat for the Red Sox— and Jesse Orosco gets two strikes on him.

Orosco threw, and Barrett swung. It was over.

GREG PRINCE

And Jesse Orosco flings his glove, and from what we can see on TV, it never comes down.

JEFF PEARLMAN

It's a glorious moment. Just a glorious moment.

MOOKIE WILSON

There is no feeling like that one.

RAY KNIGHT

It's the sweetest thing in the world.

The Mets all raced toward the infield—from the dugout and their positions in the field—congregating in a massive pile on the mound.

GREG PRINCE

There they were, all on the field, all on the mound, this wild orange-and-blue embrace in front of fifty-five thousand people, and there was no doubt. The heist was done. Mission accomplished.

KEVIN MITCHELL

I had cuts all on my hands from spikes.

DAVEY JOHNSON

It's a sigh of relief. Really, we knew it's what we were shooting for.

KEITH HERNANDEZ

Gary [Carter] and I didn't find each other when we were celebrating on the field, and we finally did.

RAY KNIGHT

I felt so much elation that when I was pulled out of the line that was going in [to the clubhouse to] celebrate, and they said, "You've been named MVP," I didn't hear anything about the MVP.

KEITH HERNANDEZ

Gary came up to me and said, "I heard Ray Knight won the MVP. Did he win the MVP?" I said, "Gary, who cares? We just won!"

HOWARD BRYANT

You hate using the word, and you don't really wanna say it, because everyone's out there competing, but the Red Sox choked.

BILL BUCKNER, 1986

That's really weak on your part. 'Cause we had the right people at the right time. They just beat us, that's all. Give 'em credit for that.

HOWARD BRYANT

People talk about the curse. There was no curse in Boston in 1986—the curse happened *because* of Game 6. And, of course, losing Game 7. Post-1986, there is no question that the attitude in Boston toward the Red Sox changed.

MOOKIE WILSON

I didn't get to enjoy it until like a week later because I was still on cloud nine. I couldn't eat and couldn't sleep, but it took me a week

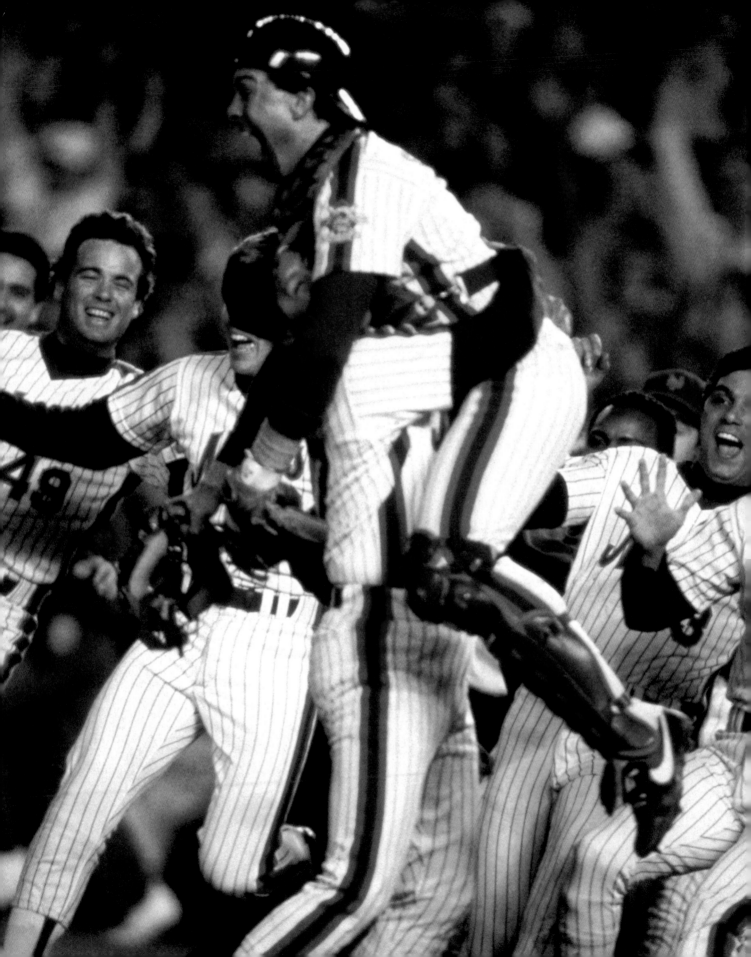

to actually settle down, and then now all of a sudden I could enjoy it.

DAVEY JOHNSON

We deserved it.
We had the best
record in baseball.
World champs.

MOOKIE WILSON

We went through Houston; what a horrifying series. We went through Boston, and that fight was just as tough, and by all rights we almost lost it.

DAVEY JOHNSON

The good guys got it.

JEFF PEARLMAN

It was just a really poetic postseason, and just a really poetic way to win a World Series.

LENNY DYKSTRA

Anybody will say that was the most exciting series in all of history. This is a big fuckin' word, that was that dude who thought the world was flat or whatever. Who's that dude? In the boat? Columbus? Yeah, that's history. History.

DWIGHT GOODEN

That night should have been the best night of my life. It started off the best day of my life, I mean, the greatest day ever. I went back into the training room to celebrate with my team, and I made two phone calls. First I call my dad. My parents made so many sacrifices to make sure I had whatever I've wanted or needed. In high school, my dad and I shared the same winter coat because we just didn't have it. So I just always wanted to show my family the appreciation for what they did for me and the sacrifices. So we celebrated on the phone; we were talking, he's so excited. Never heard him so excited in my life.

Unfortunately, the next phone call went to the drug dealer. Yup.

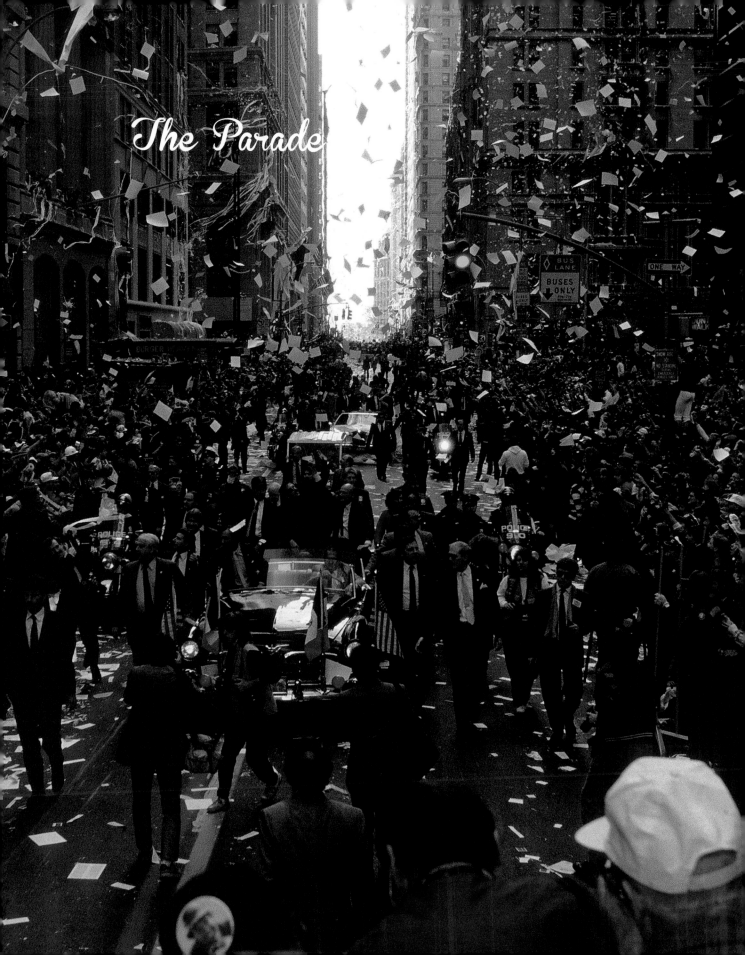

RAY KNIGHT

That next day, before the parade, I was called up to Frank Cashen's office and I took my little daughter, Ashley, with me. We go into his office, I sat down, he pushes an envelope across the table and it was a contract for the 1987 season for a $5,000 raise. I immediately said, "Frank, I'm not that concerned about the money, although this is almost laughable, getting a $5,000 raise with the year that I had, but I'm not worried about the money. I just want a two-year contract so that I can finish out my career here in New York." And he said, "That's just not gonna be possible." I was taken aback because this all happened within a minute. I actually pushed it back across to him and I said, "You know, I sure hope we can get something worked out." When I walked out of there and got on the bus to go to the parade, I was crestfallen.

JEFF PEARLMAN

It's a great all-time parade. It feels like it's almost a hurricane of humanity.

GREG PRINCE

I was in the most frightening crowd I've ever been in, being moved along by other people; maybe my feet touched the ground, I don't know.

JOHN STRAUSBAUGH

I think it would be an unfair burden on any sports team, the Mets, the Yankees, anybody, to expect to bring New York City together. Of course, there were all kinds of people there, and all kinds of people loved them or hated them. But maybe, for that moment of euphoria, when they win the World Series, everybody's cheering together.

KEITH HERNANDEZ

I overslept, and so did Ojeda, and I woke him up.

JEFF PEARLMAN

Bobby Ojeda had stayed over at Keith Hernandez's apartment.

BOBBY OJEDA

I wound up staying at Keith's house. We went out on the island; we went out to Finn's [Finn MacCool's, in Port Washington]. The owner of Finn's was awesome and he threw a big party for us, wouldn't take any money; we took care of all the staff. Awesome big party there. We're supposed to be at Shea at 8:00 a.m. No problem—how hard's that?

I go over, Keith throws me in the extra bedroom. I'm asleep and I sort of wake up, and you know when your curtains are closed but you can tell if it's light, and it was like really light and the sun was kind of high, it's starting to feel like . . . seven o'clock. I look at the clock; it says eight o'clock. I go running

through the apartment. I go, "Keith! It's eight o'clock!" He's in a coma. "Keith, it's eight o'clock!"

SID FERNANDEZ

I remember Jay Horwitz come up to me, 'cause, uh, Bobby O was M.I.A. [Laughs] He didn't come home, and he lived near me; at the time he was married to his first wife. So, Jay asked me if I would sit in the car with her, 'cause we didn't know where Bobby is. I said, "I'm not sitting with her. I don't even know who that is."

BOBBY OJEDA

So we throw our clothes on, run out the door, run downstairs, jump in a cab. We told the cabbie where we had to go; he's like, "I'm not gonna be able to get near there, there's a bunch of people down there," so he drives us as close as he can. Now Keith and I are hungover, no sleep, no shower, and probably smell like God knows what; we're running down the street together. And we get closer and there's so many people, and the people were starting to recognize us, and they started yelling, and we're like, "Yeah, we gotta go."

KEITH HERNANDEZ

And we took a cab downtown, we go down to Battery Park, where it starts, and there's just swarms of people—and we're not going to get to our [parade] cars.

BOBBY OJEDA

So we're running and pushing our way through the people; then we reach this wrought-iron fence that's kinda high.

KEITH HERNANDEZ

The people literally lifted us up, Bobby and I, and put us over the fence.

BOBBY OJEDA

Then we run, we see the cars all lined up, ready to go, and we come waving, "Oh wait!" We're running, jump in our cars, and off we go in the parade.

MOOKIE WILSON

That ticker-tape parade, that was great, man.

BOBBY OJEDA

The parade was just out of a movie. The people were so into it. What an ending to this season, because it's typical, but it had to do with being up too late, drinking too much, almost missing it. Why would I go to bed early and do everything right? Like no, it's "Let's almost miss it."

GREG PRINCE

New York must be the only city in the world where you thank people by throwing garbage on them, but that's how we show our love.

WALLY BACKMAN

It was weird, they were throwing stuff out of windows, a hundred stories up. It seemed like it was almost a dream.

KEVIN MITCHELL

That was a beautiful thing, to see all them; man, that was so beautiful.

BOBBY OJEDA

I'm in this car and I'm just like, holy smoke, what a culmination.

LENNY DYKSTRA

The most intense thing of all of '86, the ticker tape parade. That was fuckin' crazy.

GREG PRINCE

I won't say it was all smiles when you get a crowd of New Yorkers together, but the underlying happiness was profound.

LENNY DYKSTRA

All the people hanging out of the buildings, that was badass.

SANDY CARTER

The parade was scary, but extremely exciting. There were police going around each car, which felt really safe, except that right on the other side of the policemen were mobs of people. The streets were completely full of crowds and people. As high as you could see there was confetti and people yelling out, and it took a long time because you just barely crawled, you know. But it was unbelievable how many . . . I don't know how many . . . like hundreds of thousands, or . . . There was so many people. Somebody will know. [Laughs]

JOE McILVAINE

It's just wonderful to see all the people out the windows throwing things and cheering, and the effect that your little game of baseball had on people. You know that your work paid off a hundredfold, just to see what the people feel.

HOWARD BRYANT

How many other places have a Canyon of Heroes? There's a bit of arrogance having a Canyon of Heroes, right? I mean, this is that New York thing, which makes New York different from all the other places. When the Mets won, it wasn't just a victory over the Red Sox and over baseball, it was a victory over

the Yankees. It was a real validation for the franchise. And it goes back to why we're still talking about the '86 Mets. It's an iconic team. And an iconic moment. Those guys had their moment. That moment still endures.

VINNY GRECO

The guys were fucked up. I remember they said, "Okay, you guys gonna march, you're gonna lead the parade." We had the banner in front of us, so me and a bunch of the clubhouse guys, we had uniforms on, our jackets on, we led the parade into the city, sat at city hall. I actually got a key to the city.

MICHAEL "CHOPS" LACONTE

We were the only ones wearing a uniform. The batboys and the clubhouse kids—they had us all wear uniforms. And I remember getting out of the bus and looking up and seeing all the buildings and people hanging out the windows, and I went and waved, and it was like [Cheers]. And I was just a clubhouse guy! They didn't know who they were looking at, and the place erupted, and it was like, wow, this is cool. And we walked up the Canyon of Heroes. We were holding the "1986 World Championship" banner, and it was like euphoria.

VINNY GRECO

I have the pictures. We were fist-pumping.

Paper, shit coming in every direction and you just look behind you and the guys on the cars and everything else, and it was surreal. You know, how many times can that ever happen to a normal guy like me?

SID FERNANDEZ

Jay said, "You know what? Take your rings off. Take your watches off." A lotta hands.

The parade ended at city hall, where each Met was presented with the key to the city. Mookie Wilson was told to speak to the crowd.

MOOKIE WILSON

They gave me the mic, that was the amazing thing, and I went crazy. I predicted we were gonna win three more; of course, it didn't happen, but you get caught up in the moment and people hanging out the windows. The only place to play is in New York, man. You gotta love it.

SID FERNANDEZ

I remember meeting [Mayor] Ed Koch. He was a character, I liked that guy. [Laughs] It was just, you know, pretty much people kissing your ass, you know.

GREG PRINCE

It was 1986 and it had been the year of the Mets in New York and in baseball . . . and it forever would be.

JEFF PEARLMAN

It's just this whirlwind of orange and blue, and people and humanity and this real connectedness between the team and the city. The '86 Mets *were* New York; they blended into the city.

TAMA JANOWITZ

New York City was a galaxy: We had the garbage collectors, we had struggling artists, we had athletes, we had seamstresses, we had rich people, poor people, and at that moment the Mets brought the whole constellation together.

JEFF PEARLMAN

It was hard to tell where baseball ended and New York began, like they were all just part of the same thing, and that's why that parade had such an organic, personal feel to it. 'Cause it wasn't just honoring your heroes, it was honoring yourselves and honoring New York and what we did.

RAY KNIGHT

Behind the scenes, there was a little bit of stuff going on. One of the players' wives shows up with a black eye.

GREG PRINCE

And it was a thrill to see every single one of the Mets, every single Met—but one.

BOBBY OJEDA

Everyone's like, "Where's Doc?" And he wasn't there. And we were like, "Dang." We knew why he missed it, but we were just like, ugh. So disappointed for him. We're like, "Man, you should really be a part of this. You really should be enjoying this."

JAY HORWITZ

I must have called him a hundred times, and other players called him. We just couldn't get ahold of him.

DARRYL STRAWBERRY

I went to his house. Jay asked me to go, to see if he was home, and I did—and I got no answer. I just headed on to the ballpark.

GREG PRINCE

The word was he overslept.

JEFF PEARLMAN

If you want to talk about the damage of drug abuse and the power of addiction: You just won a World Series in New York City, you are a star on this team, and you are maybe the most popular athlete in New York. They're holding a parade in your honor and the honor of your team, to celebrate an achievement. A dream of dreams: Not only have you won the World Series, but you won the World Series in New York as a Met—and you miss the freakin' parade.

ERIK SHERMAN

The official word from the Mets was that Dwight Gooden had the sniffles. But the reality was, he ended up watching on TV as his teammates celebrate in the most grandiose parade that New York has ever thrown, which is probably one of the saddest things I've ever heard of in baseball.

DWIGHT GOODEN

The night before. I was supposed to meet my teammates at a club. I never made it to the club. Got stuck in the projects on Long Island with some people I didn't know. But at the moment they were my best friends, and it went from the best day of my life to the worst day of my life in a matter of four hours. Watching the parade from a drug house and seeing my teammates celebrate, that was like . . .

GREG PRINCE

Dwight Gooden, according to his own memoirs, goes off and smokes crack that night.

DWIGHT GOODEN

I've never been able to describe it; even in therapy, I really came up with nothing. Just a numb feeling. You see signs that say, "Doc." You sober up when you see that. At that point you know: You screwed up. Then I'm driving home and it's like, *Wow, how do I get out of this?* There's no way out. There's only two choices: Either you continue destroying yourself or you get better, ask for help. And Jay called: "Doc, you all right?" "Yeah I'm fine, I overslept." All this BS. Team already knew because the rumor was starting the whole year. Darryl came by the house, I didn't open the door; he peeped through the curtains. The answering machine was full, calls from my mom, calls from my dad, calls from Jay, calls from Frank Cashen, Darryl, and all these guys.

It's like, man, it's just a mess, and you feel the lowest you can possibly feel. Then after that, you talk to the team, they're like "You gotta get help" and you're still in denial, you're in denial that you have a problem, you're in denial about what really took place when everybody knows, so you're just lying to yourself. Where do you go from there? It's like wow. It's almost like you don't wanna live, 'cause you don't want to face it. The baddest part about it: You can't redo it.

You can't redo it. The parade's over.

Extra Innings

"SOME GOOD BROTHERS"

In the aftermath of the World Series, the Mets management made two key changes to the team, letting Ray Knight become a free agent (he eventually signed with the Baltimore Orioles), and sending Kevin Mitchell to the San Diego Padres for Kevin McReynolds. The front office was apparently concerned that Mitchell was a bad influence on Darryl Strawberry and Dwight Gooden. The two moves forever altered the team's destiny.

MOOKIE WILSON

I've said it before and I'll say it again, you get rid of players like Ray Knight, you lose a player like Kevin Mitchell, there's more than what they did on the field, there's other things that they contribute to that attitude. Then you bring other players that don't quite cover what they did; it makes it very difficult. So you don't have that chemistry.

RAY KNIGHT

I think of myself as a huge part of the Mets. And not being signed back, it broke my heart.

WALLY BACKMAN

Mitch was not a bad influence on anybody, you know.

LENNY DYKSTRA

Worst trade they ever made. They traded him, they thought he was a bad influence on fucking Strawberry and Doc. Mitchell never took a drug in his life. He didn't even drink. That was fucking terrible.

KEVIN MITCHELL

It felt like spikes in my chest. Oh man.

DARRYL STRAWBERRY

Ray and Mitchell was tough. They wasn't gonna back down, they were hard-nosed. The personality of Mac [Kevin McReynolds] and HoJo was more of a "whatever." But in New York, they don't look for "whatever." They look like, "Where's the fire?"

LENNY DYKSTRA

McReynolds was a hillbilly. I'm talking about backwoods, fucking Arkansas, lives on his duck farm. He kept telling me you gotta come visit and go hunting with me. Hunting. I mean, this is gun season. So I say, okay, fine. I go down, get there. There's this big fucking lodge in the middle of the woods in Arkansas. People live there. And next thing I know it's like four in the morning, these dudes got their fucking gear on, eye-black on. "Get up, man, let's go!" I said, what the fuck? It's pitch-black out there—I never been hunting. And these dudes are all fired up like it's the World Series. And they got their fucking guns and we're walking in the dark through the woods. I'm saying, what the fuck are we doing? They said, we got to get there, to set up and every-thing. So we finally get to this fucking tree and . . . and McReynolds says, that's where you're going, you know, stand up there. I said, what do you mean that's where I'm going? And then when I get up, what do I do? He says, you wait for a deer and you shoot the motherfucker. I said, okay, even if I did do that, what happens then? He says, you drag it back, or you gut it right here.

I says, listen man. Here's the deal—I'll buy the steaks, I'll go to the store, I'll get 'em ready, prime fucking best fucking cut. Perfect. You guys can stick around in your fucking trees. I'm done. Because I also wanna know something else. There's seven other motherfuckers here, okay. So where are they going? 'Cause I'm not that smart, but there's seven dudes, and like say you shoot and you miss, the fucking bullet keeps traveling. So I said, fuck this, man. You guys do whatever, I'm done. Plus, I don't know

how to shoot a fucking gun. I mean, I worked at the batting cages in California every day. Anyways, McReynolds, he was one of them guys that could have been a great player. Didn't like baseball.

Despite the changes to the roster, as the Mets gathered for spring training, 1987, they were optimistic they could repeat as champions. But on April Fools' Day, just six days before the season was scheduled to start, shocking news: Dwight Gooden had tested positive for cocaine. He would enter the Smithers clinic in Manhattan immediately and miss the first two months of the season.

LENNY DYKSTRA

We're all waiting in the clubhouse and Cashen came in with his bow tie and says, "Gentleman, Doc Gooden has entered rehabilitation." He told us all the story, we were going, "Wow, the fuck?" I didn't even know what they were doing . . . dancing with the white lady. But I didn't even know what that was back then. Back then.

SID FERNANDEZ

I never seen Doc do drugs. You know, I'm not naïve, but yeah, I was shocked.

DAVEY JOHNSON

Doc was a mystery to me. I had no inkling. That was probably the biggest shock that I've ever had about a player, that's ever happened to me. I couldn't believe it.

VINNY GRECO

People who said they were stunned, I think they were in denial. As a clubhouse guy, we knew. So as a player or somebody working in the front office, that they were shocked . . . you know, in 1986 he didn't show up to the parade—they knew where Doc was. If they were stunned, they were living under a rock.

KEITH HERNANDEZ

I was not surprised. I remember distinctly we were playing the Tigers at Lakeland [Florida]. It was spring training, it might have been '86, actually, and Doc pitched that game, and it was the middle of spring, so I played around six innings, Doc went around five innings. The game went to extra innings, and when it went past the ninth inning, I was already showered. I would just get my stuff and went on the bus, and Doc was in the very back of the bus, the last row, and he was like a caged cat. I've had my experience with it; I knew. I just sat down in the middle of the bus and I remember saying, "Please no, please, don't, no. This can't be happening."

When the season began, the Mets didn't seem ready. Despite a still-powerful offensive lineup, they struggled to score runs. With Gooden out,

the Mets split their first fifty games. Even after he returned, the Mets limped along for most of the year, at one point falling 10 ½ games out of first place.

ERIK SHERMAN

At some point during the season, all five Mets starting pitchers go down with injuries, or in Dwight Gooden's case, drug rehab.

WALLY BACKMAN

'Eighty-seven was a down year for us. We were all on a big high from winning the World Series in '86, and we struggled, and it was, "Hey, we'll be okay, we're going to be fine, we know how good we are, we're going to overcome all this kind of stuff."

DWIGHT GOODEN

Yeah, '87—so much turmoil. At one time or another the whole pitching staff went down. I spent the first two months in treatment, Ronnie tore his thumb, so that was a big part, because without pitching, you don't have anything. But we still almost got back.

GREG PRINCE

They're chasing the Cardinals again, and although it's been a disastrous season spiritually, they are somehow only a game and a half out of first place going into a three-game series at Shea [against the Cards]

in September. And if they can sweep, they're in first place again, where they were supposed to be.

It was September 11, 1987.

GREG PRINCE

It's Friday night, huge crowd, everybody's ready for the changing of the guard at the top of the division, or to get closer to it.

Behind home runs from Darryl Strawberry and Mookie Wilson, the Mets took a 4–1 lead into the ninth inning. A victory would reduce the Cardinals lead to half a game, with Dwight Gooden set to pitch the next day. The Mets could smell first place.

GREG PRINCE

In the ninth inning, Roger McDowell—the guy's been the most dependable reliever for three years running—is on the mound.

With two outs, the Shea Stadium crowd— 51,975 in paid attendance—got to its feet, roaring with every pitch. But Willie McGee singled in a run for the Cardinals, making the score 4–2.

GREG PRINCE

So now McDowell has a runner on base. Terry Pendleton, good hitter, but not a monster by any means, is up for the Cardinals.

Pendleton sent a McDowell pitch high and deep into the night. The ball carried over the center-field fence, sailed into the players' parking lot, and dented Ron Darling's BMW. The game was tied.

GREG PRINCE

It's four to four. It's not over, but it's over.

The Cardinals scored two in the tenth, beat Gooden the following afternoon, and cruised to the National League East division championship.

JAY HORWITZ

It just wasn't to be.

ROGER ANGELL

It was disappointing. Because you thought that this wonderful sandwich can go on, but baseball doesn't work that way.

The Comet

GREG PRINCE

By the middle of October, the Mets had gone away, and New York had other things to worry about. One of them was the stock market, which experienced what is known as Black Monday. And maybe it's just a coincidence that within the span of a couple of weeks, the dynasty that never was was ended and the good times that were never going to end were put on pause.

KURT ANDERSEN

In the fall of 1987, there was the big stock market crash. That certainly was a chastening moment for the manic, go-go, financial, Wall Street '80s, and people thought, "Oh, my God, what's gonna happen? The good times are over."

JOHN STRAUSBAUGH

It didn't hurt Wall Street, of course, or the big banks. They recovered almost immediately, and the federal government helped them recover almost immediately, of course. But for everybody else, it was the beginning of tough years.

GREG PRINCE

Halley's Comet burst through the sky in 1986. It doesn't do that very often. The Mets burst through the sky in 1986 and left behind a trail of light that stays with us to this day.

RAY KNIGHT

I will always cherish those memories, and it certainly doesn't mean any less to me as I've gotten older. You may not be able to remember every out and every play, but you remember the people that were making the plays, and the people that you broke bread with and flew on flights with and busted your tail and sweated with in spring training.

HOWARD BRYANT

They're legend. They are legend. And for a

lot of people and in Queens, on that side of the world, that's their team. If you're a Mets fan, that's your team. That team hasn't been replaced, it hasn't been topped, it hasn't been tied at halftime. Right? The '86 Mets are such a huge, huge team. They're not gonna be replaced anytime soon, if at all.

MOOKIE WILSON

I look at my whole career and how I got to that team and what that team was really able to accomplish, and to have been a part of it, I feel very satisfied. It didn't end the way I wanted it to end, but I mean, that's the story; I accomplished some things. I left a mark on the game. A part of the game that people will never forget, and they tell me that every day, and I feel good about that. So I started as a son of a sharecropper, and ended up a part of baseball history. That ain't too bad. That ain't too bad.

TAMA JANOWITZ

The Mets cemented everybody together, and I'm not sure the city has ever returned to that sense, that a ball team could freaking pull a city together and make everybody feel good, even if you weren't a fan. You felt, like, really proud that this is your city and your ball team and that there was a way that people of such diverse backgrounds, such diverse lives, such diverse everything, were suddenly, just for a brief little shining window: *Yeah, we are New Yorkers. We are New Yorkers and we're really proud.*

JAY HORWITZ

The Buckner play, I think it just plays into it: No matter what was going to happen, the Mets would find a way to win, you know what I mean? By hook or by crook—the Cincinnati game, Dave Parker drops a ball in the ninth, Tim Teufel had a pinch-hit grand slam to win one game, fireworks night. The Buckner play was part of the mystique of that team, that some way, somehow—a miracle, no miracle—the Mets were going to find a way to win.

BOBBY OJEDA

A lot of things aligned. You know, there's some little lynchpin in there that made it come together in spite of itself, or maybe that they won in spite of themselves: "The Team that Won in Spite of Themselves." That ain't bad. I'm writing a novel, I might use that.

MICHAEL "CHOPS" LACONTE

It was a good time. It was a crazy time. It was a party time, you know, in New York City. It was destined to happen, and what makes it that special is the way that it happened. You know, everything with Mookie and Bill Buckner, it was really something, you know. Strawberry, Doc, Gary, Keith, it was amazing.

ROGER ANGELL

I think it was a lot like the Beatles. The Beatles arrive, and everybody is blown away

and feels a whole lot better and a lot younger. Sudden joy. Unalleviated, pure joy. You feel grateful, when it's over.

HOWARD BRYANT

The game's lost its personality. On the field, the game has moved toward metrics and analytics. Off the field, because guys have so much to protect, they don't say anything. That was a team of characters. That team had a heartbeat.

TAMA JANOWITZ

Since '86, I have never followed baseball again. They weren't characters anymore. It became a giant screen with dots, and protection over the audience, and big suits up in the suites, and it became dead to me. I lost interest. I need the lunatics back.

JEFF PEARLMAN

When you write a book about a team that you watched as a kid, and you're only watching it through the lens of a fourteen-, thirteen-year-old kid, it has to change, because everyone is a hero to you. But I wouldn't say it changed for the worse. Because I saw the human side of these guys, and the flaws. I always say: Flaws don't make someone not a hero. If someone is flawed and can still accomplish amazing things, there's something about that that's really inspiring. So I started as just fourteen-year-old Jeff Pearlman sitting on his floor with a mitt on his hand in Mahopac, New York. And ended it as an adult aware of all the shortcomings, but more in awe of the accomplishment.

JOE PETRUCCIO

When those individuals came together, they created a force that baseball hadn't seen before. They had this attitude that baseball hadn't seen before. Maybe teams had one guy like that, or two people like that, but they never had a whole team like that. There wasn't one person on that team that didn't have some kind of character flaw, or something about them that people could point to.

BOBBY OJEDA

I just wish all the dirty laundry didn't come out. It's like, I didn't wanna know Greg Brady wanted to sleep with Mrs. Brady. I loved the show. Just leave it at that. I think that's what's happened to our team. Too much.

KEITH HERNANDEZ

I looked it up: There's only fourteen teams, in the history of the game, that won 108 games or more, and that's something to be very proud of. That's pretty remarkable. So we're right there. The '75 Reds won 108 games. We're right there with those teams, that's something to be proud of. For all the trash about our team, they can't take that away from us; they cannot.

DWIGHT GOODEN

I remember the last talk I had with Gary. They had someone at Citi Field who was signing stuff, and I got on the phone with Gary and we was talking, and he said, "I'm going to battle this thing. I don't know how much time I've got left." He said, "When I'm battling this thing, I want you to battle your disease as well. Carry on, you have to be strong."

On February 16, 2012, Gary Carter died after a nine-month battle with brain cancer. He was fifty-seven years old.

LENNY DYKSTRA

How crazy is this God dude, whoever he is. Like, why'd you fucking take Carter, he didn't do— He was a great husband, he lived a clean life, and they take him first. The fuck? You gotta wonder about this dude, God.

SANDY CARTER

I've got the World Series ring; it's something that's never gonna be sold. People were begging to buy his ring. But no way. It meant so much to Gary, that ring. He wore it all the time. He said, "I'm wearing a wedding ring, and I'm wearing this." It's gonna go to our son, and he knows he's gonna get it. He said, "Son, I want you to have the World Series ring and the Hall of Fame ring." So, they both are going to him. But it's a big size. He had big fingers.

KEITH HERNANDEZ

It's too bad Gary's not alive that we can get his take on everything. He had quite a story to tell. . . . You know what, it's so fleeting. It's here. [Snaps] It's gone.

In 2019, Bill Buckner died at the age of 69.

MOOKIE WILSON

I did not speak to Bill Buckner till 1989. He was in Kansas City; how he got to Kansas City I don't know. I got traded and went to Toronto, so before the game in Kansas City, during pregame workouts I'm down the right-field line stretching, and their batting cages are down the right-field corner, so I'm stretching and I look up and I see Bill Buckner come across the field!

I don't wanna face the guy. I don't wanna say nothing to the guy. He and the stuff he was goin' through—I felt guilty about what happened to him. But I end up, after doing my sprints, coming back to the side line, and I'm on my back doing my stretching and he comes over to me. I don't wanna talk to him. I see him come over with a bat, he comes over with the bat and he says, "Hey, Mookie, do you wanna hit me some ground balls?"

DWIGHT GOODEN

For a long time, I can't speak for Darryl, I used to beat myself up, saying, man, I should've been

in the Hall of Fame, I could've been in the Hall of Fame—but why do I say that? When I made the team, I was just happy to make the team, I wanna have a great career, stay healthy, win the World Series, and I was very fortunate to win every award a pitcher can win. I won the World Series for the Mets. Who am I to say what could've been? I accomplished everything that I never even thought of, and then, where I came from, I wasn't even supposed to be there, from in the projects in Tampa. A lot of people don't make it out of there. What I've been through, people lost their lives to a lot less than what I've did. I've still got an opportunity to right this ship, and that's what I'm trying to do.

Today, Darryl Strawberry lives with his wife just outside St. Louis.

DARRYL STRAWBERRY

They didn't like us, and they called us a bunch of pond scums here. But in reality, living here now is just so peaceful, so quiet, and it's so different. My wife's from here and our whole family's from here, and I just found this place where I can find peace. And I could never imagine— I said, "God, you have such a great sense of humor, that you would send me to St. Louis and allow me to be in a place where I was never liked by the fans and live a life." It wasn't like I didn't have the right principles growing up, I did. My mother raised me with the right principles, I just didn't follow 'em.

I had a lot of wrong actions, and I met major consequences behind 'em . . . but at the same time, you know, I came back to this place of humility, and humbled myself, because my mother raised me right. It brought me back to the place that always knew, the man that she wanted me to be, and that I was created to be . . . I knew that person was inside of me.

LENNY DYKSTRA

I don't live back there, man. But I do go back and think about the team and the fans, and you can't explain the feeling, you know. That was a team, see, '86 was a team, a real team; you don't see that anymore. But I'm being honest with you: Playing in New York and with those fans and winning a World Series there, that's it, bro, that's it. It's like my life now, you know. Days turn into nights, nights turn into weeks, weeks turn into months, but it's okay, and you know why? I played in New York and I won a World Series. Now that was—where do you go from there? Where do you go from there?

KEVIN MITCHELL

Once upon a time . . . I played with some good brothers. I'm not gonna bash nobody. You know, as long as I hear their voices, I'm on top of the world. I get scared when I don't hear their voice, when I don't hear from them, you know, which God willing they'll keep calling me: "Mitch! It's me, World. What's up, baby?"

Acknowledgments

Who do you thank for a dream?

My dad took me to Willie Mays's first game as a Met on Mother's Day in 1972 (also St. Petersburg for spring training; Tom Seaver's return on opening day, 1983; Darryl Strawberry's first game that May; and Games 1 of both the 1973 and 1986 World Series, after which we decided we'd had enough of ground balls to second base), so he's leading off. Dad, I love you, and thanks for baseball.

Major League Baseball has been an invaluable partner on the project, and Nick Trotta has been the mastermind: consigliere, friend, sounding board, musicologist, gadfly.

Thank you to everyone at the New York Mets, especially Lorraine Hamilton and Jay Horwitz for working their Mets magic to bring this project to fruition. And thanks to Bruce Boisclair, who kept me going in the lean years.

Scott Lonker was the pivot man, making sure the double play got turned smoothly in the first place; without Scott, this project might never have happened, and we definitely wouldn't have been backed by the incredible team at ITV.

Thanks of course to Brent Montgomery and the Wheelhouse gang, and all the folks at ITV during the most challenging season of all: Danielle Bibbo, David George, Greg Starr, Matt Haught, Ross Rosenberg, Kenneth Solis, Morgan Mirvis, Amanda Ross, Niki Bhargava, Missy Berkowitz, Jonathan Griggs, and Jamie Zoll.

In the field, our crews performed masterfully, working under absurd conditions, and switching positions like Orosco and McDowell in Cincinnati. I especially want to thank Eddie Marritz, as well as Cliff Traiman, Paul Duchowitz, Daniel Maraccino, Rob Cain, Tony Dimond, Michael Fitzgerald, Justin Uchendu, Lou DiMaggio, and Kyle Thomas. And, as always, Joel Goodman.

Rowdy curtain calls for the whole team at NDP, whose work was inspiring and sustaining, full of excellence and resilience throughout: my right arm on the project, Lincoln Farr, Lauren Franklin, Leyla Brittan, and our incredibly talented editors Colin Cosack, Jack Mankiewicz, and the backbone, Josh Freed. Thanks too to our tireless interns—Robbie Shindler, Madi Howard, Hope Green, Teddy Benchley, and Ben Brewster—and to Adam Freifeld, and my agent, Bill Clegg.

A personal thanks to my astonishing wife, Jane, and my amazing daughters, Lily and Grace, whose only flaw is to have inherited their mother's level of fascination with this great game.

A tip of the cap to Mets fans everywhere, especially those who sent in their indelible memories of Game 6, and also those in the home dugout: Johanna Davis, Tim Davis, Jane Mankiewicz, Brooks Hansen, Nick Glass, Dan Wilhem, Daniel Paisner, and Amiel Weisfogel.

Working with the folks at Hyperion Avenue was like the 2015 Mets after acquiring Cespedes—stunning, fast, and over much too quickly: my incomparable editor, Jennifer Levesque; publisher Tonya Agurto; art director Scott Piehl; copy chief Guy Cunningham; designer Sammy Yuen; and Radhi Parikh.

In July, 2018, I met with Adam Neuhaus at ESPN. When I told him I wanted to do a project on the 1986 Mets, he laughed gently—this thing had never been done before, for good reasons—but rather than discouraging me from overly grand ambitions, he provided an excellent and detailed roadmap. Just a little over a year later we were making the series. He has been a rock throughout, and the entire group at ESPN—Gentry Kirby, Jennifer Leyden, Brian Lockhart, Eve Wulf, Trevor Gill, and a roster of All Stars—has been like the 1986 Mets, a team of diverse talents who came together for one magical run.

So much gratitude to the people who sat for interviews and contributed their patience and wisdom about a team and a time and a place: Kurt Andersen, Roger Angell, Billy Beane, Howard Bryant, Bill Burr, Sandy Carter, Chuck D, Gary Della'Abate, Renee Graham, Mark C. Healey, Jay Horwitz, Vinny Greco, Tama Janowitz, Cyndi Lauper, Mike "Chops" LaConte, Ann Liguori, George R. R. Martin, John McEnroe, Joe McIlvaine, Jeff Pearlman, Terry Pendleton, Joe Petruccio, Greg Prince, Calvin Schiraldi, Erik Sherman, Oliver Stone, John Strausbaugh, and Mike Tyson.

Photography Credits

Pages II–III, 100, 103, 111, 132, 181, 227 (top left), 227 (top right), 227 (bottom): New York Daily News Archive/*New York Daily News* via Getty Images

Page 3: Manny Millan/*Sports Illustrated* via Getty Images

Pages 5, 106, 144: Associated Press

Pages 7, 218: Courtesy of Keith Hernandez

Pages 8, 34, 129, 136: Bettmann/Bettmann via Getty Images

Pages 10–11: Allan Tannenbaum/Archive Photos via Getty Images

Page 13: Louis Requena/Major League Baseball via Getty Images

Page 14: RFS, Associated Press

Page 17: Courtesy of Darryl Strawberry

Page 20: Tony Triolo/*Sports Illustrated* via Getty Images

Page 23: Louis DeLuca

Page 24: David Durochik, Associated Press

Page 29: Ron Frehm, Associated Press

Page 33: Courtesy of Dwight Gooden

Page 36: B Bennett/Bruce Bennett via Getty Images

Pages 39, 47, 164: Focus On Sport/Getty Images Sport via Getty Images

Pages 42, 89, 161, 184, 202, 216: Ronald C. Modra/Getty Images Sport via Getty Images

Page 45: Rich Pilling/Getty Images Sport via Getty Images

Page 51: Walter Iooss Jr./*Sports Illustrated Classic* via Getty Images

Pages 55, 182: George Gojkovich/Getty Images Sport via Getty Images

Page 59: Ron Vesely/Getty Images Sport via Getty Images

Page 61: From *The New York Times*. © 1986 The New York Times Company. All rights reserved. Used under license.

Page 64: Rick Stewart/Getty Images Sport via Getty Images

Pages 66, 78: Bruce Bennett/Bruce Bennett via Getty Images

Page 69: G. Paul Burnett, Associated Press

Pages 73, 168: Mickey Pfleger/*Sports Illustrated* via Getty Images

Pages 75, 117: Andrew D. Bernstein/Getty Images Sport via Getty Images

Pages 76, 123: Stephen Dunn/Getty Images Sport via Getty Images

Page 82: Kathy Kmonicek, Associated Press

Page 90: Yves GELLIE/Gamma-Rapho via Getty Images

Page 92: Courtesy of Vinny Greco

Page 93: Patrick McMullan/Patrick McMullan via Getty Images

Pages 104, 157, 187, 208–209: Newsday LLC/*Newsday* via Getty Images

Page 109: From *The New York Times*. © 1986 The New York Times Company. All rights reserved. Used under license.

Page 126: Rose Hartman/Archive Photos via Getty Images

Pages 134–135, 191, 194, 224, 226: Focus on Sport/Focus on Sport via Getty Images

Page 139: Ray Stubblebine, Associated Press

Page 151: SPX/Diamond Images/Diamond Images via Getty Images

Page 156: Jerry Wachter/*Sports Illustrated* via Getty Images

Pages 159, 221: John Iacono/*Sports Illustrated* via Getty Images

Page 189: Chuck Solomon/*Sports Illustrated* via Getty Images

Page 225: Ronald C. Modra/*Sports Illustrated* via Getty Images

And, of course, special appreciation to every member of the 1986 New York Mets, not limited to those I was lucky enough to interview: Wally Backman, Ron Darling, Lenny Dykstra, Sid Fernandez, Dwight Gooden, Ed Hearn, Keith Hernandez, Davey Johnson, Ray Knight, Ed Lynch, Roger McDowell, Kevin Mitchell, Bobby Ojeda, Darryl Strawberry, and Mookie Wilson.

Extra thanks to Jeff Pearlman, ally of this project from the beginning, whose stalwartness extended to permitting us to use interviews he'd conducted early in this century with two integral, but now sadly missing, parts of the team: Gary Carter and Frank Cashen.

Thanks to Sal Iacono, sly and funny, who helped the project in immeasurable ways.

And finally, I thank Jimmy Kimmel, the best cleanup hitter in the game. He has been like Davey Johnson, Mookie Wilson, Gary Carter, and Keith Hernandez rolled into one: a leader of fearless instincts and matchless ability and charisma, but also almost criminally nice and supportive, and incidentally brilliant—though unlike the '86 Mets, he doesn't rub it in your face.

Amid all the come-from-behind heroics and chest-thumping swagger of the 1986 Mets, what often gets forgotten are the easy victories, those games where they'd be up by three runs in the second inning and never seemed to break a sweat. That's how I feel about the team that put this book together. The pressure was on, but the outcome was never in doubt.

With gratitude to all,

Nick Davis
New York City